KEY DATES IN
ART HISTORY

FROM 600 BC TO THE PRESENT

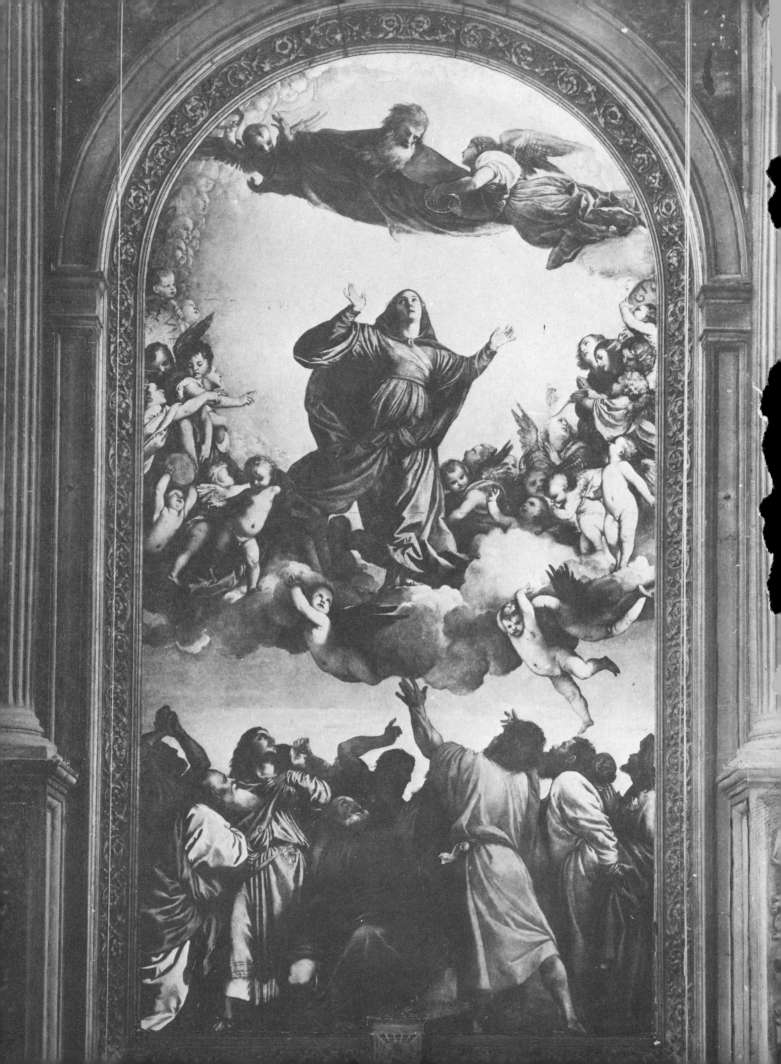

KEY DATES IN ART HISTORY

FROM 600 BC TO THE PRESENT

ROSLIN MAIR

PHAIDON

OXFORD

CONTENTS

Consultant editors Ian Chilvers
Jane Cunningham
Dr Roger Ling
Margaret Tatton-Brown

Phaidon Press Limited, Littlegate House, St Ebbe's Street, Oxford

Published in the United States of America by E. P. Dutton, New York

© Phaidon Press Limited 1979

ISBN 0 7148 1929 8
Library of Congress Catalog Card Number: 79–88175

Set, printed and bound in Great Britain by Fakenham Press Limited, Fakenham, Norfolk

Acknowledgements

I would like to thank Roger Ling, Jane Cunningham, Ian Chilvers and Margaret Tatton-Brown for their kind cooperation in checking the entries. For advice, encouragement and editorial attentiveness my special thanks are due to Anne Bosman of Phaidon Press.

Frontispiece: Titian. *Assunta.* 1518. S. Maria Gloriosa dei Frari, Venice

PREFACE

If you were to stop a stranger in the street and ask him if he could think of an important date in history you would certainly get 1066 (for an American stranger in the street read 1776), and probably not much else. After that, there would be a longish pause, with the unspoken implication that dates are 'important' only to pedants and competitors in television quiz-games. Is this really true, and do dates have any significant connection with works of art?

For most people, the emotional response to a work of art is what matters; Greek temples, the Bayeux tapestry and van Gogh all exist together in a timeless vacuum—it does not matter at all that the Parthenon is over two thousand years older than the *Sunflowers*, so long as the aesthetic emotion aroused by both is the same. In one sense, of course, this is unarguable: I myself derive deep pleasure from Chinese pots and Persian rugs, while knowing little about either. Nevertheless, I am aware that I would get even deeper satisfaction from these works of art if I knew more about them, just as I know that the more familiar European works mean more to me because they are part of the web of the history of Europe and part of my heritage. Anyone who hopes to understand his own civilization must obviously have a sense of history; and a basic grasp of temporal sequence, chronology (or just plain dates), is the ABC of the historical sense. Anyone who thought that *Guernica* was part of the Spanish Armada would clearly not be a very reliable mentor for the young, so it may be assumed that teachers, at least, have a few dates in their heads to guide them. But why should anyone else?

Events can only be understood when their causes are known, even if only approximately; and historical causation is sequential—that is, chronological. It may well be that the Sack of Rome in 1527 had little or no influence on the development of Mannerism as a distinctive style in art and architecture, but the point is worth arguing about; just as the part played by David's *Oath of the Horatii*, painted in 1785, in forwarding the French Revolution will probably never be fully known—but to understand one you need to be aware of the other. To understand a work of art fully you must know something of the society in and for which it was produced, and a historian of society is foolish indeed if he imagines that he can comprehend his subject without knowing the works of art it produced.

This book has been designed to help anyone in search of a chronological skeleton, either in order to arrive at a fuller understanding of the art of the past or as a means of using that art to create new works. It was Cézanne who said that what he was trying to do was 'to make Impressionism into something solid and lasting, like the art of the museums' – in other words, he was measuring his contemporaries against their predecessors; and Cézanne, the greatest painter of recent times, knew what he was talking about.

London, March 1979 *Peter Murray*

INTRODUCTION

Key Dates in Art History is an illustrated chronology of the most important works of art from 600 BC to AD 1970. The arrangement of such a huge survey requires some explanation.

Each double page covers a period of years, varying from four hundred in the so-called Dark Ages to ten in the modern era. For each of these periods the reader is given a selection of the major works of art, arranged under three subject headings – architecture, sculpture and painting – and according to certain geographical divisions. Illustrations and a chronology of important contemporary events, particularly those concerning the arts, accompany the selection of works. The aim is to give the reader a good general impression of the artistic activities of a particular period, viewed within a social, historical and cultural context. The illustrations provide a continual visual narrative of the styles and subjects of each period.

The grouping of geographical regions varies considerably according to changes in territorial massing and the relative importance of an area in the history of Western art. Thus the Eastern empire is not represented after 1300 because of its dwindling political significance and less active influence on the arts elsewhere. From then on, particularly important monuments and paintings in Eastern Europe are included under Northern Europe. North America is represented from 1850 onwards, when indigenous artistic achievements began to build their own traditions.

It should be noted that works of art appear under the region where they were executed, rather than according to the nationality of the artist. Works executed outside the geographical areas covered are not included (Gauguin's Tahiti paintings, for instance). It is hoped that by arranging the selection of works in this way a clear picture of the main centres of creativity emerges, and the international importance of certain individuals, such as Rubens or Tiepolo, becomes apparent. (Tiepolo, for instance, is represented under Germany and Spain, as well as under his native Italy.) Difficulties have arisen in the earlier ages when the place of execution is not obvious and may be the subject of controversy; similarly, in the modern period, when artists travel widely and frequently, it has been difficult to establish where certain works were created.

There have been some restrictions of space when a great number of very important artists have to be represented in one section. As an example, in the modern period, when many major artists converged on Paris, much more space has been devoted to France than to Southern Europe, and as a result the latter may appear to be poorly represented. Any such disproportion is a condition of the system of entry adopted, and reinforces the intention of portraying the major centres of cultural activity within a given period.

The brief comments made on each work vary in nature.

The intention is always to give as much information as possible within the restricted space. There are four categories of entry. Firstly, priority is given to indicating the nature of a key work, or to placing a work firmly with a school or group (such as 'first truly Baroque façade' or 'earliest surviving illustrated Beatus manuscript'). Secondly, there are comments which shed light on a work's history, for instance 'work executed according to the donor's will' or 'church built as a thanks offering for a military victory'. Thirdly, a selected work may simply be described because this makes the artist's main intention apparent. Fourthly, for a work included because of its representative value the comment is more general.

The accompanying chronology varies according to the historical period. During the long early sections, when documentary evidence of artists' lives and travels is poor, the dates are mainly political, often with a direct significance, as, for instance, is the case with major political upheavals and invasions. Other dates, such as those of prominent patrons, are useful for reference in relation to contemporary works, and more general dates are included to give an impression of historical developments. Also recorded are certain events in individual artists' lives, such as journeys or exhibitions, reflecting new influences and individual successes.

In the modern period more literature is listed, especially artistic treatises, and important dates in philosophy, science, music and popular culture are given. The list of dates is as balanced and comprehensive as possible, but the reader must of course accept some omissions as the inevitable concomitant of the general scheme. The particular advantage of the widely varied list of dates lies in the relationship which emerges between artistic and other activities.

Destroyed monuments, such as the Crystal Palace, are included in the list of dates when they are considered of major importance. A complete record of destroyed key works does not lie within the scope of this book, though it would be extremely useful to the art historian.

It may be said that what constitutes a key date is questionable in more than one way. Leading art historians may argue differently the importance of a building, piece of sculpture or painting, and the date itself may well be a matter of controversy. This book does not represent only dated works, however, and not every work of art included is a turning point in the history of art. The aim of the book is to give a chronological framework and a balanced impression of art historical developments in successive periods.

Finally, the comprehensive index of artists and their works will allow the book to be used for general and particular reference. It is to be hoped that *Key Dates in Art History* will prove a useful guide through the many centuries of art historical developments.

BIBLIOGRAPHY

GENERAL

DICTIONARIES AND ENCYCLOPAEDIAS

Pall Mall Enclyclopaedia of Art, London, 1971.
The Oxford Companion to Art, Oxford, 1970.
Fleming, J., Honour, H. and Pevsner, N., *The Penguin Dictionary of Architecture*, Harmondsworth, 1966.
Murray, P. and L., *A Dictionary of Art and Artists*, Harmondsworth, 1965.
Hatje, G., ed. *Encyclopaedia of Modern Architecture*, London, 1963.

ART HISTORY

Bazin, G., *A Concise History of Art*, Paris, 1958.
Focillon, H., *The Art of the West*, London, 1963, vol. 1 and 2.
Gombrich, E., *The Story of Art*, London, 1950.
Hartt, F., *A History of Art*, New York, 1976, vol. 1 and 2.
Holt, E. G. ed., *The Literary Sources of Art History*, New York, 1947.

ARCHITECTURE, SCULPTURE, PAINTING AND REGIONAL ART

Furneaux-Jordan, R., *A Concise History of Western Architecture*, London, 1969.
Kidson, P., Murray, P., and Thompson, P., *A History of English Architecture*, London, 1965.
Lavedan, P., *French Architecture*, London 1956.
Lucie-Smith, E., *A Concise History of French Painting*, London, 1971
McLanathan, R., *Art in America, a Brief History*, London, 1973.
Molesworth, H. D., *European Sculpture*. London, 1965.
Pevsner, N., *An Outline of European Architecture*, Harmondsworth, 1943.
Rice, T. T., *A Concise History of Russian Art*, London, 1963.
Wilenski, R. H., *French Painting*, New York, 1973.
Wilmerding, J., *American Art*, Harmondsworth, 1976.
Wittkower, R., *Sculpture: Processes and Principles*, London, 1977.

CLASSICAL

Allsopp, H. B., *A History of Classical Architecture*, London, 1965.
Arias, P., Hirmer, M., and Shefton, B. B., *A History of Greek Vase Painting*, London, 1961.
Beazley, J. D., and Ashmole, B., *Greek Sculpture and Painting*, Cambridge, 1932.
Bloch, R., *The Etruscans*, London, 1958.
Boardman, J., *Greek Art*, London, 1964.
Boëthius, A., and Ward Perkins, J. B., *Etruscan and Roman Architecture*, Harmondsworth, 1970.
Brilliant, R., *Roman Art from the Republic to Constantine*, London, 1974.
Heintze, H. von, *Roman Art*, London, 1972.
Lawrence, A. W., *Greek Architecture*, Harmondsworth, 1957.

Pallottino, M., *Etruscan Painting*, Geneva, 1952.
Pollitt, J. J., *The Art of Greece (1400–31 B.C.): Sources and Documents*, New Jersey, 1965.
Probé, M., and Roubier, J., *The Art of Roman Gaul*, London, 1961.
Richter, G. M. A., *A Handbook of Greek Art*, London, 1959.
Robertson, D. S., *A Handbook of Greek and Roman Architecture*, London, 1929.
Schuchhardt, W-H., *Greek Art*, London, 1972.
Strong, D. E., *Roman Imperial Sculpture*, London, 1961.
Toynbee, J. M. C., *The Art of the Romans*, London, 1965.
Wheeler, R. E. M., *Roman Art and Architecture*, New York, 1964.

MEDIEVAL

WESTERN EUROPE

Aubert, M., *La Sculpture Française au Moyen-âge*, Paris, 1946.
Aubert, M., *High Gothic Art*, London, 1964.
Beckwith, J., *Early Medieval Art*, London, 1964.
Bony, J., and Hürlimann, M., *French Cathedrals*, London, 1961.
Conant, K. J. C., *Carolingian and Romanesque Architecture: 800–1200*, Harmondsworth, 1959.
Dodwell, C. R., *Painting in Europe: 800–1200*, Harmondsworth, 1971.
Evans, J., *Art in Medieval France, 987–1498*, London, 1948.
Frankl, P., *Gothic Architecture*, Harmondsworth, 1962.
Grabar, A., and Nordenfalk, C., *Early Medieval Painting*, Lausanne, 1957.
Kendrick, T. D., *Anglo-Saxon Art to A.D. 900*, London, 1958.
Lasko, P., *The Kingdom of the Franks*, London, 1971.
Martindale, A., *Gothic Art*, London, 1967.
Pope-Hennessy, J., *Italian Gothic Sculpture*, London, 1955.
Rickert, M., *Painting in Britain: The Middle Ages*, Harmondsworth, 1955.
Salvini, R., *Medieval Sculpture*, London, 1969.
Stone, L., *Sculpture in Britain: The Middle Ages*, Harmondsworth, 1955.
Swarzenski, H., *Monuments of Romanesque Art*, London, 1954.
Rice, D. T., *The Beginnings of Christian Art*, London, 1957.

BYZANTIUM

Beckwith, J., *Early Christian and Byzantine Art*, Harmondsworth, 1970.
Demus, O., *Byzantine Art and the West*, London, 1970.
Grabar, A., *Byzantine Painting*, London, 1953.
Grabar, A., *Byzantium*, London, 1966.
Krautheimer, R., *Early Christian and Byzantine Architecture*, Harmondsworth, 1965.
Rice, D. T., *The Art of Byzantium*, London, 1959.

RENAISSANCE TO NINETEENTH CENTURY

GENERAL SURVEYS BETWEEN 1500 AND 1830

Blunt, A., *Art and Architecture in France, 1500–1700*
Harmondsworth, 1953.
Piper, D., *Painting in England 1500–1800*, Harmondsworth, 1965.
Summerson, J., *Architecture in Britain 1530–1830*, Harmondsworth, 1963.
Waterhouse, E. K., *Painting in Britain 1530–1830*, Harmondsworth, 1962.
Whinney, M. D., *Sculpture in Britain, 1530–1830*, London, 1964.
Wittkower, R., *Art and Architecture in Italy 1600–1750*, Harmondsworth, 1973.

RENAISSANCE TO MANNERISM

Benesch, O., *The Art of the Renaissance in Northern Europe*, Harvard, 1945.
Gould, C., *Introduction to Italian Renaissance Painting*, London, 1957.
Levey, M., *Early Renaissance*, Harmondsworth, 1967.
Levey, M., *High Renaissance*, Harmondsworth, 1975.
Martindale, A., *Man and the Renaissance*, London, 1966.
Murray, L., *The High Renaissance*, London, 1967.
Murray, L., *The Late Renaissance and Mannerism*, London, 1967.
Müller, T., *Sculpture in the Netherlands, France, Germany and Spain, 1400–1500*, Harmondsworth, 1966.
Ring, G., *A Century of French Painting, 1400–1500*, London, 1949.
Seymour, C. Jr., *Sculpture in Italy: 1400–1500*, Harmondsworth, 1966.
Shearman, J. K. G., *Mannerism*, Harmondsworth, 1967.
Smart, A., *The Renaissance and Mannerism outside Italy*, London, 1972.

BAROQUE TO ROCOCO

Bazin, G., *Baroque and Rococo*, London, 1964.
Blunt, A., ed., *Baroque and Rococo Architecture and Decoration*, London, 1978.
Cannon-Brookes, P. and C., *Baroque Churches*, London, 1969.
Hubala, E., *Baroque and Rococo Art*, London, 1976.
Hempel, E., *Baroque Art and Architecture in Central Europe*, Harmondsworth, 1965.
Kitson, M., *The Age of Baroque*, London, 1966.
Waterhouse, E. K., *Italian Baroque Painting*, London, 1963.

NEOCLASSICISM TO ROMANTICISM

Brion, M., *Art of the Romantic Era*, London, 1966.
Friedlander, W., *David to Delacroix*, Cambridge, Mass., 1952.
Honour, H., *Neoclassicism*, Harmondsworth, 1968.
Vaughan, W., *Romantic Art*, London, 1978.

NINETEENTH AND TWENTIETH CENTURY

Arnason, H., *A History of Modern Art*, London, 1969.
Besset, M., *Art of the Twentieth Century*, London, 1976.
Bowness, A., *Modern European Art*, London, 1972.
Burnham, J., *Beyond Modern Sculpture*, London, 1969.
Dixon, R., and Muthesius, S., *Victorian Architecture*, London, 1978.
Elsen, A. E., *Origins of Modern Sculpture: Pioneers and Premises*, London, 1974.
Hamilton, G. H., *Painting and Sculpture in Europe, 1880–1940*, Harmondsworth, 1967.
Hammacher, A. M., *The Evolution of Modern Sculpture*, London, 1969.
Hitchcock, H-R., *Architecture: Nineteenth and Twentieth Centuries*, Harmondsworth, 1958.
Hofmann, W., *Turning Points in Twentieth-Century Art: 1890–1917*, London, 1969.
Joedicke, J., *Architecture since 1945. Sources and Directions*, London, 1969.
Lucie-Smith, E., *Movements in Art since 1945*, London, 1969.
Mathey, F., *The World of the Impressionists*, London, 1969.
Nochlin, L., *Realism*, London, 1971.
Pevsner, N., *Pioneers of Modern Design*, Harmondsworth, 1960.
Pool, P., *Impressionism*, London, 1967.
Read, H., *A Concise History of Modern Painting*, London, 1964.
Read, H., *A Concise History of Modern Sculpture*, London, 1964.
Rewald, J., *The History of Impressionism*, New York, 1961.
Ritchie, A. C., *Abstract Painting and Sculpture in America*, New York, 1951.
Rosenblum, R., *Cubism and Twentieth Century Art*, London, 1960.
Schmutzler, R., *Art Nouveau*, London, 1964.
Selz, J., *Modern Sculpture and its Origins and Evolutions*, New York, 1963.
Winter, J., *Modern Buildings*, London, 1969.

GREECE AND THE EASTERN MEDITERRANEAN

PAINTING

c. 570 *François Vase* by **Clitias**, Archaeological Museum, Florence; masterpiece of miniaturist painting in phase of Corinthian influence on Attic black-figure.

c. 560–30 *Bird Nester*, East Greek Little Master cup, Louvre; a fine decorative interior in which there is no clear top or bottom.

c. 540–30 *Achilles and Ajax playing Draughts*, and *Return of the Dioscuri*, scenes on an amphora by **Exekiaas**, Vatican Museum; finest work of mature black-figure, in which the medium achieves a tragic grandeur.

c. 530–20 *Apollo and Heracles struggling for the tripod* by the **Andocides Painter**, Staatliche Museen, Berlin; a pioneering work in the red-figure technique.

c. 510 *Heracles and Antaeus*, calyx-crater by **Euphronius**, Louvre; one of the boldest works by the chief experimental painter of the late Archaic period.

c. 500–490 *Dionysus with satyrs and maenads*, pointed amphora by the **Cleophrades Painter**, Antikensammlungen, Munich; new emphasis on mood and decorative folds of drapery.

c. 490 *Hermes and the satyr Orimachus* by the **Berlin Painter**, Staatliche Museen, Berlin; painting in 'spotlight' technique with one or two figures isolated on black ground.

c. 465–50 *Ilioupersis and Nekyia* by **Polygnotus** in the Lesche of the Cnidians at Delphi; the most famous murals of antiquity, now lost.

c. 450–40 *Achilles* by the **Achilles Painter**, Vatican Museum; name-piece of the greatest Classical vase-painter.

c. 410 *Rape of the Daughters of Leucippus* by the **Midias Painter**, British Museum; new elegant style of filmy drapery and three-quarters faces

ARCHITECTURE

c. 600 *Temple of Hera*, Olympia; early Doric temple originally constructed in wood.

c. 560 *Temples of Artemis* at Ephesus and *Hera* at Samos; gigantic Ionic temples in Asia Minor, each with double peristyles.

c. 540 *Temple of Apollo*, Corinth; Doric temple with thick, monolithic columns; seven still standing.

c. 530 *Siphnian Treasury*, Delphi; exquisite little Ionic building in marble; caryatids used in the porch.

c. 490 *Later temple of Aphaea*, Aegina; beautiful hilltop temple with double tier of internal columns.

c. 460 *Temple of Zeus*, Olympia; early Classical masterpiece of Doric order, the focal point of Greece's greatest international sanctuary.

c. 450–40 *Temple of Hephaestus* (so-called Theseum), Athens; the best-preserved Greek temple.

447–32 *Parthenon*, Athens, designed by **Ictinus** and **Callicrates**; finest of all Greek buildings, a Doric temple with Ionic features.

437–2 *Propylaea*, built by **Mnesicles**, a monumental gateway for the Athenian Acropolis.

c. 420 *Temple of Apollo Epicurius*, Bassae, designed by **Ictinus**; anomalous Doric temple oriented north and south; contains first Corinthian column.

421–5 *Erechtheum*, Athens; Ionic temple built on different levels, with caryatid porch on south side.

c. 390 *Marble tholos* at Delphi, by **Theodorus**; circular Doric building with internal Corinthian columns.

c. 356 *New temple* at Ephesus begun on even grander scale than the first.

353 *Tomb of Mausolus* at Halicarnassus, built by a Greek architect for a Carian dynasty; Ionic colonnade surmounted by a stepped pyramid.

SCULPTURE

c. 600 *Kouros* from Sunium, National Museum, Athens; early example of large-scale marble sculpture in Attica.

c. 600–580 *West pediment of temple of Artemis*, Corfu; earliest surviving large-scale architectural sculptures in stone.

c. 575–500 *Hera*, headless statue from Samos, dedicated by Cheramyes, Louvre; female figure showing folds in drapery.

c. 570 *The Calf-bearer*, a votive offering, Acropolis Museum, Athens; variant on the kouros type.

c. 520 *Bronze kouros* from Piraeus, National Museum, Athens; first life-size hollow-cast bronze work.

c. 490 *East (later) pediment from temple of Aphaea*, Aegina, Glyptothek, Munich; integrated composition formed entirely of human figures engaged in battle.

465–57 *Metopes and pediments of temple of Zeus*, Olympia; revolutionary new style of mood and violence (lapiths and centaurs).

c. 460 *Poseidon*, bronze, National Museum, Athens; over life-size figure of striding god.

c. 450 *Discobolus* by **Myron** (copy in Terme Museum, Rome); bold experiment in posture.

c. 440 *Doryphorus* by **Polyclitus** (copy in National Museum, Naples); ideal athletic type by the greatest Classical master of proportion.

c. 442–38 *Parthenon frieze*, Athens; sublime embodiment of Classic ideal and mastery of relief technique.

437–2 *Parthenon pediments*, statues in British Museum, London; figures of exquisite richness and effortless majesty.

c. 435–30 *Zeus at Olympia*, gold and ivory statue by **Phidias**, now lost; most famous work of ancient world.

c. 375–70 *Eirene and Plutus* by **Cephisodotus** (copy in Glyptothek, Munich); mother and child group.

ITALY AND SICILY

PAINTING

c. 520–10 *Tomb of Hunting and Fishing*, Tarquinia; Etruscan landscape paintings showing small figures in a world of birds and rocks.

c. 480 *Tomb of the Diver*, Paestum; banqueting scenes by a fine provincial Greek painter of the late Archaic style.

c. 470 *Musicians and Revellers*, Tomb of the Leopards, Tarquinia; ambitious, but not entirely successful, Etruscan work in Greek manner.

c. 430–390 *Paintings of Alcmene and Helen* by **Zeuxis**, the first great master of chiaroscuro; originally exhibited in Agrigento, now lost.

c. 350 *Ajax and Cassandra* by **Asteas**, Villa Giulia Museum, Rome; comic scene by the finest vase-painter of the Paestan school.

ARCHITECTURE

c. 575 *Temple of Apollo*, Syracuse; early Doric temple with closely spaced columns.

c. 550 *Temple C*, Selinus; Doric temple with doubled front portico.

c. 540 *Temple F*, Selinus; Doric temple with screen-wall between columns.

c. 530 So-called *Temple of Ceres*, Paestum; small Doric temple with elaborate ornament and pronounced curvature of the columns.

c. 509 *Temple of Jupiter Capitolinus*, Rome; building of Tuscan type with three cellas side by side.

c. 480–06 *Temple of Zeus Olympius*, Agrigentum, largest and most unusual of Doric temples; peristyle replaced by half-columns engaged in a continuous wall.

c. 460 So-called *Temple of Poseidon*, Paestum; first Greek temple in Italy to reflect the orthodoxy of the Classical period.

SCULPTURE

c. 550 *Perseus beheading the Gorgon*, metope from temple C at Selinus, National Museum, Palermo; early Western attempt at relief carving.

c. 510–500 *Running nereids*, sandstone metope from later Heraeum at Foce del Sele, Paestum Museum; female figures in eastern Greek style.

c. 500–480 *Apollo* from Portonaccio temple at Veii, Villa Giulia, Rome; impressive Etruscan architectural statue in terracotta.

c. 500–450 *She-wolf*, bronze, Palazzo dei Conservatori, Rome; adopted as the emblem of Rome.

c. 470–60 *Metopes* from temple E at Selinus, limestone with details in marble, National Museum, Palermo; provincial version of Greek early Classical style.

c. 470–60 *Ludovisi Throne*, three-sided relief, Terme Museum, Rome; enigmatic work probably produced in southern Italy or Sicily.

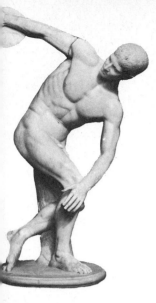

left: *Discobolus*. **Myron**

above: *Apollo and Heracles struggling for the tripod.*
Andocides Painter

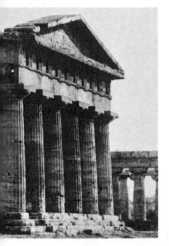

left: *Temple of Poseidon*, Paestum

below: *François Vase*. **Clitias**

bottom: *Parthenon*, Athens. **Ictinus and Callicrates**

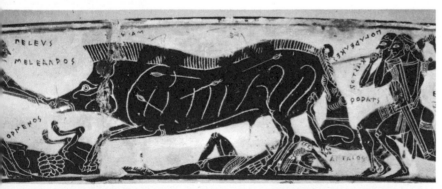

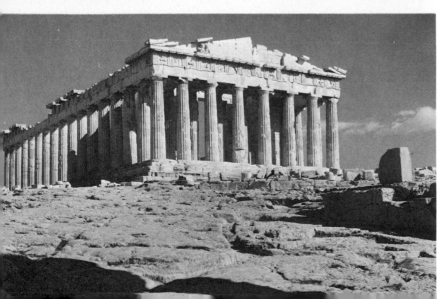

594 Laws of Solon promulgated in Athens.

585 Death of Periander.

582 Pythian Games at Delphi reorganized.

566 Reorganization of Panathenaic Games at Athens.

560 Pisistratus seizes the Athenian Acropolis; **his rule sees the climax of Attic black-figure pottery and a great building programme in Athens.**

546 Croesus of Lydia defeated by Cyprus.

525–500 Etruscans dominant in Italy.

512 Darius leads the Persians into Europe.

510 Hippias expelled from Athens.

c. 509 Establishment of Republic in Rome.

508 Cleisthenes' reforms bring democracy to Athens.

c. 500 Death of Pythagoras; Heraclitus *On Nature*.

499 Ionian Greeks revolt against Persian rule.

498 Earliest extant epinician ode by Pindar.

496 Battle of Lake Regillus.

494 Miletus captured, collapse of Ionian Revolt.

490 Battle of Marathon; Athens defeats the Persians.

480 Persians invade Greece, defeat Spartans at Thermopylae, sack Athens. Battle of Salamis. Carthaginians defeated by Gelon of Syracuse.

479 Battles of Plataea and Mycale.

477 Delian League against Persians.

474 Etruscans defeated by Hieron of Syracuse.

472 Aeschylus produces *The Persians*.

466 Battle of the Eurymedon; final defeat of Persians.

461 Pericles comes to prominence in Athens.

458 Aeschylus' greatest work, the *Oresteia*.

456 Athens' land empire reaches its greatest extent.

449 Peace of Callias. Codification of Roman law.

445 Thirty Years' Peace; Athens surrenders land empire.

443 Thucydides, son of Melesias, exiled, Pericles unchallenged in Athens; **building programme on Acropolis in full swing.**

c. 440 **Polyclitus' *Canon*, book on proportion for sculptors.**

431 Outbreak of Peloponnesian War.

430 Plague in Athens.

425 Spartan force captured at Pylos. Earliest surviving comedy by Aristophanes, the *Acharnians*.

421 Peace of Nicias brings respite from war.

415 Athens sends ill-fated expedition to Sicily. Euripides' *Trojan Women*.

406 Battle of Arginusae, last great Athenian victory. Deaths of Sophocles and Euripides.

405 Athenian fleet destroyed at Aegospotami.

404 Athens surrenders to Sparta.

399 Socrates condemned to death.

396 Romans capture Etruscan city of Veii.

390 Gauls sack Rome

c. 385 Plato founds the Academy in Athens.

377 Second Athenian confederacy established.

371 Battle of Leuctra. Thebes supreme in Greece.

367 Aristotle joins Plato's Academy.

362 Battle of Mantinea ends Theban hegemony in Greece.

359 Philip II becomes King of Macedonia.

356 Alexander the Great born.

351 Demosthenes delivers *First Philippic*.

	Key works: PAINTING	Key works: ARCHITECTURE	Key works: SCULPTURE
GREECE AND THE EASTERN MEDITERRANEAN	*c.* 330–300 *Aphrodite Anadyomene* by **Apelles,** originally exhibited on Cos; the most famous panel-picture in antiquity, now lost. *c.* 330–300 *Alexander with the Thunderbolt* by **Apelles**; portrait of the king as Zeus, now lost; striking light-effects. *c.* 320–300 *The Battle of Issus* (mosaic copy from Pompeii in National Museum, Naples); complex figure composition with mastery of foreshortening and highlights. *c.* 300 *Stag Hunt* by **Gnosis**, Pella; pebble mosaic showing figure-scene with pictorial tricks, against a dark background. *c.* 300–200 *Stele of Hediste* from Demetrias, Volos Museum; painted gravestone showing an attempt to portray a setting, here an interior. *c.* 200–100 *Scenes from New Comedy,* **Dioscurides of Samos**; mosaic panels imported from the East to be set in a floor in Pompeii. *c.* 100 *Dionysus riding a Cheetah,* mosaic in House of the Masks, Delos; one of latest and finest Hellenistic mosaics in pictorial style.	*c.* 350 *Tholos* at Epidaurus, by **Polyclitus the Younger**; regarded in antiquity as the finest of its type. 334 *Temple of Athena Polias*, Priene, dedicated by Alexander the Great; a finely ornamented Ionic temple constructed according to precise mathematical modules. 334 *Monument of Lysicrates*, Athens, the first structure to use Corinthian columns externally. *c.* 330 *Temple of Apollo* at Didyma begun, gigantic temple containing open-air court, still unfinished in late antiquity. *c.* 330 *Theatre* at Epidaurus, by **Polyclitus the Younger**; most perfect and best-preserved of Greek theatres. *c.* 300 *Gates* at Priene, an early example of monumental archways. *c.* 280 *Arsinoeum* at Samothrace, drum-shaped temple with plain wall below and colonnade above. *c.* 180 *Great altar* at Pergamum, built for Eumenes II; the most magnificent altar of antiquity. *c.* 170 *Temple of Zeus Olympius*, Athens, resumed by Roman architect **Cossutius**; the first major temple in the Corinthian style. *c.* 170 *Bouleuterion* at Miletus, a council-house containing a theatre-like auditorium. *c.* 150 *Stoa of Attalus*, Athens; two-storeyed portico with shops and offices, recently reconstructed. *c.* 130 *Temple of Artemis Leucophryene*, Magnesia on the Meander, masterwork of architect **Hermogenes**; use of Attic features east of Aegean. *c.* 50 *Tower of the Winds*, Athens; octagonal clock-tower set up by **Andronicus of Cyrrhus**. 49 *Inner Propylaea*, Eleusis, built by Roman official **Ap. Claudius Pulcher**; combination of Corinthian columns and Doric Frieze.	*c.* 350 *Aphrodite of Cnidos* by **Praxiteles** (copy in Vatican Museum); the first important female nude statue in antiquity; lavishly praised. *c.* 340–30 *Demeter from Cnidus*, British Museum, London; seated statue with fine treatment of drapery. *c.* 330 *Hermes and the infant Dionysus* by **Praxiteles**, from temple of Hera, Olympia; sensuous S-curved figure expressing new wistful emotion. *c.* 325–10 *Apoxyomenus* by **Lysippus** (copy in Vatican Museum); athletic statue embodying new system of proportions and new three-dimensional quality. *c.* 325–300 *Alexander sarcophagus*, from Sidon, Archaeological Museum, Istanbul; complex battle-relief with new realism of detail. *c.* 300–290 *Tyche of Antioch* by **Eutychides** (copy in Vatican Museum); seated figure with restless treatment of drapery. *c.* 280 *Colossus of Rhodes* by **Chares**; bronze statue seventy cubits high, now lost. 280 *Portrait of Demosthenes* (copy in Ny Carlsberg Glyptothek, Copenhagen); the figure expresses the subject's character. *c.* 240–200 *Statues of Gauls* set up in Pergamum (copies in Capitoline and Terme Museums, Rome); new sympathy for non-Greek racial type. *c.* 197–80 *Battle of gods and giants*, frieze of Great Altar at Pergamum, Pergamon Museum, Berlin; masterpiece of academic and bombastic style. *c.* 190 *Winged Victory of Samothrace*, Louvre; the crowning ornament of composition of rocks and water. *c.* 167 *Frieze from monument of Aemilius Paullus*, Delphi; early work by Greek artists for Roman patron. *c.* 125–100 *Venus de Milo*, Louvre; the finest surviving female nude statue from antiquity.
ITALY AND NORTH EUROPE	*c.* 350–25 *Darius in Council*; volute-krater by the **Darius Painter**; masterpiece of the Apulian ornate style of red-figure with figures ranged at various levels. *c.* 300–200 *Tomb of Orcus*, Tarquinia; paintings of Greek legends and Etruscan demons in a purely Greek style. *c.* 300–100 *Murals from the François Tomb* at Vulci, Villa Albani, Rome; scenes from the Trojan War combined with Etruscan legend. *c.* 60–50 *Dionysiac frieze*, Villa of the Mysteries, Pompeii; enigmatic large-figure paintings set against red panels of the Second Style. *c.* 50–40 *Odyssey landscapes* from a house on the Esquiline Hill, Rome, Vatican Museum; sole survivor of a genre mentioned by Vitruvius. *c.* 20 *Paintings from house* in the grounds of the Villa Farnesina, Terme Museum, Rome; finest works of late Second Style.	*c.* 200 *Porta Augusta*, Perugia; fine example of Etruscan arched gateway. *c.* 150–100 *Temple of Fortuna Virilis*, Rome; well-preserved temple of Roman type with high podium and frontal stairway. *c.* 110 *Sanctuary of Fortuna Primigenia*, Praeneste (Palestrina); masterpiece of axial architecture and concrete structural techniques. *c.* 100 *Round temple by the Tiber*, a Hellenistic-style building in Rome. 78 *Tabularium*, Rome; an early example of the use of pavilion vaults and the combination of an arched façade with the Greek columnar orders. 62 *Pons Fabricius*, well-preserved bridge across the Tiber; arches spanning eighty feet. 55 *Theatre of Pompey*, first permanent stone theatre in Rome. 20–16 *Pont du Gard*, finely proportioned bridge in three storeys carrying aqueduct across gorge near Nîmes.	*c.* 150–50 So-called *Brutus*, Palazzo dei Conservatori, Rome; bronze head blending dry, linear Etruscan style with pictorial treatment of Greeks. *c.* 100–50 So-called *Altar of Domitius Ahenobarbus*, reliefs in Glyptothek, Munich, and Louvre; Hellenistic subject combined with the first documentary relief in Rome (census). *c.* 80 *Portrait of Aule Metele* (the Orator) from Sanguineto, Archaeological Museum, Florence; bronze statue of a magistrate wearing the Roman toga. *c.* 50 *Head of a Priest*, Vatican Museum; embodies the veristic style of portraiture. 13–9 *Ara Pacis*, Rome; the first great Roman imperial sculptured monument, combining processional reliefs with allegories of Rome's greatness.

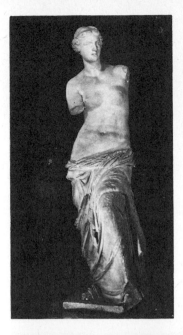

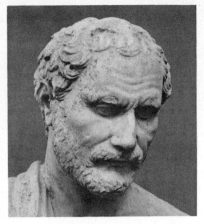

above: *Portrait of Demosthenes*

left: *Venus de Milo*

below: *Theatre* at Epidaurus. **Polyclitus the Younger**

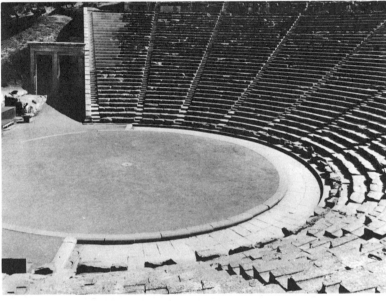

below: *Temple of Apollo*, Didyma

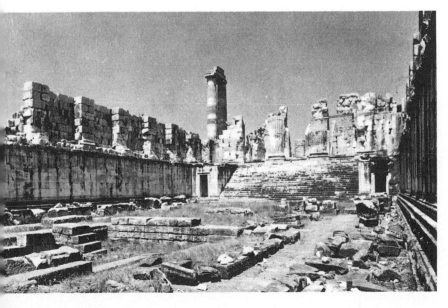

348 Philip conquers the cities of Chalcidice.

338 Battle of Chaeronea; Philip master of Greece.

336 Philip assassinated, succeeded by Alexander.

335 Aristotle head of Peripatetic school in Athens.

334 Alexander invades Asia; battle of the Granicus.

333 Battle of Issus.

332 Siege of Tyre; Alexander enters Egypt.

323 Death of Alexander.

317–07 Demetrius of Phalerum in power at Athens; **decree forbidding erection of sculpted gravestones.**

312 Appius Claudius censor in Rome; **Appian Way and Aqua Appia under construction.**

306–5 Alexander's Successors take the title of king; Ptolemy King of Egypt, Seleucus of Syria.

c. 300 Euclid established in Alexandria.

c. 287 Birth of Archimedes of Syracuse, the greatest mathematician and engineer of antiquity.

264–41 First Punic War.

263 Kingdom of Pergamum established.

241 Hamilcar surrenders Sicily to the Romans.

222 Battle of Sellasia; Macedonians capture Sparta.

220 **Construction of Flaminian Way.**

218 Hannibal crosses Alps; start of Second Punic War.

216 Romans crushed at Cannae.

214–05 First Macedonian War.

202 Scipio defeats the Carthaginians at Zama.

200–196 Second Macedonian War.

197–59 **Eumenes II of Pergamum, great patron of arts.**

179 **Lepidus carries out extensive building in Rome.**

168 Perseus routed by Romans at Pydna.

166 *The Andrian Girl*, first play by Terence.

147 Macedonia becomes a Roman province.

146 Destruction of Carthage; Africa made a Roman province. **Sack of Corinth; enormous haul of Greek works of art taken to Italy.**

133 Tiberius Gracchus initiates land reform, is assassinated. Pergamum bequeathed to Rome.

90 Outbreak of Social War in Italy.

88 Mithridates sacks Delos.

82–79 Dictatorship of Sulla.

73–71 Revolt of Spartacus and the gladiators.

63 Mithridates' death. Syria made Roman province.

60 Formation of the First Triumvirate: Pompey, Caesar and Crassus.

58–6 Caesar conquers Gaul.

55–4 Caesar's invasions of Britain. Catullus dies.

49 Caesar crosses the Rubicon; civil war begins.

48 Battle of Pharsalus; death of Pompey.

44 Assassination of Caesar.

43 The Second Triumvirate: Antony, Octavian and Lepidus. Death of Cicero, Rome's greatest orator.

31 Naval battle off Actium; Antony and Cleopatra commit suicide; Octavian master of Roman world.

29 Virgil starts his *Aeneid*, Livy begins his *History*.

27 Octavian assumes the title Augustus.

17 Horace's *Carmen Saeculare*.

	Key works: PAINTING	Key works: ARCHITECTURE	Key works: SCULPTURE
GREECE AND THE EASTERN MEDITER RANEAN	*c.* 100–200 *Judgement of Paris*, mosaic from Antioch, Louvre; one of a long series of mosaics from the Antioch region preserving the Hellenistic pictorial tradition. *c.* 300–400 *Painted tomb at Silistra*, Bulgaria; boldly painted provincial version of metropolitan styles.	*c.* 1–250 *Sanctuary of Jupiter*, Baalbek; monumental axial complex with hexagonal and rectangular courts leading to gigantic temple. *c.* 100–200 *Theatre at Aspendus*; exceptionally well-preserved stage building with columnar screen. *c.* 135 *Library of Celsus*, Ephesus; richly carved façade with alternating curved and triangular pediments. 216 *Forum and Basilica*, Lepcis Magna; Western plan adapted to irregular site and combined with Eastern detail.	*c.* 138 *Reliefs from Antonine monument* at Ephesus, Neue Hofburg, Vienna; combine dramatic battle scenes with frontal group of imperial family. 203 *Arch of Septimius Severus*, Lepcis Magna; documentary reliefs using frontality and drill-grooves. 296 *Reliefs of Arch of Galerius*, Salonica; short friezes depicting the Persian wars of the Tetrarchs. *c.* 390 *Base of the Obelisk of Theodosius*, in the Hippodrome, Istanbul; ceremonial reliefs of the Emperor watching events in the circus.
ITALY	*c.* 1–10 *Paintings from villa* at Boscotrecase, near Pompeii, now in National Museum, Naples, and Metropolitan Museum of Art, New York; first great landscape panels in Western art. *c.* 40–50 *Tablinum of House of Marcus Lucretius Fronto*, Pompeii; ornate work of the late Third Style. *c.* 63–9 *House of the Vettii*, Pompeii; the finest and best preserved paintings of the Fourth style. 64–8 *Paintings of Nero's Golden House*, Rome by **Famulus**; luxuriant vegetal ornament which inspired the grotesques of the Renaissance. *c.* 69–79 *View of a Harbour*, from Stabiae, National Museum, Naples; impressionistic style with browns and blues dominant *c.* 140–60 *Paintings of house* in Via Merulana, Rome, now in Antiquarium Comunale; imitation architecture applied to panel-scheme of red and yellow. *c.* 200–300 *Hypogeum of the Aurelii*, Rome; figures set in framework of fine coloured lines on white ground. *c.* 250–300 *Return of Persephone from Hades*, house under church of SS. Giovanni e Paolo, Rome; large-figure style with classicizing motifs and map-like treatment of space. *c.* 305 *Great Hunt mosaic*, imperial villa at Piazza Armerina, Sicily; all-over tapestry effect with polychrome groups set at different levels. *c.* 337–50 *Vault-mosaics of S. Costanza*, Rome; the first well-preserved examples of their genre, using pagan motifs and a similar colour-scheme to floor mosaics.	41–54 *Porta Maggiore*, Rome, monumental city-gate using rusticated masonry. 64–68 *Golden House of Nero*, Rome; grand palace showing important developments in vaulting technique and the planning of space. 72–80 *Colosseum*, Rome, the finest Roman amphitheatre; seating raised on a network of vaults and stairways. 92 *Domus Augustana* inaugurated, the new imperial palace on the Roman Palatine; built by **Rabirius**. 113 *Forum of Trajan*, Rome; designed by **Apollodorus of Damascus**; masterpiece of axial planning. *c.* 118–25 *Pantheon*, Rome; the largest domed structure in the ancient world. 118–34 *Villa of Hadrian* at Tivoli; complex of experimental architectural forms set in a landscaped park. 132–9 *Mausoleum of Hadrian*, Rome; massive drum-shaped tomb, now Castel Sant' Angelo. 211–17 *Baths of Caracalla*, Rome; the best preserved of the monumental bath-complexes of the imperial period. *c.* 270–80 *Walls of Rome*; constructed by Emperor Aurelian; massive brick-faced defences used till 1870. *c.* 298–306 *Baths of Diocletian*, Rome; vast complex now housing National Museum and church of S. Maria degli Angeli. *c.* 300–6 *Palace of Diocletian*, Spalato (Split); a villa built like a fortress; imports Eastern ideas like arcaded colonnades. *c.* 300–20 So-called *Temple of Minerva Medica*, elaborate domed nymphaeum with nine projecting apses. *c.* 310–20 *Basilica of Maxentius*, Rome; hall with three vaulted bays in lieu of side-aisles.	*c.* 14–27 *Statue of Augustus* from Prima Porta, Vatican Museum; emperor wearing breastplate with allegorical and historical reliefs. 69–79 *Portraits of Vespasian*; down-to-earth features replace idealized portraits of previous emperors. *c.* 81 *Reliefs in Arch of Titus*, Rome; crowded pictorial compositions depicting Titus' triumph after sack of Jerusalem. 106–13 *Trajan's column*, Rome; spiral frieze depicting Dacian wars in continuous narrative technique. 161–80 *Equestrian statue of Marcus Aurelius*, bronze, Piazza del Campidoglio, Rome; preserved because thought to represent Constantine. *c.* 180–96 *Column of Marcus Aurelius*; Rome; a new era marked by increasing use of drill-grooves and by simplifications in composition. *c.* 200–30 *Badminton sarcophagus*, Metropolitan Museum of Art, New York; highly polished representations of the four seasons. 203 *Arch of Septimius Severus*, Rome; map-like reliefs commemorating the emperor's Eastern campaigns. 211–17 *Bust of Caracalla*; Museo Capitolino, Rome; sharp turn of the head gives portrait new vitality. 222–35 *Portrait of Severus Alexander*, Vatican Museum; highly expressive head with drilled eyes and linear treatment of hair. *c.* 250 *Ludovisi battle sarcophagus*, Terme Museum, Rome; tapestry of interlocking figures with twisting postures and tortured faces. 312–15 *Reliefs of Arch of Constantine*, Rome; hieratic style with emperor shown frontally and on larger scale than other figures. *c.* 313 *Colossal head of Constantine*, Palazzo dei Conservatori, Rome; mask-like and awe-inspiring.
NORTH EUROPE	*c.* 200–300 *Mosaics showing circus scenes and the nine muses*, Rheinisches Landesmuseum, Trier; Western carpet style, figure-subjects are subordinate to overall pattern. *c.* 300–25 *Painted ceiling-panels from the imperial palace*, Trier, now in Bischöfliches Museum; nimbed female busts reconstructed from fragments.	*c.* 80–120 *Amphitheatres* at Arles and Nîmes; vertical emphasis created by pilasters and semi-columns. *c.* 300–10 *Basilica*, Trier, audience hall of the imperial palace; severe interior with arched windows and semi-circular apse. *c.* 306–16 *Porta Nigra*, Trier; monumental gateway with projecting semi-circular towers.	*c.* 1–25 *Battle between Romans and Gauls*, relief from monument of the Julii, St-Rémy; provincial version of Hellenistic style. *c.* 50–100 *Head of man* in limestone, City Museum, Gloucester; bulging eyes and stylized hair show Celtic artist working in Classical medium. *c.* 150 *Pedimental sculptures* from temple of Sulis Minerva, Bath; powerful Romano-Celtic work.

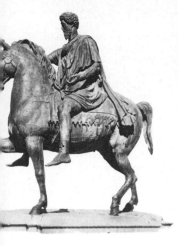

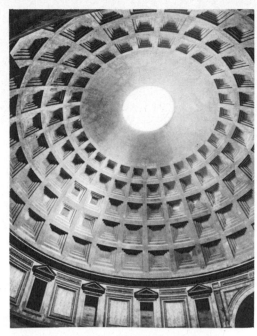

above: *Equestrian statue of Marcus Aurelius*

right: *Pantheon,* Rome. Interior

below: *Colosseum*, Rome

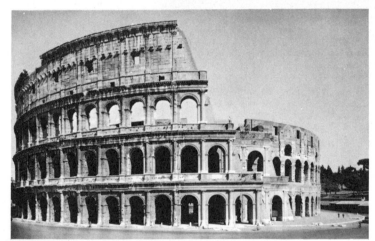

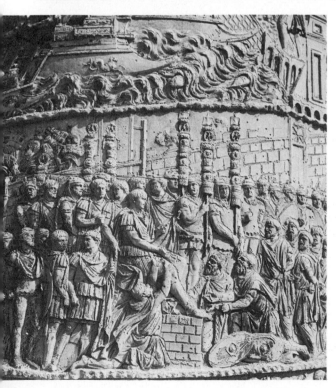

left: *Trajan's column*

7 Ovid's *Metamorphoses*.

14 Augustus dies and is deified; Tiberius succeeds.

26 Tiberius retires to Capri; Sejanus in ascendant.

c. 30 Crucifixion of Jesus Christ.

31 Downfall and death of Sejanus.

43 Invasion of Britain by Claudius.

54 Claudius dies, Nero becomes Emperor.

61 British rebellion led by Boudicca.

64 Great fire in Rome; persecution of Christians.

65 Conspiracy of Piso discovered; deaths of Seneca, Lucan, and Petronius Arbiter.

70 Destruction of Jerusalem, end of Jewish Revolt.

79 Eruption of Vesuvius; destruction of Pompeii and Herculaneum. Death of Pliny the Elder.

84 Agricola defeats the tribes of Scotland.

98 Trajan becomes the first Emperor of provincial stock. First historical works of Tacitus appear.

100 Pliny the Younger delivers eulogy on Trajan.

117 Trajan dies; succeeded by Hadrian.

122 **Hadrian visits Britain, starts building wall from Tyne to Solway.**

c. 130 Death of Juvenal, Rome's greatest satirist.

140–2 **Antonine Wall built from Forth to Clyde.**

c. 150 Ptolemy produced his great works on astronomy (the Almagest) and geography.

161 Marcus Aurelius comes to power.

180 Marcus dies; son Commodus abandons northern wars.

211 Septimius Severus, Emperor, dies in York.

212 Constitutio Antoniniana; citizenship extended to all free men of the Empire.

229 Dio Cassius, historian of Rome, Consul.

235 Murder of Severus Alexander brings anarchy.

250 Persecution of Christians by Decius.

258 Goths invade Asia Minor. Alemanni invade Italy.

260 Rival Gallic Empire established. Emperor Valerian captured and killed by Shapur I of Persia.

267 Goths sweep Asia Minor.

269 Goths crushed by Claudius Gothicus.

284 Accession of Diocletian brings return to settled government.

312 Battle of Milvian Bridge; Constantine takes Rome.

313 Edict of Milan; freedom of worship for Christians.

c. 315–20 Pachomius establishes the first monastery.

324 Defeat of Licinius; Constantine sole Emperor.

325 Council of Nicaea condemns Arian heresy.

330 Imperial capital moved to Constantinople.

341 Synod of Antioch deposes Athanasius.

360–3 Julian the Apostate; revival of paganism.

367 Picts, Scots and Saxons invade Britain.

373 Ambrose becomes Bishop of Milan.

378 Romans defeated by Goths at Adrianople.

380 Christianity made official religion of Empire.

393 Last Olympic Games held.

396 Augustine becomes Bishop of Hippo.

Key works: PAINTING	Key works: ARCHITECTURE	Key works: SCULPTURE

SOUTH EUROPE

c. 400–50 Vatican Vergil, Biblioteca Apostolica, Rome; one of very few early copies of an illustrated Classical book.

c. 400–50 The Good Shepherd, Mausoleum of Galla Placidia, Ravenna; part of oldest mosaic scheme in Ravenna.

432–40 Life of the Virgin Mary, S. Maria Maggiore, Rome; unusual mosaic programme in Roman classical manner, commissioned by Pope Sixtus III.

c. 547 Justinian and his Suite, S. Vitale, Ravenna; majestic courtly scene in mosaic, part of extensive decorative scheme.

c. 705–7 Maria Regina, S. Maria in Trastevere, Rome; great icon commissioned by Pope John VII.

c. 762? Annunciation, S. Sofia, Benevento; Italianized Byzantine style fresco in centrally-planned Benedictine abbey church.

432–40 Nave of S. Maria Maggiore, Rome; Classical hypostyle building, largest surviving of the period.

530 Tomb of Theoderic, Ravenna; domed mausoleum built in stone probably by Eastern masons.

532–47 San Vitale, Ravenna; octagonal brick church possibly modelled on Constantine's destroyed Golden Church in Antioch.

579–90 East Church, San Lorenzo fuori le Mura, Rome; galleried basilica designed for pilgrims.

762–76? Tempietto, Cividale; little church with sumptuous interior decoration in marble, stucco, fresco and mosaic.

c. 400 Diptych of Stilicho, Cathedral Treasury, Monza; late imperial-style ivory, probably made in Milan.

c. 400 Projecta Casket, British Museum, London; Roman silver work with Christian and Classical decoration.

c. 422–32 Doors of S. Sabina, Rome; wooden doors probably contemporary with the church, carved with biblical scenes.

c. 556–69 Ambo, Archiepiscopal Museum, Ravenna; remains of massive marble pulpit, made for Archbishop Agnellus.

c. 764–86 Sigvald Panel, Cividale; inscribed marble slab from baptismal font ordered by Sigvald.

NORTH EUROPE

c. 700 Lindisfarne Gospels, British Museum, London; masterpiece of intricate Northern Insular decorative art.

716 Codex Amiatinus, Laurentian Library, Florence; written at Jarrow, miniatures following a Mediterranean model.

781 Godescalc Sacramentary, Bibliothèque Nationale, Paris; commemorates the baptism of Charlemagne's son Pepin.

c. 790–800 Harley Gospels, British Museum, London; one of the 'Ada' manuscripts, luxury productions of the Carolingian Renaissance.

c. 790–800 Coronation Gospels, Staatsbibliothek, Vienna; first of the 'Palace' group, illuminated in Antique style.

c. 400–25 Baptistery, Fréjus; niched octagon, one of number of small structures which have survived from this period.

c. 650–700 Crypt, Monastery of Jouarre; early Merovingian construction with funerary chapels, commissioned by Bishop Angilbert of Paris.

c. 650–700 Baptistery of S.-Jean, Poitiers; much altered building, upper part with elaborate ornamental masonry.

c. 680 Brixworth, Northamptonshire; only surviving large-scale Anglo-Saxon church.

c. 792–805 Chapel of Charlemagne, Aachen; self-consciously imperial, centrally-planned monument of the Carolingian Renaissance.

c. 675–85 Ruthwell Cross, Ruthwell Parish Church, Dumfriesshire; first of great Celtic crosses, unique example of full-scale figure sculpture of the time.

c. 682 Sarcophagus of St Angilbert, Jouarre; Merovingian work with remarkable figure carving.

c. 700 Franks Casket, Bargello, Florence and British Museum, London; whalebone with Christian and pagan scenes, work of Northumbrian Renaissance.

c. 775–800 Pinecone, Chapel of Charlemagne, Aachen; bronze work of court school, in imitation of ancient pinecone of St Peter's, Rome.

c. 777–88 Tassilo Chalice, Stiftsbibliothek, Kremsmünster; copper, silver and niello work showing insular influence.

pre 795 Ivory Bookcover of the Dagulf Psalter, Louvre, Paris; inspired by late Antique diptych sculpture, cover of Psalter presented to Pope Hadrian I.

BYZANTIUM

c. 500–600 Book of Genesis, Vienna; famous fragment of purple manuscript with illustrations explained by the text.

c. 500–600 Rossano Codex, Rossano Cathedral; one of earliest surviving illustrated texts of the Greek Gospel, from Asia Minor or Constantinople.

c. 500–600 St Peter, Monastery of S. Catherine, Mount Sinai; realistic image in encaustic, painted in Alexandria.

586 Rabbula Gospels, Laurentian Library, Florence; dated Syriac text with illustrations, Eastern in style and iconography.

c. 640 S. Demetrius and Suppliants, S. Demetrius, Salonika; mosaic portraits from major monument of the period, damaged in fire in 1917.

c. 463 S. John Studios, Istanbul; partly ruined church in classical tradition, rare survival of the period.

527–36 SS. Sergius and Bacchus, Istanbul; centralized church, one of first built by Justinian.

532 S. Eirene, Istanbul, begun; one of rare domed basilicas of the time, rebuilt in 740.

532–7 S. Sophia, Istanbul; technically daring construction on magnificent scale.

c. 527 Justinian(?) on Horseback, Louvre, Paris; Barberini Ivory, official production probably from Constantinople.

545–53 Throne of Maximian, Archiepiscopal Museum, Ravenna; ivory carving of exceptional quality, provenance uncertain.

565–78 Stuma Paten, Archaeological Museum, Istanbul; dated silver paten showing the Communion of the Apostles, possibly of Syrian workmanship.

c. 575–600 Multiple Diptych, Museo Nazionale, Ravenna; five ivory panels possibly from Alexandria.

610–29 The Marriage of David, Nicosia Museum, Cyprus; splendid dated silver plate with scene in classical style.

left: *Throne of Maximian*. Detail

left: Page from *Lindisfarne Gospels*

below left: *San Vitale*. Interior

below: *Chapel of Charlemagne*. Interior

bottom: *S. Sophia*, Istanbul

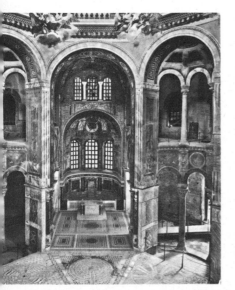 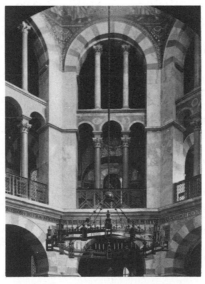

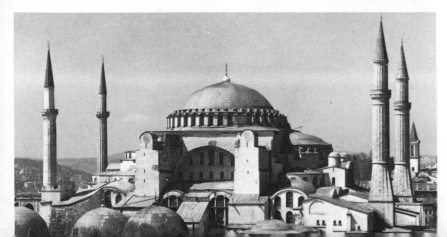

c. 400 St Jerome translates *Scriptures* into Latin.

406 Vandals invade Gaul. Romans leave Britain.

408 Stilicho, Vandal general of the Western Emperor, falls from power.

410 Alaric the Goth sacks Rome. *c.* 410 St Augustine of Hippo begins his *City of God*.

441–2 Angles, Jutes and Saxons invade Britain.

458 **Edict of Majoran forbids plundering of ancient edifices of Rome.**

493 Theoderic (493–526) makes Ravenna his residence.

496 Merovingian King Clovis (*c.* 481–511) baptized.

c. 500 Influential Neoplatonic treatise written, the so-called *Pseudo-Dionysius*.

516–37 Arthur, Celtic King of Britain, resists Saxon invaders.

523 Boethius writes his *Consolation of Philosophy*.

c. 526–30 First part of *Liber Pontificatis* written.

527–65 Justinian the Great, last Emperor of the East and West.

c. 540 St Benedict, founder of Montecassino, formulates his monastic rule.

563 St Columba founds monastery on Iona.

569 Lombards establish rule in northern Italy.

573–94 St Gregory of Tours writes the *History of the Franks*.

590–604 Pope Gregory the Great undertakes union of Western Church under Rome.

597 St Augustine lands in Kent.

622 Isidore of Seville writes his encyclopaedia *Etymologiae*.

630 True Cross brought to Constantinople. Prophet Mahomet begins conversion of Arabs to Islam.

635 Monastery of Lindisfarne founded under aegis of Oswald of Northumbria (633–41).

669 St Wildrid, great patron of arts, reinstalled as Bishop of Northumbria.

705–7 Pope John VII, great patron of the arts, educated in Constantinople.

711 Muslim invaders take Seville, Cordoba and Toledo.

c. 717 *Beowulf*, Old English epic poem.

730 **Emperor Leo III enforces Edict against the display of images; age of Iconoclasm until 843.**

731 Bede's *Historia Ecclesiastica Gentis Anglorum*.

732 Charles Martel defeats Muslims at Poitiers.

751 Pepin le Bref becomes King of Franks. Aistulf of Lombardy forces Byzantine withdrawal from Ravenna.

757–96 Offa, King of Mercia, reigns.

771 Charlemagne becomes sole ruler of the Franks.

778 Carolingean defeat at Ronçevalles.

780 *Commentary on the Apocalypse* by Beatus of Liebana.

c. 786 *Historia Langobardorum* by Paul the Deacon.

786–809 Abbasid Caliph Harun al-Raschid rules.

787 Tassilo of Bavaria surrenders to Charlemagne. **Greek Council on Iconoclasm**.

c. 791 Carolingian court settles at Aachen.

794 **Synod of Frankfurt; Iconoclasm condemned.**

c. 794 *Libri Carolini* **expound Frankish attitudes to image worship.**

796–804 Sacred texts revised and copied at Tours by order of Alcuin of York.

Key works: PAINTING	Key works: ARCHITECTURE	Key works: SCULPTURE
SOUTH EUROPE		
817–24 *S. Prassede*, Rome; finest mosaics of the period, commissioned by Pope Paschal I. 920 *Léon Bible*, Léon Cathedral; commissioned by Abbot Maurus; major work in first period of Mozarab illumination. 922? *Beatus*, Pierpont Morgan Library, New York; earliest surviving illuminated manuscript of the Beatus commentary on the Apocalypse. 1047 *Beatus*, Biblioteca Nacional, Madrid; exceptionally fine copy of Beatus for Ferdinand and Sancha of Aragon and Castile. *c.* 1060 *Montecassino Exultet Roll*, British Museum, London; sophisticated work showing strong Byzantine influence. 1073–5 *Desiderius offering the Church*, S. Angelo in Formis, near Capua; part of finest extensive mural cycle in Italy at the time.	848 *S. Maria de Naranco*, Oviedo, consecrated; hall with early tunnel vaulting and transverse arches. 961 *Mihrab of the Mosque*, Cordoba; perfect example of Moorish vault, part of alterations made by Caliph Al-Hakam II. 1032 *S. Maria*, Ripoll, dedicated; one of grandest Spanish monuments of First Romanesque style. *c.* 1063 *S. Marco*, Venice, rebuilt; five-domed, Greek-cross basilica modelled on the (destroyed) Apostoleion in Constantinople. 1075–1122 *Cathedral of Santiago de Compostela*; major pilgrimage church in Western Europe. 1089 *Pisa Cathedral* begun; designed by **Buschetus**, part of fine group of marble-faced cathedral buildings, with exterior arcading.	*c.* 840 *Golden Altar* by **Vuolvinio**, S. Ambrogio, Milan; reliquary altar, with reliefs in sheet gold, ordered by Archbishop Angilbert II. *c.* 980 *Christ in Majesty with St Maurice adored by Otto II and Theophanu*, Museo del Castello Sforzesco, Milan; ivory probably carved in Milan for the Emperor. 1063 *Shrine of St Isidore* donated, San Isidoro, Léon; gift of King Ferdinand and Queen Sancha; earliest surviving reliquary shrine on this scale. *c.* 1066–1100 *Journey to Emmaus*, cloister in S. Domingo de Silos; relief showing Christ as a pilgrim, cloister with double capitals of delicate workmanship. *c.* 1090–1100 *Bronze Doors* of S. Zeno, Verona; biblical scenes, transitional between Carolingian and Romanesque art; panels later rearranged and portal enlarged.
NORTH EUROPE		
c. 806 *The Ark of the Covenant*, apse of S.-Germigny-des-Prés; only surviving Carolingian mosaic, in private oratory of Theodulph of Orléans. *c.* 816–23 *Utrecht Psalter*, University Library, Utrecht; extraordinary psalter with illustrative pen drawings of Hellenistic character. 845–6 *First Bible of Charles the Bald*, Bibliothèque Nationale, Paris; written at Tours, presented by Abbot Vivian to the Emperor. 966 *New Minster Charter*, British Museum, London; first-known Winchester manuscript in lively linear style. 977–93 *Egbert Codex*, Stiftsbibliothek, Trier; masterpiece of Ottonian art, of Early Christian inspiration. 1045–46 *Golden Gospel Book*, Escorial Library, near Madrid; most important work of Echternach school. *c.* 1077 *Bayeux Tapestry*, Museum of Queen Mathilda, Bayeux; epic secular narrative; woollen embroidery on linen.	*c.* 810 *Abbey Gatehouse of Lorsch*; famous Carolingian three-arched gateway with decorative masonry. 873–85 *Westwork of Corvey*; outstanding example of typical Carolingian structure. *c.* 950 *S.-Philibert*, Tournus, begun; important example of First Romanesque architecture. 1001–18 *Rotunda of St-Bénigne*; Dijon; surviving part of William of Volpiano's many-towered, vaulted church. 1037–66 *Notre-Dame of Jumièges*; early Norman Romanesque church. 1061 *Speyer Cathedral* dedicated; finest of German Early Romanesque churches; much rebuilt. 1067 *White Tower*, London, begun; one of earliest and largest towers in Europe, with small Norman chapel. 1079 *Winchester Cathedral* begun; early Norman transept and crypt unaltered. *c.* 1080 *St-Benoît-sur-Loire* begun; grand monastic church with double transept. 1093 *Durham Cathedral* begun; first ribbed high vaults in Europe in massive Norman church.	*c.* 810 *Lorsch Gospels Bookcover*, Victoria and Albert Museum, London; one of pair of ivory covers, strongly Byzantine in style. *c.* 855–69 *Lothar Crystal*, British Museum, London; crystal with lively engravings showing the story of Susanna and the Elders. 1015 *Bronze Doors* mounted, Hildesheim Cathedral; commissioned for nearby Abbey by Bishop Bernward, with sophisticated relief scenes. *c.* 1020 *Marble Lintel*, S.-Genis-des-Fontaines; one of first carved portals, inscribed and showing Christ in majesty. 1084 *Altar of Bishop Henry of Werl* by **Roger of Helmarshausen**, Paderborn Cathedral Treasury; documented work; first appearance of a new linear style in Germany. *c.* 1090–5 *Third Tone of the Gregorian Chant*, Musée du Farin, Cluny; capital of highly refined subject-matter and style from greatly destroyed abbey church. 1096 *Altar Table* by Bernard Gilduin, S.-Sernin, Toulouse; signed marble low-relief in classical tradition.
BYZANTIUM		
880–3 *Homilies of St Gregory of Nazianzus*, Bibliothèque Nationale, Paris; luxuriously illustrated copy of text, with imperial portraits. *c.* 900–1000 *Paris Psalter*, Bibliothèque Nationale, Paris; psalter with large-scale illustrations in classically-inspired naturalistic style. 912–13 *Emperor Alexius*, North Gallery, S. Sophia, Istanbul; precisely dated mosaic, personification of Byzantine majesty. *c.* 985 *Menologion of Basil II*, Biblioteca Apostolica, Rome; illustration with new concern for creating scenes, work of eight artists. *c.* 1000 *Crucifixion*, narthex of Hosios Loukas, near Delphi; expressive scene from unusually complete mosaic programme.	1011/22 *Hosios Loukas*, near Delphi, consecrated; early Middle Byzantine church designed around the tomb of its founder, with extensive mosaic decoration. 1042–55 *Nea Moni*, Chios; domed octagonal church begun in reign of Constantine IX Monomachos. *c.* 1060–70 *Theodoroi*, Athens; small church with heavily ornamented exterior.	*c.* 950–1000 *Christ Pantocrator*, Treasury of Mount Athos, Great Lavra; enamel miniature on silver gilt bookcover, possibly a gift of Basil II to the monastery. *c.* 980–1000 *Europa and the Bull*, Veroli Casket, Victoria and Albert Museum, London; scene clearly modelled on classical original; finest of large group of ivory caskets. *c.* 980–1000 *Harbaville Triptych*, Louvre, Paris; one of outstanding ivory works of the Macedonian Renaissance. 1042–50 *Crown of Constantine IX Monomachos*, National Museum, Budapest; incomplete crown with triple enamel imperial portraits.

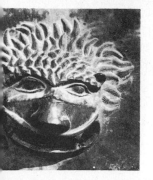

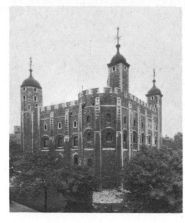

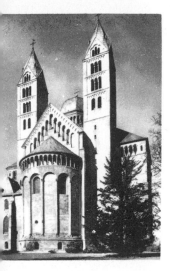

above left: *Bronze Doors*, S. Zeno. Detail

above: *White Tower*, London

left: *Speyer Cathedral*

below: *Bronze Doors*, Hildesheim Cathedral. Detail

bottom left: *Hosios Loukas*. Detail

bottom right: *St-Benoît-sur-Loire*. Interior

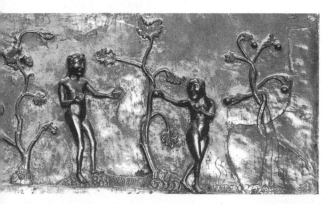

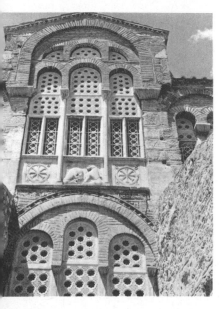

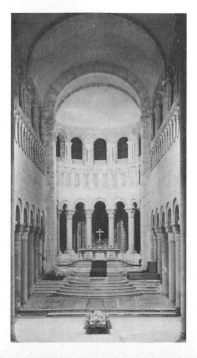

c. 800 Coronation of Charlemagne as Holy Roman Emperor.

814–40 Louis the Pious reigns.

c. 820 **St Gall Plan; carefully organized ground plan for a monastic community.**

c. 821 Einhard's *Life of Charlemagne*.

843 Treaty of Verdun; Carolingian Empire divided. **Final Restoration of Images in the Eastern Empire.**

855–69 Lothar II, Carolingian Emperor.

867–86 Basil I, first Emperor of the Macedonian Renaissance.

871–900 Alfred the Great, King of Wessex.

875–7 Charles the Bald rules as Emperor.

891 *Anglo-Saxon Chronicle* begun.

910 Foundation of Cluny, great monastic order.

912–13 Eastern Emperor Alexius rules.

929 Caliphate established at Cordoba.

936–73 Otto I, the Great; crowned by Pope John XII in 962.

959–75 Edgar, King of all England.

961 Liutprand of Cremona's *History of Otto I*.

963–1025 Basil II and Constantine VIII, Macedonian Emperors.

969–76 Emperor Nicephorus II Phocas.

983 Otto III crowned in Aachen.

987 Hugh Capet made King of France; end of Carolingian dynasty.

989 Emperor Vladimir of Russia adopts Christianity; **summons Byzantine artists to his court at Kiev.**

991 King Ethelred defeated by the Danes at Maldon.

993–1022 Bishop Bernward of Hildesheim, great patron of arts.

c. 1000–10 *Chanson de Roland* written.

c. 1002–3 Raoul Glaber's *Concerning the Construction of Churches throughout the World*.

1028–42 Byzantine Empress Zoë rules.

1033–65 Ferdinand I of Castile.

1039–56 Emperor Henry III.

1042–66 Edward the Confessor. 1042–55, Emperor Constantine IX Monomachos.

1049–1109 St Hugh, Abbot of Cluny.

c. 1059–78 *Chronographia* by Michael Psellus.

1066 Norman Conquest. 1066–87, William I of England.

1070–89 Archbishop Lanfranc of Canterbury.

1071 Battle of Manzikert; Byzantine forces defeated by Seljuk Turks in Asia Minor.

1075 Leo of Ostia's *Chronicle of Monte Cassino* ends.

1077 Emperor Henry IV submits to Pope Gregory VII (1073–85) at Canossa. Turks take Jerusalem.

1078–81 Emperor Nicephorus Botaniates.

1081–1118 Emperor Alexius I Comnenus.

1085 Alfonso VI (1065–1109) of Léon-Castile captures Toledo from the Moors.

1088 Official foundation date of great abbey church Cluny III.

1094 El Cid captures Valencia from the Moors.

1095 Pope Urban II (1088–99) proclaims the First Crusade at Clermont.

1099 Crusaders capture Jerusalem.

	Key works: PAINTING	Key works: ARCHITECTURE	Key works: SCULPTURE
SOUTH EUROPE	*c. 1123 Christ in Majesty*, from San Clemente, Tahull, now in Barcelona Museum; foremost example of Spanish Romanesque mural painting. *c. 1125–50 Pantheon Bible*, Biblioteca Apostolica, Rome; influential giant bible, most lavish of its kind. *1138 Crucifix* by **Guglielmo of Lucca**, Sarzana Cathedral; inscribed painted wood crucifix in delicate linear style. *1148 Christ Pantocrator*, apse of Cefalù Cathedral; mosiac by Greek artists, completed by 1148. *1157–88 Annunciation*, Pantéon de los Reyes San Isidoro, Léon, best-known scene from mural cycle in unusual style, commissioned by Ferdinand II. *c. 1170–83 Creation*, Monreale Cathedral; mosaic in new style reflecting developments in Late Comnene Byzantine art.	*1140–8 S. Maria in Trastevere*, Rome; church with timber roof and pillars supporting an architrave, in traditional Roman manner. *1153 Baptistery*, Pisa, designed by **Diotisalvi**; large rotunda, exterior later remodelled in Gothic style. *1174 Monreale Cathedral* begun for William II of Sicily; rapidly built, with extraordinary exterior ornament and interior mosaic scenes from the Old and New Testaments. *1196 Parma Baptistery* begun; octagon with colonnaded galleries possibly built by the sculptor Antelami.	*c. 1100–6 Creation* by **Wiligelmo**, façade of Modena Cathedral; one of four reliefs, scenes from Genesis in robust style of influential northern Italian sculptor. *pre 1109 St James*, Puerta de las Platerias, Cathedral of Santiago de Compostela; statue possibly given by Alfonso VI; part of double portal. *1135 Three Prophets* by **Niccolò**, Ferrara Cathedral; early examples of column figures, part of signed and dated portal. *c. 1150 Portal of S. Maria*, Ripoll; complete iconographic programme in horizontal registers, possibly commissioned by Count Ramón Berenguer IV to celebrate victories over the Moors. *c. 1168–88 Pórtico della Gloria*, Cathedral of Santiago de Compostela, by **Mateo**; triple portal richly sculpted, signed and dated. *c. 1178 Descent from the Cross* by **Antelami**, Parma Cathedral; signed and dated panel, early masterpiece of sculptor.
NORTH EUROPE	*c. 1100 Christ in Majesty*, Berzé-la-Ville; mural in priory church, famous surviving example of Cluniac pictorial art. *c. 1120 Albani Psalter*, British Museum, London; masterpiece of English Romanesque book illustration. *c. 1140, Life of Moses*, S.-Denis, Paris; scenes from earliest considerable remnants of stained glass. *c. 1150–60 Winchester Bible*, Library of Winchester Cathedral; unfinished bible with illustrations by artists in a mixture of styles. *c. 1175–1200 St Paul and the Viper*, St Anselm's Chapel, Canterbury Cathedral; high quality mural of Byzantine inspiration, exceptional in England.	*c. 1130–45 Notre-Dame-de-la-Grande*, Poitiers; richly ornamented façade typical of group of western French churches. *1139–47 Fontenay Abbey*; oldest ensemble of Cistercian conventual buildings; austere pointed tunnel-vaulted church. *1140–4 West Front and choir of St.-Denis*, Paris; earliest precisely dated Gothic building, commissioned by Abbot Suger; choir rebuilt in the thirteenth century. *c. 1150 Borgund*, Norway; finest example of wooden Norwegian stave-church. *c. 1155–60 Laon Cathedral* begun; major Early Gothic building with four-storey elevation. *1156 Maria Laach* abbey church dedicated; mature German Romanesque work. *1174–84 Choir of Canterbury Cathedral* by **William of Sens**; introduction of French Gothic to England; building documented in detail. *c. 1180 Wells Cathedral* begun; first truly English Gothic church. *1194 Chartres Cathedral* begun; structure of immense importance, with classic High Gothic elevation.	*1100 Moissac Cloister* completed; large number of richly carved capitals and pier reliefs of the Apostles. *1104–1113 Gloucester Candlestick*, Victoria and Albert Museum, London; elaborate gilt bell-metal work, dated by inscription. *1107–18 Font* by **Rainer of Huy**, Liège; bronze; established a classical style in the Mosan area. *c. 1135 Last Judgement Portal*, St.-Lazare, Autun; inscribed tympanum by the sculptor **Gislebertus**. *c. 1140 Eagle Vase*, Louvre, Paris; Antique vase adapted for Abbot Suger. *c. 1150–55 Royal Portal*, west front of Chartres Cathedral; triple portal with majestic column figures. *1181 Klosterneuburg Altar* by **Nicholas of Verdun**, Stiftskirche, Klosterneuburg; one of first works in Transitional style; enamel plaques presenting complex iconographical programme.
BYZAN TIUM	*c. 1100 Pantocrator*, dome of church of Daphni; awesome mosaic representation of Christ. *1102–18 Central panel of Pala d'Oro*, S. Marco, Venice; Byzantine enamel from altar of complex history and construction. *c. 1125 Our Lady of Vladimir*, Tretyakov Gallery, Moscow; one of earliest icons to reach Russia from Constantinople. *1164 Lamentation*, St Pantaleimon, Nerezi; expressive Pietà, first dated appearance of agitated style in drapery.	*c. 1118 South Church* begun, Monastery of the Pantocrator, Istanbul; splendid decorative effects of Middle Byzantine architecture. *c. 1183 Church of the Virgin*, Studenica, begun; best example of mixed Middle Byzantine and Romanesque features.	*c. 1100–1200 Virgin and Child*, Victoria and Albert Museum, London; unique ivory statuette with features of the new Comnene style. *c. 1100–1200 Virgin Orans*, Archaeological Museum, Istanbul; marble panel from St George the Mangana, in heavy style.

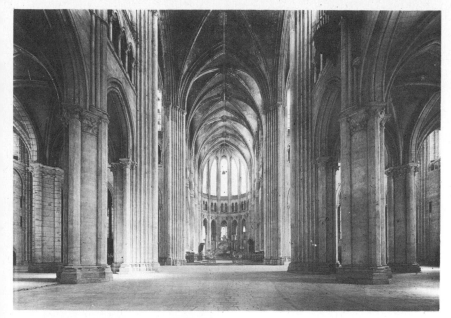

1100 Latin Kingdom of Jerusalem established.

1100–35 Henry I of England. **c. 1100–50 _De Diversis Artibus_, treatise on monastic craftsmanship by German monk, Theophilus.**

1106–25 Emperor Henry V.

c. 1114–20 Adelard of Bath translates Euclid's _Elements_ from Arabic.

1115 St Bernard founds first Cistercian daughter-house at Clairvaux.

1116 University of Bologna founded.

1118 Alfonso of Aragon (1104–34) captures Saragossa. Knights Templars instituted.

c. 1120 Anna Comnena begins the _Alexiad_.

1121 Abelard's teaching condemned at Synod of Soissons.

1122–51 Concordat of Worms settles the Investiture Conflict. Suger, Abbot of S.-Denis.

1123 First Lateran Council.

c. 1125 **St Bernard's Apologia to William of S.-Thierry.**

1130 Roger II crowned King of Sicily in Palermo.

1135 Stephen of Boulogne takes English crown.

1137–80 Louis VII of France.

1138–58, Otto, Bishop of Freising, author of the _Gesta Frederici_.

c. 1139 _Guide for Pilgrims_ to Santiago Compostela in the _Codex Calixtinus_.

c. 1140 Gratian writes _Decretals_.

1143–80 Manuel I Comnenus. **c. 1143 _Marvels of Rome_ written by Canon Benedict of St Peter's, Rome.**

1144 Arnold of Brescia establishes Republic in Rome.

1146 Almohads invade Spain. Abbot Suger appointed Regent in France. **c. 1146–51, book of Suger describing building and decoration of S.-Denis.**

1147–9 Second Crusade.

1152–90 Emperor Frederick Barbarossa.

1154–89 Henry II of England. 1154–66, William I of Sicily.

1157–88 Ferdinand II of Léon.

1158 Frederick Barbarossa imposes his rule in Lombardy. Henry the Lion of Saxony and Bavaria founds Munich.

1159–81 Pope Alexander III. 1159, John of Salisbury's _Policraticus_ and _Metalogicon_.

c. 1160 _Tristan et Iseult_.

1166–89 William II of Sicily.

c. 1167 Oxford University founded.

c. 1170 _Lancelot and Perçeval_ by Chrétien de Troyes.

1170 Assassination of Archbishop Thomas à Becket of Canterbury.

c. 1172 _Description of Holy Places_ written by Theoderich, a pilgrim.

1174 **Fire at Canterbury Cathedral; subsequent rebuilding described by Gervase of Canterbury.**

1175 Order of Knights of Santiago founded.

1187 Saladin captures Jerusalem.

1194–7 Henry VI, Emperor and King of Sicily.

1197–1250 Frederick II, Emperor and King of Sicily. **1197, Richard I builds Château Gaillard, now a ruin.**

1198–1216 Pope Innocent III.

1199–1216 King John of England.

above: _Chartres Cathedral_. Interior

left: _Pórtico della Gloria_. **Mateo**

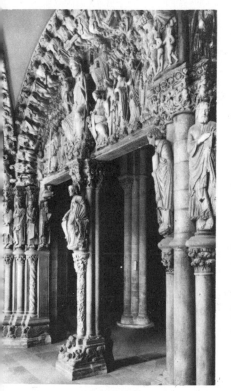

below: _Borgund_, Norway

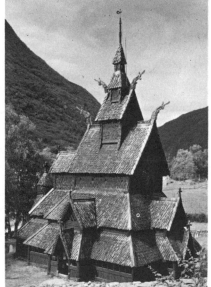

below: _Descent from the Cross_. **Antelami**

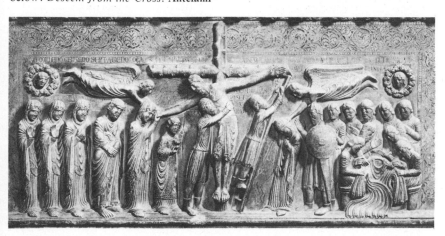

	Key works: PAINTING	Key works: ARCHITECTURE	Key works: SCULPTURE
SOUTH EUROPE	c. 1210–20 *Painted Cross* by **Berlinghiero**, Pinacoteca, Lucca; signed example of Italianized Byzantine type. c. 1218 *Genesis Scenes* completed, S. Marco, Venice; earliest mosaic work in the narthex. c. 1235 *Altarpiece of St Francis* by **Bonaventura Berlinghieri** (1205/10–74), S. Francesco, Pescia; new kind of formalism in one of earliest St Francis altarpieces. c. 1260 *Madonna della Trinità* by **Cimabue** (c. 1240–1302?), Uffizi, Florence; twice life-size figure. 1285 *Rucellai Madonna* by **Duccio di Buoninsegna** (c. 1255–c. 1318), commissioned, Uffizi, Florence; Sienese work reflecting Gothic influences. c. 1290 *Last Judgement* by **Cavallini** (active 1273–1308), S. Cecilia, Rome; turning point, Byzantine iconography is deliberately varied. c. 1296 *Life of St Francis* begun, Upper Church of S. Francesco, Assisi, probably by **Giotto** (died 1337); sculptural figures presented in realistic settings; essentials of modern painting emerging.	1227 *Choir of Burgos Cathedral* begun; double-aisled design of clear French Gothic inspiration. 1230 *S. Maria della Spina*, Pisa, begun; tiny, highly decorated marble Gothic church, enlarged after 1323. c. 1240 *Castel del Monte*, Apulia, begun; octagonal hunting lodge of Emperor Frederick II. pre 1260 *Siena Cathedral* begun; boldly polychromed work showing persistence of Romanesque forms in Italian architecture. 1298 *Barcelona Cathedral* begun; influential church with tall peripheral chapels; most original version of Spanish Gothic.	c. 1200–25 *Trivulzio Candelabrum*, Milan Cathedral; large bronze with highly naturalistic details. c. 1235 *Portada del Sarmental*, Burgos Cathedral; elaborate portal on French design. 1260 *Pulpit* by **Nicola Pisano** (c. 1220/5–1284?) completed, Pisa Baptistery; free-standing work with statuettes and reliefs showing extensive reference to the Antique. 1265 *Pulpit* of Siena Cathedral by **Nicola Pisano**, commissioned; classicism of earlier work modified by French Gothic influence. c. 1275–8 *King Charles of Anjou*, Museo Capitolino, Rome; large seated marble figure of King of Naples; probably by major sculptor and architect **Arnolfo di Cambio** (died 1302?). 1299? *Virgin and Child* by **Giovanni Pisano** (c. 1245/50–after 1314), Cathedral Treasury, Pisa; ivory statuette reflecting contemporary French work.
NORTH EUROPE	c. 1200 *Ingeborg Psalter*, Musée Condé, Chantilly; unusual example of the classical Transitional style in illumination. c. 1200–3 *Weingarten Missal*, Pierpont Morgan Library, New York; peak of German zig-zag style of illumination. c. 1220 *Story of Charlemagne*, Chartres Cathedral; one of unusually complete series of original stained glass windows. c. 1220 *Sketchbook* of **Villard de Honnecourt**, Bibliothèque Nationale, Paris; collection of architectural and other drawings, including designs for Reims Cathedral. c. 1250 *Historia Anglorum* by **Matthew Paris**, British Museum, London; text with illustrations by St Albans' artist and historian. 1252–70 *St-Louis Psalter*, Bibliothèque Nationale, Paris; chief example of work commissioned by royal patron. c. 1275–1300 *Westminster Retable*, Westminster Abbey, London; extraordinary court style painting, originally decorated with enamels and stones. c. 1290 *Book of Hours*, Nuremberg, possibly by **Master Honoré**; first appearance of design of widespread popularity, by Parisian court artist.	1210 *Reims Cathedral* begun; first appearance of bar tracery in major High Gothic building; architects commemorated in a labyrinth. 1236–57 *St Elizabeth*, Marburg; earliest truly Gothic church in Germany. 1243–8 *Sainte-Chapelle*, Paris; masterpiece of Rayonnant luxury architecture; extensive use of glass in delicate tracery. 1245 *Westminster Abbey* rebuilding begun by Henry III; Parisian-influenced construction with extensive interior surface ornament. 1248 *Cologne Cathedral* begun; strongly influenced by French Gothic design, particularly of Amiens and Beauvais. 1256 *Angel Choir*, Lincoln, begun; richly ornamented Purbeck and limestone elevation with intricate traceried clerestory. 1262 *St Urbain*, Troyes, begun; elaborately developed Rayonnant style. 1277 *Façade of Strasbourg Cathedral* designed by **Erwin von Steinbach**; refined Gothic creation for which drawings still exist. c. 1295–1330 *Beaumaris Castle*, Wales; one of new concentric fortifications begun by Edward I.	c. 1210–15 *South Portal*, Chartres; magnificent ensemble of reliefs and detached column figures. c. 1225–55 *West Front*, Wells Cathedral; façade framing large number of full-length statues. 1245–55 *Visitation*, Reims Cathedral; column figures of Mary and Elizabeth with remarkable classical drapery. c. 1230 *Angel Pillar*, Strasbourg Cathedral; unusual disposition of figure sculpture inside the church. 1248–50 *Uta*, Naumburg Cathedral; one of series of unusually realistic portraits of the cathedral founders. post 1260 *Tomb of Dagobert I*, S.-Denis, Paris; commissioned by St Louis, one of series of monuments to Carolingian and Capetian kings. c. 1275–1300 *Descent from the Cross*, Louvre, Paris; painted ivory figures from a larger group, sophisticated Parisian work. 1291–3 *Queen Eleanor*, Westminster Abbey; bronze effigy by **William Torel**, commissioned by Edward I.
BYZANTIUM	1285 *Gospel Book* by **Theophilus the Monk**, British Museum, London; example of new Palaeologue style. 1295 *Kiss of Judas*, by **Michael** and **Eutychios**, St Clement, Ochrid; signed frescos, earliest full examples of new metropolitan style.	1282–9 *Panagia Paregoritissa*, Arta; strangely built early Palaeologue church with clearly Western features. 1284–1300 *South Church of Constantine Lips*, Istanbul; one of churches marking rebirth of Byzantine culture.	c. 1200–1300 *Madonna dello Schioppo*, north transept, S. Marco, Venice; flat marble relief from undistinguished period of Byzantine sculpture.

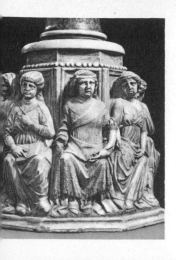

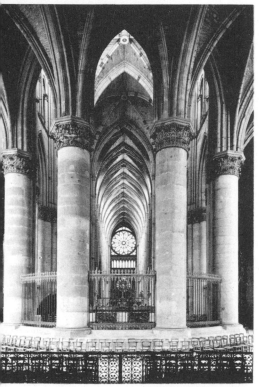

above left: *Pulpit* of
Siena Cathedral. Detail.
Nicola Pisano

above: Album page from
Sketchbook, showing the
rose-window in Lausanne
Cathedral. **Villard de
Honnecourt**

left: *Reims Cathedral.*
Interior

below: Gallery of Kings.
West Front, Wells
Cathedral

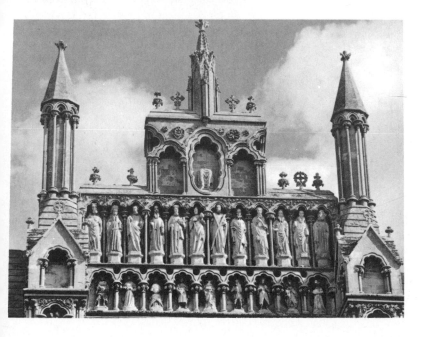

c. 1200 *Niebelungenlied* written. *Carmina Burana*
songs written.

1204 Fourth Crusade; sack of Constantinople.
Conquest of Normandy by Philip Augustus.

c. 1207 Villehardouin's account of the *Conquest of
Constantinople* ends.

1210 Battle of Las Navas de Tolosa ends Moorish
supremacy in Spain.

1214 King John defeated at Bouvines.

1215 Magna Carta. Fourth Lateran Council.
Foundation of Franciscan and Dominican Orders.

1216–72 Henry III of England. *Conquest of
Constantinople, c.* 1216, account by Robert of Clari.

1220 Emperor Frederick II's son crowned King of
the Romans.

1226–36 Blanche of Castile acting Regent for Louis
IX (1226–70).

1228 Francis of Assisi canonized. **Church of Assisi
begun.**

1231 Castile and Léon reunited by Ferdinand III.
**Hugh Libergier designs façade of S.-Niçaise,
Reims (destroyed).**

c. 1236 *Roman de la Rose.* **Chronicler Matthew
Paris becomes Head of Scriptorium at St Albans.**

1237 **New transept of S.-Denis finished.**

1239 Crown of Thorns arrives in Paris.

1245 Council of Lyons: Pope Innocent IV deposes
Frederick II.

1248–54 Crusade of Louis IX (St Louis) to Egypt.

1250 Interregnum. 1250–6, St Bonaventura in Paris.

1256 Sorbon founds theological college in Paris.

1258 **Jean de Chelles begins new transepts of Notre-
Dame, Paris, work continued by Pierre de Montreuil.
Rebuilding of Old St Paul's Cathedral, London,
begun (destroyed).**

1261 Fall of Latin Kingdom of Constantinople.

1266 Charles of Anjou crowned King of Sicily. Roger
Bacon's *Opus Maius.*

c. 1270 *Summa Theologica* by Thomas Aquinas.
Arnolfo di Cambio working in Rome *c.* 1270–5.

1272–1307 Edward I reigns. **1272, Cimabue in Rome.**

1273 Rudolph of Hapsburg elected Emperor.
Cavallini first documented in Rome.

1277 Edward I defeats Llywellyn of Wales. Roger
Bacon imprisoned for heresy.

1278 **Duccio di Buoninsegna first recorded working
for the Commune of Siena.**

1285–1314 Philippe IV, le Bel of France. **Giovanni
Pisano begins work on façade of Siena Cathedral
c. 1285.**

c. 1286 *Rationale Divinorum Officiorum* by **Durandus.**

1288 Ottoman Empire founded by Osman I.

c. 1290 Dante's *Vita Nuova.*

1291 Succession dispute in Scotland between Robert
the Bruce and John Balliol. 1291–1327, James II of
Aragon.

1296 **Florence Cathedral begun; Arnolfo di Cambio
appointed Capomaestro. Giotto called to Assisi by
the head of the Franciscan Order.**

1297 Louis IX of France canonized.

1298 Marco Polo's *Travels.*

1299 **Giotto summoned to Rome by Pope Boniface
VIII to work in the Lateran Basilica.**

	Key works: PAINTING	Key works: ARCHITECTURE	Key works: SCULPTURE
ITALY	1304–5 *Fresco cycle in Arena Chapel*, Padua, by **Giotto** (died 1337); highly influential work of exceptional naturalism. 1308 *Maestà*, Opera del Duomo, Siena, commissioned; famous vast altarpiece by **Duccio di Buoninsegna** (*c.* 1255–*c.* 1318). *c.* 1310 *Ognissanti Madonna* by **Giotto**, Uffizi, Florence; important panel painting of restrained majesty. 1328 *Guidoriccio da Fogliano* by **Simone Martini** (died 1344), Palazzo Pubblico, Siena; fresco; tribute to a victorious Sienese general. *c.* 1330 *Descent from the Cross* by **Pietro Lorenzetti** (died 1345), Lower Church of S. Francesco, Assisi; powerfully emotive fresco. *c.* 1333 *Annunciation Altarpiece* by **Simone Martini**, Uffizi, Florence; graceful linear work reflecting contemporary trend towards increased realism.	1309 *Ducal Palace*, Venice, begun; delicately galleried Gothic palace with façades dating from 1375 to 1400 and 1423 to 1457. 1310 *West Front of Orvieto Cathedral* begun by **Lorenzo Maitani** (*c.* 1275–1330); two drawings for the façade exist. 1334 *Campanile*, Florence, begun by **Giotto** (died 1337); design altered later by Andrea Pisano (*c.* 1290–1348) and Talenti.	1302 *Pulpit*, Pisa Cathedral, by **Giovanni Pisano** (*c.* 1245/50–after 1314), commissioned; work of complex iconography, later dismantled and rebuilt. 1321 *Madonna and Child* by **Tino da Camaino** (died 1337), Bargello, Florence; work from the Orso monument. *c.* 1325–30 *Last Judgement*, probably by **Lorenzo Maitani** (*c.* 1275–1330), façade of Orvieto Cathedral; part of extensive sculptural programme. 1330–6 *Bronze doors*, south side of Baptistery, Florence, by **Andrea Pisano** (*c.* 1290–1348); work influenced by French Gothic metalwork and Giotto's frescos in S. Croce.
FRANCE AND SPAIN	1311 *La Somme le Roy*, Bibliothèque de l'Arsenal, Paris; written for Jeanne d'Evreux, illuminated by **Master Honoré**. *c.* 1325 *History of St Louis*, Bibliothèque Nationale, Paris; manuscript with miniature of the historian Joinville presenting his work to the King. 1325–8 *Book of Hours of Jeanne d'Evreux*, by **Jean Pucelle**, Cloisters, Metropolitan Museum of Art, New York; miniatures commissioned by Charles IV for his wife. 1344 *Falconry*, Hall of the Stags, Palace of the Popes, Avignon; important secular frescos commissioned by Pope Clement VI. 1346 *Entombment*, by **Ferrer Bassa** (died 1348), S. Miguel de Pedralbo, near Barcelona; murals showing thorough knowledge of contemporary painting.	1304 *Jacobin*, Toulouse; highly unusual church built for Mendicant Order. 1317 *Cloister of Pamplona* begun; fully developed use of tracery and gables reflecting French influence. 1318 *St.-Ouen*, Rouen, begun; elegant masterpiece of late Rayonnant style. 1334–42 *Palace of the Popes*, Avignon; one of most extensive castle complexes in the Gothic style.	*c.* 1323 *Tomb of Countess Mahaut of Artois*, S.-Denis; first praying figure in tomb of great patroness of the arts. 1325–51 *North Choir Screen*, Notre-Dame, Paris; continuous frieze showing scenes from Christ's life, in painted sandstone. 1339 *Madonna of Jeanne d'Evreux*, Louvre, Paris; famous statue in gilt beaten metal given by great patroness of the arts to Abbey of S.-Denis.
NORTH AND CENTRAL EUROPE	*c.* 1310 *Queen Mary Psalter*, British Museum, London; Parisian-influenced work with extensive border illustration. *c.* 1320 *Manesse Codex*, Universitäts Bibliothek, Heidelberg; most famous of series of illuminated texts of Minnesinger poetry. *c.* 1320–25 *Annunciation*, Wallraf-Richartz Museum, Cologne; delicately coloured oak panel from flourishing period of the Cologne school. 1335–40 *Luttrell Psalter*, British Museum, London; East Anglian style work with lively scenes of contemporary life. *c.* 1349 *Great East Window*, Gloucester Cathedral; huge wall of glass with Coronation of the Virgin and rows of canopied figures; commemorates victories of Edward III.	*c.* 1306 *Bristol Cathedral Choir* begun; unusual English hall church with skeleton arches in the aisles. 1311 *Octagon and spire of Cathedral Freiburg-im-Breisgau* begun; famous open tracery work. 1322–42 *Lantern Tower of Ely Cathedral*; wooden octagon, possibly designed by **Alan of Walsingham**. 1331 *Wiesenkirche*, Soest, begun; Late Gothic hall church influential in Germany. 1343 *Marienkirche*, Lübeck begun; one of largest brick churches in Europe, decisive in development of brick Gothic. 1344 *Choir of Prague Cathedral*, designed by **Matthias of Arras** (died 1352); work of French architect summoned by the Emperor; completed by **Peter Parler** (died 1399). *c.* 1337–57 *Chancel of Gloucester Cathedral*; most important work of Early Perpendicular, sumptuously lined with tracery.	*c.* 1320 *Milan Madonna*, Cologne Cathedral; mistakenly named painted wood; smiling figure. *c.* 1330–5 *Edward II*, Gloucester Cathedral; alabaster effigy of murdered King by court artist. *c.* 1334–45 *Grandisson Ivory*, Victoria and Albert Museum, London; one panel of diptych of English workmanship. *c.* 1340–50 *Pietà Roettgen*, Rheinisches Landesmuseum, Bonn; sentimental work intended to arouse mystic compassion. *c.* 1342–5 *Percy Tomb*, Beverley Minster, Yorkshire; luxuriant stone canopied sepulchre with northern English features.

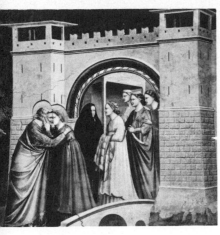

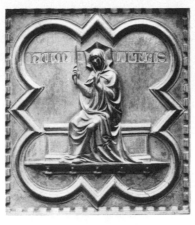

above: *Fresco cycle in Arena Chapel.*
Meeting of Joachim and Anna. **Giotto**

above: *Bronze doors.* Baptistry,
Florence. Detail. **Andrea Pisano**

below: *Maestà*. **Duccio di Buoninsegna**

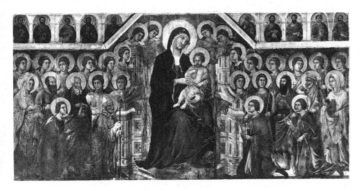

below: *Palace of the Popes*, Avignon

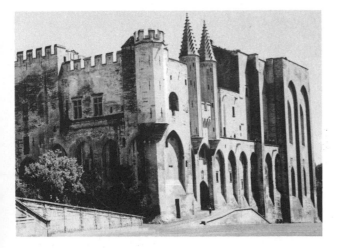

below: *Ducal Palace*, Venice

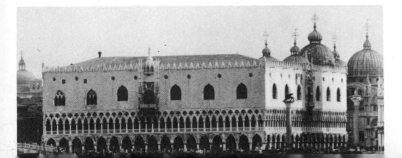

1300 Papal Jubilee. Villani begins his *History of Florence c.* 1300.

1302 Flemings defeat Philip IV at Courtrai. Dante exiled from Florence. **Cimabue's only securely dated work, part of mosaic in apse of Pisa Cathedral.**

1303 Foundation of Rome University. **Enrico Scrovegni founds Chapel in amphitheatre at Padua.**

1305 Papacy moves from Rome to Avignon.

1306 Scots revolt against Edward I led by Robert the Bruce.

1307–27 Edward II of England.

1308 **Cavallini, Roman painter, working in Naples. Simone Martini summoned to Orvieto.**

1309–43 Robert the Wise of Anjou, King of Naples. 1309–13, Dante's *De Monarchia*. 1309, Joinville's *History of St Louis*. **1310–30, Lorenzo Maitani heads Orvieto Cathedral works.**

1312 Trial of Templars by Philip IV of France. **Tino di Camaino** (died 1337), **sculptor, working in Siena.**

1314 Battle of Bannockburn. Dante's *La Divina Commedia c.* 1314.

1316 **Expertise of Chartres, document concerning the condition of the cathedral fabric.**

1317 **Simone Martini working for Robert the Wise in Naples. Lippo Memmi painting in San Gimignano (later goes to paint at papal court at Avignon)·**

1320 Peace of Paris between France and Flanders.

1322–8 Charles IV of France.

1323 Thomas Aquinas canonized. Trial of Louis IV by Pope John XXII. **1323/4, Tino di Camaino working in Naples.**

1324 *Defender of the Peace* by Marsilio of Padua.

1326 Rebellion of Isabella and Mortimer.

1327 Edward II deposed. **Pietro Lorenzetti** (died 1345) **enters Guild at Florence. 1327–70, Master Hugh of St Albans decorates the destroyed Chapel of St Stephens, Westminster.**

1328 Louis IV crowned Emperor in Rome. Gonzaga dynasty established in Mantua. Sienese General Guidoriccio da Fogliano defeats the Florentines. **1328–33, Giotto working for Robert of Naples.**

1330–77 Edward III of England.

1333 Petrarch visiting Cologne.

1334–41 Pope Benedict XII. **1334 Giotto appointed chief architect of Florence Cathedral.**

1336 Rebellion against Count of Flanders.

1337–80 Charles V of France. Edward III claims French crown; beginning of Hundred Years War. **Andrea Pisano succeeds Giotto as master mason at Florence. 1337–9, Ambrogio Lorenzetti painting frescos in Siena Town Hall.**

c. 1340 **Simone Martini goes to Avignon.**

1341 Petrarch crowned with laurels in Rome.

1342–52 Pope Clement VI at Avignon; **employs Matteo di Giovanetti, fresco painter from Viterbo.**

1344 **Girard of Orléans** (died 1361) **appointed French court painter.**

1346 Battle of Crécy.

1347 Black Death in Western Europe. English capture Calais. Popular revolution in Rome led by Cola di Rienzo. **List of best Italian painters (candidates for commission in Pistola) headed by Taddeo Gaddi** (died 1366).

1348 Order of the Garter founded. Emperor Charles IV founds Prague University. Boccaccio's *Decameron c.* 1348–53.

	Key works: PAINTING	Key works: ARCHITECTURE	Key works: SCULPTURE

ITALY

c. 1350 *Triumph of Death* by **Francesco Traini**, Campo Santo, Pisa; secular scenes with moral intention.
1354–7 *Strozzi Altarpiece*, S. Maria Novella, Florence, by **Orcagna** (died 1368); the only painting attributed to him with certainty.
1359 *Mystic Marriage of St Catherine* by **Lorenzo Veneziano** (died 1372), Accademia, Venice; delicately coloured Venetian Gothic work.
1366–8 *Spanish Chapel frescos* by **Andrea da Firenze**, S. Maria Novella, Florence; illustration of Dominican ecclesiastical doctrine.
c. 1380 *Nativity* by **Menabuoi** (died 1393), Padua Baptistery; one of most ambitious programmes in fresco in Italy.
c. 1380 *Visconti Hours* begun by **Giovanni Grassi** (died 1398), Biblioteca Nazionale, Florence; best work of highly inventive Parisian-influenced miniaturist.

1367 *East End of Florence Cathedral* by **Talenti**; elements of the 1294 design by Arnolfo di Cambio (died 1302?) remain.
1387 *Nave of Milan Cathedral* begun; immense problematic work in marble; foreign architects summoned to advise.

1359 *Death and Assumption of the Virgin* by **Orcagna** (died 1368), Or San Michele, Florence; signed and dated relief from tabernacle by major Florentine artist.
c. 1360–70 *Madonna della Rosa* by **Nino Pisano** (died 1368), S. Maria della Spina, Pisa; smiling Virgin of French Gothic type.
c. 1375 *Monument to Cansignorio della Scala*, S. Maria Antica, Verona, by **Bonino da Campione**; one of most impressive Gothic tombs in northern Italy.
1391 *Porta della Mandorla*, Duomo, Florence, begun; work of several sculptors, including **Giovanni d'Ambrogio** (died 1418) and **Quercia** (1374–1438); reliefs of lower part showing strongly classicizing tendencies.

FRANCE AND SPAIN

c. 1360 *John the Good*, Louvre, Paris; inscribed portrait possibly painted in England by **Girard of Orléans**, the King's valet.
1373–8 *Le Parement de Narbonne*, Louvre, Paris; Parisian-style brush drawing in grisaille on white silk.
1376–81 *Apocalypse Tapestry* designed by **Jean Bondol**, Angers Museum; sixty-nine surviving tapestry scenes created for staterooms of Angers castle.
c. 1390 *Petites Heures du Duc de Berri*, Bibliothèque Nationale, Paris, by **Jacquemart de Hesdin** (died 1410); probably earlier than the *Grandes Heures*.

1360–1402 *Alcazar*, Seville; extensions made for Peter I of Castile, outstanding example of Hispano-Moresque style.
c. 1384–6 *Great Hall of Palais des Comtes*, Poitiers, by **Guy de Dammartin** (died 1398); Flamboyant tracery screen placed over enormous fireplace.
1387 *Batalha Monastery* founded by King João of Portugal; building showing influence of English Perpendicular and French Flamboyant.
1391 *Court of the Lions*, Alhambra, Granada completed; novel courtyard surrounded with porticoes, part of great Muslim fortress palace.

c. 1366 *Charles V*, S.-Denis, Paris, by **André Beauneveu**; sumptuous tomb with funeral effigy by court sculptor.
1384 *Tomb of Philippe le Hardi*, Dijon Museum; elaborate work begun by **Jean de Marville** (died 1389), completed by **Sluter** (died 1410) and **Werve** (died 1439).
1391–7 *Statues of Main Portal* of Chartreuse de Champmol, near Dijon, by **Sluter**; use of perspective in arrangement, realistic figures and boldy treated drapery; important new development.
1391–9 *Entombment Retable*, Dijon, by **Jacques de Baerze**; surviving sections from wooden altarpiece sent to Broederlam for painting.
1395–1406 *Moses Well* by **Sluter**, Chartreuse de Champmol, near Dijon; surviving part of monumental stone Calvary.

NORTH AND CENTRAL EUROPE

c. 1350 *Glatz Madonna*, Gemäldegalerie Staatliche Museen, Berlin; elegant altarpiece for the Archbishop of Prague.
c. 1365 *St Guy* by **Master Theoderik of Prague**, National Gallery, Prague; panel commissioned by Charles IV for Karlštejn Castle.
1371 *Hague Bible*, by **Jean Bondol** (died 1381), Rijksmuseum, The Hague; painted in Parisian manner.
c. 1380–90 *Resurrection* by **Master of Wittingau**, National Gallery, Prague; part of altarpiece of Passion of Christ, in Bohemian Soft Style.
1385–1402 *Brussels Hours* by **Jacquemart de Hesdin** (died 1410), Bibliothèque Royale, Brussels; highly individual work of court artist to the Duke of Berri.
1395–9 *Wilton Diptych*, National Gallery, London; Richard II presented to the Virgin and Child by Saints; rare surviving panel painting from England; tempera figures on tooled gold ground.

1351 *Kreuzkirche*, Gmund, begun; early example of late German Gothic style known as *sondergotik*.
c. 1357–77 *Cloisters of Gloucester Cathedral*; first surviving fan-vaulting in England; decorative and structural innovation.
c. 1375 *West Front of Exeter Cathedral* completed; introduction of great window in English galleried façade.
c. 1376 *Civic Hall*, Bruges, begun; ornate Gothic façade with statues of Counts of Flanders; witness to Flemish prosperity.
1394–1401 *Westminster Hall*, London, remodelled by **Henry Yevele** (died 1400); characteristic English hammer-beam roof by Hugh Herland.

1365–7 *Queen Philippa of Hainault*, Westminster Abbey, London, by **Jean of Liège** (died 1382); marble effigy taken from life.
c. 1390 *Krumau Virgin*, Kunsthistorisches Museum, Vienna; most famous of large group of Beautiful Madonna statues from central Europe.
1394–6 *Richard II*, Westminster Abbey, London; gilt copper effigy executed by **Nicholas Broker** and **Godfrey Prest**.

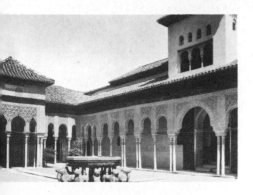

left: *Court of the Lions*, Alhambra

below left: *Statues of Main Portal*, Chartreuse de Champmol. **Sluter**

below: *Civic Hall*, Bruges

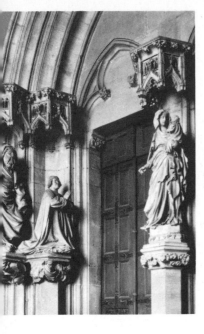

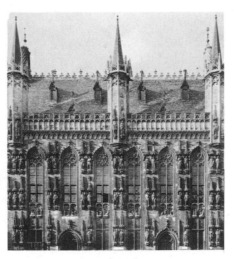

below: *Tomb of Philippe le Hardi*. **Jean de Marville, Sluter** and **Werve**

bottom: *Great Hall of Palais des Comtes*, Poitiers. **Guy de Dammartin**

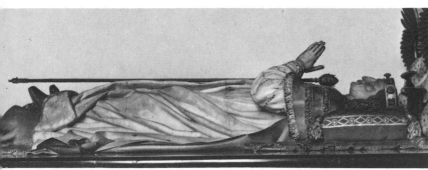

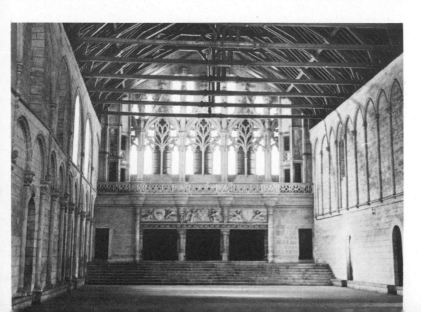

1350–64 John the Good of France. *The Book of Nature* by Conrad von Megenberg. Arthurian legend *Sir Gawain and the Green Knight c.* 1350.

1355 Charles IV crowned Emperor in Rome.

1356 Battle of Poitiers; John the Good captured by the English and imprisoned. Golden Bull issued by Emperor Charles IV.

1357 Jacquerie, peasant revolt, in France, Petrarch's *Triumphs*.

1360 **Henry Yevele becomes disposer of the King's works of masonry at Westminster palace and the Tower.**

c. 1362 *Piers Plowman* by Langland.

1363 Tamerlaine begins conquest of Asia. 1363–1404, Philip the Bold, Duke of Burgundy.

1367–*c.* 1415 **Master Bertram of Minden working in Hamburg. Castle of Mehun-sur-Yèvre begun *c.* 1367 for Dukes of Berri (later destroyed).**

1368 **Jean Bondol** (died 1381) **becomes court painter to Charles V of France.**

1369 Chaucer's *Book of the Duchesse*.

c. 1370 **Theophanes the Greek, Byzantine painter, settles in Russia.**

1371 Robert II of Scotland, first Stewart king.

1372 English defeated at La Rochelle by French and Castilians. War between Venice and Genoa. Sicily separates from Naples. **1371–84, Altichiero working in Padua.**

1377–99 Richard II of England. **1377, Andrea da Firenze painting in the Campo Santo, Pisa.**

1378 Great Schism begins. 1378–1402, Gian Galeazzo Visconti, Duke of Milan.

1379 William of Wykeham founds New College, Oxford.

1380–1422 Charles VI, the Mad, of France. 1380, Wyclif translates the Bible into the vernacular.

1381 Peasants' Revolt. Rhenish Town League formed.

c. 1383 John Gower's *Vox Clamantis*.

1384 Philip of Burgundy gains Flanders. **1384–1411, Jacquemart de Hesdin painting for Duke of Berri.**

1385 **Melchior Broederlam becomes painter to Philip of Burgundy. 1385–9, Sluter assisting Jean de Marville, sculptor to the Burgundian court at Dijon.**

1387 *L'Histoire de Lusignan* by Jean d'Arras. Chaucer's *Canterbury Tales c.* 1387–8.

c. 1390 **Cennino Cennini's *Libro dell' Arte*.**

1391 **Easel Painters given Charter in recognition of their trade. Lorenzo Monaco** (*c.* 1370–1425) **enters Camaldolese monastery in Florence.**

1393 **Richard II orders sculptural cycle to decorate the remodelled Westminster Hall.**

1394 **Ulrich von Ensinger, architect** (died 1419) **goes to Milan.**

1396 Turkish victory at Nicopolis. Marriage of Richard II of England and Isabella of France. Manuel Chrysoloras appointed to teach Greek in Florence.

1397 **Jean Malouel** (died 1419) **becomes painter to Philip of Burgundy. In 1397 and 1400 Luis Borrassa** (died *c.* 1425), **Spanish artist, painting scenery for dramas.**

1398 John Hus lectures at Prague University. **1398–1401, Starnina** (*c.* 1354–*c.* 1413), **Italian painter, in Spain.**

1399 Henry of Lancaster returns to England, deposes Richard II. 1399–1413, Henry IV.

	Key works: PAINTING	Key works: ARCHITECTURE	Key works: SCULPTURE
ITALY	1403 *Funeral Oration of Gian Galeazzo Visconti*, illuminated by **Besozzo** (1388–1455), Bibliothèque Nationale, Paris; deluxe copy of text by highly individual court artist. *c.* 1404–13 *Thebaïd* by **Starnina**, (*c.* 1354–*c.* 1413), Uffizi, Florence; one of few surviving works by important Florentine painter. 1413 *Coronation of the Virgin* by **Monaco** (*c.* 1370–1425), Uffizi, Florence; huge painting in luminous colours. 1423 *Adoration of the Magi* by **Gentile da Fabriano** (*c.* 1370–1427), Uffizi, Florence; masterpiece of International Gothic.	1418 *Dome of the Cathedral*, Florence, competition announced; double-shell dome of superb engineering designed by **Brunelleschi**; acclaimed by Alberti as surpassing Antiquity. *c.* 1419 *Foundling Hospital*, Florence, by **Brunelleschi** (1377–1446); first public building by Renaissance architect abandoning Gothic traditions. 1421–40 *Ca d'Oro*, Venice, by **Matteo Raverti**; one of last Late Gothic Venetian palazzi.	1401–2 *Sacrifice of Isaac* by **Ghiberti** (1378–1455), Bargello, Florence; winning entry in competition of 1401–3 for the north side Baptistery doors; elegant composition and masterly technique. 1401–2 *Sacrifice of Isaac* by **Brunelleschi** (1377–1446), Bargello, Florence; dramatic bronze relief with clear borrowings from the Antique, entered for Baptistery doors competition. 1405–6 *Tomb of Ilaria del Carretto Guinigi* by **Quercia** (1374–1438), Lucca Cathedral; elaborate marble monument of French scheme by great Sienese sculptor of the Early Renaissance. 1408–9 *David*, marble, by **Donatello** (1386–1466), Bargello, Florence; earliest monumental figure by sculptor; well-documented. *c.* 1414 *Assumption of the Virgin* begun by **Nanni di Banco** (*c.* 1384–1421), Porta della Mandorla, Florence Cathedral; figures full of movement in Gothic scheme.
FRANCE AND SPAIN	*c.* 1400–10 *Large Circular Pietà*, Louvre, Paris; painting attributed to **Malouel** (died 1419) or to **Bellechose** (died 1440/4), his successor as chief Burgundian court painter. 1403 *Book of Famous and Noble Women*, Bibliothèque Nationale, Paris, lavishly illuminated text of Bocaccio presented to Duke of Burgundy. *c.* 1409 *Grandes Heures du Duc de Berri* by **Jacquemart de Hesdin**, Bibliothèque Nationale, Paris, completed; exceptionally rich and refined illumination. pre 1416 *Très Riches Heures du Duc de Berri* begun by **Paul de Limbourg** (died *c.* 1416), Musée Condé, Chantilly; masterpiece of French International Gothic painting. *c.* 1416 *Holy Communion and Martyrdom of St Denis*, Louvre, Paris; altarpiece completed by **Bellechose** for Jean sans Peur; perhaps begun by **Malouel** in 1398.	1401–1521 *Seville Cathedral* rebuilt; old mosque replaced with vast double-aisled Gothic construction. 1416–25 *Palace of the Generalife*, Barcelona; Late Gothic Spanish work, much altered.	*c.* 1405 *Tomb of Jean de Berri* begun by **Jean de Cambrai** (died 1438), crypt of Bourges Cathedral; realistic effigy; marble weepers in the Berri Museum, Bourges.
NORTH AND CENTRAL EUROPE	*c.* 1400 *St Veronica*, Alte Pinakothek, Munich; panel painting in Gothic Soft Style. *c.* 1410 *Annunciation*, Kunsthistorisches Museum, Vienna; panel from French-influenced Altar of the Heiligenkreuz. *c.* 1410–20 *Icon of the Old Trinity*, Tretyakov Gallery, Moscow, by **Andrei Rublev** (1360/70–1427/30); only extant, authenticated unassisted work of famous icon painter. *c.* 1410–20 *Garden of Paradise*, panel, Städelsches Kunstinstitut, Frankfurt; enchanting small panel in characteristic Rhenish Soft Style. *c.* 1420–30? *Mérode Annunciation* by **Campin** (died 1444), Metropolitan Museum of Art, New York; famous triptych by Flemish pioneer of pictorial naturalism, long known as the Master of Flémalle.	*c.* 1400 *Chantry of William of Wykeham*, Winchester Cathedral; small chapel containing realistic funerary effigy of great patron of the arts. 1402–55 *Old Town Hall*, Brussels; secular Late Gothic work with lavish exterior sculpture. 1408 *Chancel of Franciscan Church*, Salzburg, begun by **Hans von Burghausen** (died 1432); Late Gothic choir with remarkably long slender piers.	*c.* 1400 *Seeon Pietà*, Bayerisches National Museum, Munich; painted wood; one of huge number of surviving works of this period from central Europe. *c.* 1410 *Golden Table*, Niedersächsische Landesgalerie, Hanover; splendid northern German sculpture from St Michael at Lüneburg. pre 1414 *Archbishop Friedrich of Saarwerden*, Cologne Cathedral; bronze effigy by **Eligius of Liège**; magnificent example of South Netherlands style. *c.* 1411 *Stone Choir Screen*, Canterbury Cathedral, completed; London-style tabernacle, rare survival of architectural sculpture. *c.* 1420–5 *High Altar*, Reinoldikirche, Dortmund; most effective of group of altars with dramatic scenes from the South Netherlands.

left: Page from *Très Riches Heures du Duc de Berri*. **Paul de Limbourg**

below: *Mérode Annunciation*. **Campin**

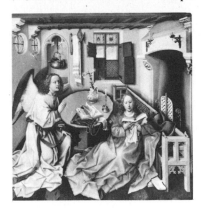

below: *Palace of the Generalife,* Barcelona

below: *Dome of the Cathedral*, Florence. **Brunelleschi**

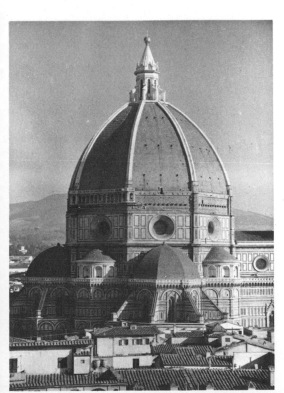

below: *Tomb of Ilaria del Carretto Guinigi*. **Quercia**

1400 Emperor Rudolph III elected. 1400–3, Emperor Manuel Palaeologus visits Paris and London. Froissart's *Chronicles c.* 1400.

c. 1402 **Donatello and Brunelleschi visit Rome together to study Antique sculpture.**

1404 John the Fearless becomes Duke of Burgundy. Venice acquires Verona and Vicenza. **Starnina completes frescos (destroyed) in S. Maria del Carmine, Florence.**

1406 Florence defeats Pisa. Venice acquires Padua. King James I of Scotland imprisoned. **Robert Campin, Flemish painter, active in Tournai.**

1407 Burgundians assassinate Duke of Orléans. Civil War in France.

1408 Rome captured by Ladislas of Naples.

1409 Council of Pisa elects Pope John XXIII. Martin of Aragon obtains Sicily by marriage.

1410 Teutonic Knights overthrown at Tannenberg.

1411 Orleanists defeated at Saint-Cloud. Pope excommunicates John Hus. Occleve's *De Regimine Principum.* **Limbourg brothers become painters to the Duke of Berri. 1411–12, Donatello's first statue for Or San Michele, Florence.**

1412 Guarino takes Chair of Greek in Florence. 1412–47, Philip Maria, last Visconti Duke of Milan.

1413 Accession of Henry V of England. Wyclif's writings condemned by Pope John XXIII.

1414 Medici family become bankers to the Papacy.

1414–18 Council of Constance; ends the Great Schism.

c. 1414 *Imitatio Christi*, ascribed to Thomas à Kempis.

1415 Battle of Agincourt. John Hus condemned to death for heresy. **1415–20, Pisanello (*c.* 1395–1455) painting Sala del Maggior Consiglio, Palazzo Ducale, Venice, under direction of Gentile da Fabriano (work destroyed).**

1416–58 Alfonso of Aragon and Sicily.

1417–31 Pope Martin V. **Jacopo della Quercia working on reliefs for the Siena Baptistery.**

1418 John of Burgundy enters Paris. **Payment made to Ghiberti for model for Dome of Florence Cathedral.**

1419 Henry V takes Rouen. Emperor Sigismund acquires Bohemia; 1419–36 Hussite War.

1420–36 English occupy Paris. Burgundian court of Philip the Good moves from Dijon to Bruges. **French painter Iverni working in the Castello della Monte, Piemont *c.* 1420–3.**

1421 Great Flood in Holland. **Fra Filippo Lippi (*c.* 1406–69) enters the Carmine monastery in Florence.**

1422 Charles VII establishes his court at Bourges. **Jan van Eyck (1390?–1440?) in service of John of Bavaria, Count of Holland.**

1422–35 John Duke of Bedford acting Regent in France during minority of Henry VI of England. Turks lay siege to Constantinople. **Masaccio (1401–28) enters Florentine Guild.**

1423 King James of Scotland imprisoned; writes *Kingis Quair*. **1423–6, Sassetta (*c.* 1400–50) first recorded painting in Siena.**

1424 **Ghiberti visits Venice. Earliest known Dance of Death cycle, Danse Macabre, painted in cloister of Church of the Holy Innocents, Paris (destroyed).**

	Key works: PAINTING	Key works: ARCHITECTURE	Key works: SCULPTURE
ITALY	c. 1425 *Healing of the Cripple* by **Masolino** (1383–c. 1447), Brancacci Chapel, S. Maria del Carmine, Florence; fresco by court artist. 1426 *Madonna and Child* by **Masaccio** (1401–28), National Gallery, London; part of the Pisa Polyptych, sombre work in artist's mature style. 1426–8 *The Tribute Money* by **Masaccio**, Brancacci Chapel, S. Maria del Carmine, Florence; famous monumental fresco by most innovatory painter of the Early Renaissance. 1433–8 *St George and the Princess* by **Pisanello** (c. 1395–c. 1455), Cappella Pellegrini, S. Anastasia, Verona; fresco masterpiece in refined International Gothic style. 1436 *Equestrian Portrait of Sir John Hawkwood* by **Uccello** (1397–1475), Florence Cathedral; fresco experiment in perspective illusion. c. 1440–7 *Annunciation* by **Fra Angelico** (1387–1455), S. Marco, Florence; part of extensive programme of conventual fresco paintings.	1429 *Pazzi Chapel* by **Brunelleschi** (1377–1446), S. Croce, Florence, commissioned; famous work completed after the architect's death. 1434–7 *S. Maria degli Angeli,* Florence, by **Brunelleschi**; unfinished centralized oratory with clearly antique features. 1444–60 *Palazzo Medici*, Florence, by **Michelozzo** (1396–1472); prototype of Tuscan Renaissance palazzi, by favourite architect of Cosimo de' Medici. 1446–55 *Tempio Malatestiano*, Rimini, by **Alberti** (1404–72); unfinished pantheon of classical inspiration. 1446 *Palazzo Rucellai*, Florence, designed by **Alberti**; sophisticated composition with Vitruvian features. c. 1447 *Suite of Nicholas V*, Vatican Palace, Rome; completed part of huge project for restoring Rome initiated by the Pope.	1425–52 *Gates of Paradise* by **Ghiberti** (1378–1455), Baptistery, Florence; highly influential masterpiece in gilded bronze, biblical scenes created in sophisticated perspective. 1431–8 *Cantoria* for the Duomo by **Luca della Robbia** (1400–82), Opera del Duomo, Florence; first singing-gallery, groups of figures of polished naturalism. c. 1434 *Cantoria* for the Duomo begun by **Donatello** (1386–1466), Opera del Duomo, Florence; unbroken frieze of dancing putti with gilt mosaic background. c. 1435 *Doors of St Peter's*, Rome begun by **Filarete** (c. 1400–69); archaism and reference to the antique typical of Early Renaissance sculpture in Rome. c. 1443 *Gattamelata Monument* begun by **Donatello**, Piazza del Santo, Padua; bronze equestrian statue ordered by the Venetian senate. c. 1445 *Tomb of Leonardo Bruni* begun by **Bernardo Rosssellino** (1409–64), S. Croce, Florence; sculptor's masterpiece, influential wall tomb.
FRANCE AND SPAIN	c. 1433 *Salisbury Breviary*, Bibliothèque Nationale, Paris; manuscript written during English occupation of Paris for Duke of Bedford. c. 1436 *Hours of King René*, British Museum, London; five large miniatures by highly gifted artist inserted. 1442 *Aix Annunciation*, Ste-Marie-Madeleine, Aix-en-Provence; Italian-influenced altarpiece. 1443–5 *Virgin of the Councillors* by **Dalmau** (died 1460?), Museo de Arte de Cataluña, Barcelona; excellent example of Flemish influence. pre 1450 *Melun Diptych* by **Fouquet**, Musée Royal des Beaux-Arts, Antwerp; Charles VII's mistress painted as Virgin with Child by court artist.	1426 *Caudebec* begun; major work of Norman Flamboyant Gothic architecture. 1442–58 *Spires of Burgos Cathedral* by **Juan de Colonia** (died 1481); work in German Late Gothic style. 1443 *Hôtel-Dieu*, Beaune; hospice founded by Cardinal Rolin; Weyden's *Last Judgement* commissioned for the chapel. 1443–51 *House of Jacques Coeur*, Bourges; private house of Charles VII's financier, decorated with *trompe l'oeuil* sculpture.	1425–36 *Alabaster Altarpiece* by **Pedro Johan** (1398–after 1458), Tarragona Cathedral; important Catalan work, Italian-influenced. c. 1430 *Gomez Manrique*, Burgos Cathedral; remarkably naturalistic portrait effigy in alabaster. c. 1430–40 *St Michael*, Musée des Augustins, Toulouse; charming work showing Burgundian influence.
NORTH AND CENTRAL EUROPE	1432 *Ghent Altarpiece* by **Jan van Eyck** (1390?–1440?) and **Hubert van Eyck** completed, St-Bavon, Ghent; magnificent inscribed polyptych by major painters of the Early Netherlandish School. 1434 *Arnolfini Marriage* by **Jan van Eyck**, National Gallery, London; portrait of remarkable realism. c. 1438 *Descent from the Cross* by **Weyden** (1399–1464), Prado, Madrid; famous emotive work, often copied. c. 1440 *Adoration of the Magi* by **Lochner** (died 1451), Cologne Cathedral; delicately coloured work, later identified as by Dürer. 1444 *Miraculous Draught of Fishes* by **Witz** (died c. 1445), Musée d'Art et d'Histoire, Geneva; extremely realistic work by Swiss painter.	1427 *Choir of St George*, Nördlingen, begun by **Heinzelmann** (c. 1390–1454); mature Late Gothic building. 1434 *S. Lorenz*, Nuremberg, begun; hall church with vault ribs rising from piers without a break. 1439 *Spire of Strasbourg Cathedral* completed by **Hültz** (died 1449); octagonal stage of tower by **Ulrich von Ensinger** (died 1419). 1448–63 *Town Hall*, Louvain, by **Matthaeus de Layens** (died 1483); civic hall built in forms of ecclesiastical Gothic.	1428 *Angel of the Annunciation* by **Delemer**, Ste-Marie-Madeleine, Tournai; bold life-size statue painted by **Campin** (died 1444), first example of its kind. 1429 *Man of Sorrows* by **Mültscher** (died 1467), west portal, Ulm Cathedral; figure influenced by eastern French work. pre 1433 *Engelbrecht of Nassau*, Grootekerk, Breda; brilliant example of Netherlandish monumental sculpture. 1443 *Virgin* by **Kaschauer** (1429–63), National Museum, Munich; Viennese work, part of High Altar from Freising Cathedral.

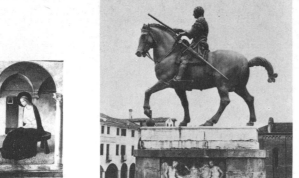

above: *Annunciation*. **Fra Angelico**

above: *Gattamelata Monument*. **Donatello**

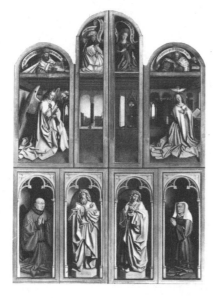

above: *The Tribute Money*. Detail. **Masaccio**

above: *Ghent Altarpiece*. **Jan** and **Hubert van Eyck**

above: *Palazzo Medici*, Florence. Courtyard. **Michelozzo**

1425 **Uccello goes to Venice to work on mosaics in S. Marco.**

1428 Philip the Good acquires Holland, Zeeland and Hainault by Treaty of Delft. **Burgundian embassy to Portugal accompanied by Jan van Eyck.**

1429 Jeanne d'Arc raises seige of Orléans. Charles VII crowned at Reims. Henry VI crowned at Westminster. Guarino summoned to d'Este court at Ferrara.

1430 Salonika falls to the Turks. **1430–2, Donatello visiting Rome. Masolino goes to Rome c. 1430.**

1431 German peasant revolt near Worms. 1431–49, Council of Basle; reforms decreed. 1431–47, Pope Eugenius IV. **Alberti goes to Rome, enrols in Papal service. Spanish court painter Dalmau visits Bruges, sent by King of Aragon. 1431–2, Pisanello completing Gentile da Fabriano's frescos in the Lateran Basilica, Rome (destroyed).**

1433 Sigismund crowned Emperor by Pope Eugenius IV. **Filarete arrives in Rome. Brunelleschi returns to Rome to study Antiquity.**

1434 Revolt in Rome. Pope moves to Florence. 1434–64, Cosimo de'Medici, founder of Medici rule in Florence. **Fra Filippo Lippi in Padua. Witz enters the Guild at Basle.**

1435 Peace of Arras between Charles VII and Duke of Burgundy. **Alberti's *Treatise on the Art of Painting*, contains painter's guide to perspective. Weyden appointed city painter in Brussels.**

1438 Pragmatic sanction at Bourges. Albert V of Austria elected King. 1433–81, King Alfonso V of Aragon.

1439 Council of Basle deposes Eugenius IV. **Huerta succeeds Werve as sculptor to the Burgundian court. 1439–45, *Scenes from Life of Virgin* by Domenico Veneziano (died 1461). assisted by Piero della Francesca (*c.* 1410/20–92) in S. Egidio, Florence (work disappeared).**

1440 Frederick III elected German King. Gutenberg invents a printing press with movable type. Platonic Academy formed at Florence. **Pisanello in Milan.**

1441 **Venetian painter Jacopo Bellini (1400–1470/1) wins competition with his portrait of Lionello d'Este of Ferrara.**

1442 Alfonso of Aragon drives Angevins from southern Italy. Foundation of humanist-dominated University of Ferrara. 1442–71, King René of Anjou holds court at Angers. **1442–51, Stephan Lochner painting in Cologne.**

1443 **Donatello arrives in Padua. French painter Fouquet visits Italy *c.* 1433–7, paints portrait of Eugenius IV (disappeared).**

1444 Laurentian Library, Florence, founded. **Painter Castagno (*c.* 1421–57) returns to Florence and designs stained glass window for the Cathedral.**

1445 Diaz discovers Cape Verde. Henry VI of England marries Margaret of Anjou. **Uccello paints *Giants* (lost) in Padua.**

c. 1446 **Fra Angelico leaves Florence for Rome; paints frescos in Chapel of Nicholas V assisted by Gozzoli (*c.* 1420–97) and others.**

1447–55 Pope Nicholas *V*. Ghiberti's *Commentari c.* 1447. **1447–55, Alberti acting as Papal Inspector of Monuments.**

1448 Frederick of Brandenburg makes Berlin his capital. **1448–56, Mantegna (*c.* 1431–1506) painting frescos in Padua. 1448/9 Pisanello makes set of medals for Alfonso of Aragon in Naples.**

ITALY

1452 *Bartolini Tondo* by **Fra Filippo Lippi** (c. 1406–69), Palazzo Pitti, Florence; Virgin and Child by painter earlier influenced by Masaccio.

c. 1452–4 *Story of the True Cross* by **Piero della Francesca** (1410/20–92), S. Francesco, Arezzo; fresco scenes of monumental simplicity and sophisticated composition.

1459 *Procession of the Magi* by **Gozzoli** (1420–97), Palazzo Medici, Florence; detailed, decorative continuous frieze.

c. 1465 *Portraits of the Duke and Duchess of Urbino* by **Piero della Francesca**, Uffizi, Florence; diptych in clear calm manner reflecting Flemish influence.

1470 *Ecce Homo* by **Antonello da Messina** (c. 1430–79), Metropolitan Museum of Art, New York; only securely dated work of painter influenced by Northern oil painting technique.

1474 *Arrival of Cardinal Francesco Gonzaga* by **Mantegna** (1431–1506), Camera degli Sposi, Palazzo Ducale, Mantua; earliest illusionistic frescos of the Renaissance; work of very important northern Italian painter.

1458 *Palazzo Pitti*, Florence, begun; colossal palace for Luca Pitti, later enlarged.

1460–2 *Pienza Cathedral* rebuilt by **Bernardo Rossellino** (1409–64); unique Italian hall church commissioned by Pope Pius II.

1468–72 *Cortile of Palazzo Ducale*, Urbino, by **Luciano Laurana** (c. 1420–79); elegant courtyard, part of complex palace built by several architects.

1470 *Sant'Andrea*, Mantua, designed by **Alberti** (1404–72); bold, imaginative adaptation of classical forms in ducal church; anticipates High Renaissance.

1470–3 *Cappella Colleoni*, Bergamo by **Amadeo** (1447–1522); first example of architect's extraordinary decorative work.

1474–86 *Faenza Cathedral* by **Giuliano da Maiano** (1432–90); Early Renaissance masterpiece.

1453 *Piero de'Medici* by **Mino da Fiesole** (1429–84), Bargello, Florence; inscribed portrait bust in minutely realistic style.

1457–60 *Judith and Holofernes* by **Donatello** (1386–1466), Piazza della Signoria, Florence; free-standing bronze invested with allegorical significance.

c. 1461 *Altar of the Sacrament* by **Desiderio da Settignano** (c. 1430–64), San Lorenzo, Florence; delicate low-relief work.

1465–71 *Sculpture of Triumphal Arch,* Castel Nuovo, Naples completed by **Pietro da Milano** (died 1473); huge enterprise by several sculptors.

c. 1470 *Hercules and Antaeus* by **Antonio Pollaiuolo** (1431/2–98), Bargello, Florence; small, struggling muscular figures in bronze.

c. 1473 *David* by **Verrocchio** (1435–88), Bargello, Florence; graceful bronze statue made for the Medici family.

FRANCE AND SPAIN

1453–4 *Coronation of the Virgin* by **Charonton** (c. 1410–post 1462), Villeneuve-les-Avignon Museum; work executed to detailed commission.

1457 *Le Coeur d'Amour Épris* completed, Nationalbibliothek, Vienna; copy of allegorical novel by King René, with miniatures.

c. 1460 *Avignon Pietà*, Louvre, Paris; work of great pathos in stark style.

c. 1465–7 *St Vincent panels* by **Gonçalves** (died 1478), National Museum, Lisbon; important surviving work by major Portuguese painter of the century.

c. 1470–5 *Pietà Nouans* by **Fouquet**, Nouans parish church; one of the last works of King's painter influenced by visit to Italy.

1460 *West Front*, Toul Cathedral; most important façade of the period in France; designed by **Tristan de Hâttonchâtel**.

1461–83 *Palacio del Infantado*, Guadalajara, by **Juan Guas** (died 1496); secular building in vigorous Gothic style.

1463–72 *Plessis-les-Tours* built for Louis XI (1465–70); no longer a fortified royal country house.

1451–4 *Entombment* by the **Sonnette brothers**, Chapel of the former Hospital, Tonnerre; theatrical almost life-size group.

1458 *Alonso de Velasco* by **Egas Cueman**, Guadalupe Abbey; alabaster portrait figure of Netherlandish character, originally highly coloured.

post 1465 *Tree of Jesse* by **Juan Aleman**, Puerta de los Leones, Toledo; early example of graphic Lower Rhenish style of sculpture.

NORTH AND CENTRAL EUROPE

1460 *Francesco d'Este* by **Weyden** (1399–1464), Metropolitan Museum of Art, New York; portrait of Italian prince educated at the Burgundian court in Brussels.

1462 *Altarpiece of St Elizabeth* by **Pleydenwurff** (c. 1420–72), Breslau; strongly Flemish work by chief artist of the time in Nuremberg.

1464–7 *Altar of the Five Mystic Meals* by **Bouts** (c. 1415–75), S.-Pierre, Louvain; theme dictated by two professors of theology.

1467–9 *Crucifixion Triptych* by **Joost van Ghent** (c. 1435–75), S.-Bavon, Ghent; unusual work, parts unified by perspective.

1466–88 *Frauenkirche*, Munich; brick church built by **Ganghofer**, the design approved by a committee whose members included Konrad Roritzer of Regensburg.

1471 *Albrechtsburg*, Meissen, designed by **Master Arnold of Westphalia**; rich example of variety and irregularity in Late Gothic.

c. 1450 *Tabernacle of Matthaeus de Layens*, S.-Pierre, Louvain; carved stone scenes influenced by Weyden.

1460 *Archbishop Dietrich von Moers* by **Konrad Kuyn** (died 1469), Cologne Cathedral; monument with figures full of movement, without usual architectural framework.

1467 *Sandstone Crucifix* by **Gerhaert** (died 1473), Old Cemetery, Baden-Baden; last important work of prolific sculptor.

1469–74 *Choir Stalls*, Ulm Cathedral, by **Syrlin the Elder** (died 1492); vast programme in vigorous style.

1471–81 *Coronation of the Virgin* by **Pacher** (1435–98), St Wolfgang, Salzkammergut; painted wooden altarpiece by foremost Late Gothic sculptor in Austria.

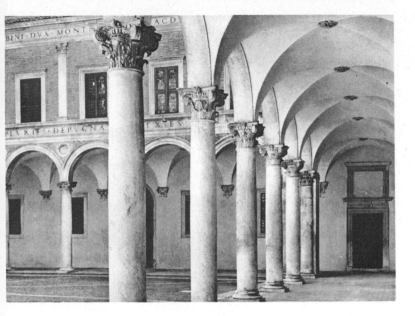

above: *Cortile of Palazzo Ducale*. **Luciano Laurana**

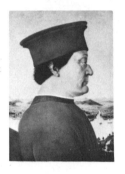 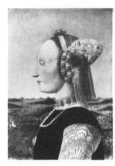

left: *Portraits of the Duke and Duchess of Urbino*. **Piero della Francesca**

below: *David*. **Verrocchio**

below: *Sculpture of Triumphal Arch*, Naples. **Pietro da Milano**

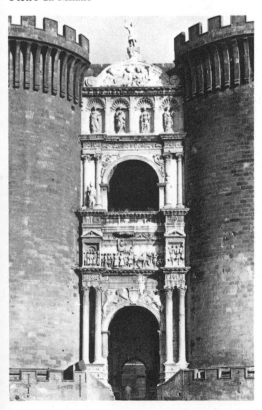

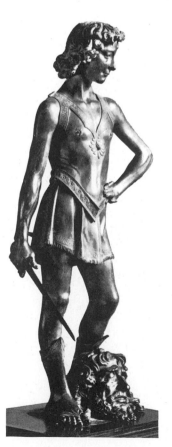

1450 Papal Jubilee. Pope Nicholas V creates the Vatican Library. Francesco Sforza enters Milan, takes title of Duke. **Alberti's architectural treatise, *De Re Aedificatoria*. Weyden visits Italy.**

1451 French financier Jacques Coeur disgraced. 1451–81, reign of Mohammed II, period of great Muslim expansion. Manetti's *On the Dignity and Excellence of Man*. **Bernardo Rossellino appointed Papal architect. Piero della Francesca working in Rimini for Sigismondo Malatesta.**

1452 Frederick III crowned Emperor. **Pietro da Milano summoned to Naples by Alfonso of Aragon. Fra Angelico (1387–1455) returns to Rome *c*. 1452 to paint Chapel of the Sacraments (destroyed).**

1453 Ottoman Turks capture Constantinople. Bordeaux surrenders to the French.

1455 **Earliest documented work of Jaime Huguet (died 1492), painting destroyed in 1909. Uccello (1397–1475) employed by the Medici *c*. 1455.**

1456 *Gutenberg Bible* printed.

1457 **Donatello goes to Siena. Venetian painter Carlo Crivelli (died 1495/1500) imprisoned for adultery.**

1458–64 Pope Pius II. **1458–89, Simon Marmion, painter, living in Valenciennes.**

1459 **Mantegna becomes court painter to Ludovico Gonzaga at Mantua.**

1461 Edward of York wins Battle of Mortimer's Cross; crowned Edward IV. Trebizond falls to the Turks. St Catherine of Siena canonized. 1461–83, King Louis XI.

1461 **Sculptor Francesco Laurana active in South of France. French painter Nicolas Froment (1425–83/6) working in or near Florence.**

1463 **Sculptor Gerhaert van Leyden summoned to Vienna by Frederick III.**

1464–71 Pope Paul II.

1465–1508 Albert the Wise, Duke of Bavaria. **1465, Flemish painter Memling becomes a Free Mason in Bruges.**

1467 Charles the Bold succeeds Philip the Good of Burgundy. **Gozzoli painting Old Testament fresco cycle (badly damaged) in the Campo Santo, Pisa.**

1468 Marriage of Duke of Burgundy and Margaret of York; **pageant designed by Hugo van der Goes (*c*. 1440–82), several other artists involved.**

1469 Ferdinand of Aragon marries Isabella of Castile.

1469–92 Rule of Lorenzo de'Medici, the Magnificent, in Florence.

c. 1470 **Austrian woodcarver and painter Pacher (1435–98) visits Padua.**

1471–84 Pope Sixtus IV. 1471–85 King René of Anjou holds court at Aix-en-Provence.

1472 Newfoundland discovered. Dante's *La Divina Commedia* first printed, at Foligno.

1473–4 **Flemish painter Joost van Ghent working for Duke Federigo da Montefeltro in Urbino.**

1474 Hapsburgs recognize independence of Swiss League. Caxton prints the first book in English, *Histories of Troy*, at Bruges.

ITALY

1475 *Martyrdom of St Sebastian* by **Antonio Pollaiuolo** (1431/2–98) and **Piero Pollaiuolo** (c. 1441–96), National Gallery, London; studied composition of figures in linear style.
1481 *Adoration of the Magi* by **Leonardo da Vinci** (1452–1519), Uffizi, Florence, left unfinished at early stage; important achievement in composition by great intellectual artist.
1481 *Giving of Keys to St Peter* by **Perugino** (c. 1445–1523), Sistine Chapel, Vatican Palace; fresco scene in artist's elegant, gentle manner.
1485–90 *Life of the Virgin*, Strozzi Chapel, S. Maria Novella, Florence by **Ghirlandaio** (1449–94); major fresco cycle by popular painter.
1488 *Triptych for S. Maria dei Frari* by **Giovanni Bellini** (c. 1430–1516), Accademia, Venice; mature work in softened restrained style by foremost Venetian painter of the century.
1494 *Calumny of Apelles* by **Botticelli** (1445–1510), Uffizi, Florence; illustration of classical text in artist's later, harshly linear style.
1495–7 *Last Supper* by **Leonardo da Vinci**, S. Maria delle Grazie, Milan; unsuccessful variation of fresco technique; refined monumental High Renaissance composition.

1480–5 *Villa Medici*, Poggio a Caiano, by **Giuliano da Sangallo** (1445–1516); earliest example of new humanist villa.
1481–9 *S. Maria dei Miracoli*, Venice, by **Lombardo** (c. 1435–1515); marble-panelled church with coffered barrel-vault and Byzantine dome.
1484 *Madonna del Calcinaio*, Cortona, begun by **Francesco di Giorgio Martini** (1439–1501/2); important development of Latin cross design, barrel-vaulted with recessed semi-circular chapels.
1484 *S. Maria delle Carceri*, Prato, begun by **Giuliano da Sangallo**; centrally-planned votive church for Lorenzo de Medici.
c. 1486 *Palazzo Venezia*, Rome, begun; influential residence, architect not certainly identified.
post 1493 *Chancel of S. Maria delle Grazie*, Milan, by **Bramante** (1444–1514); memorial chapel ordered by Ludovico il Moro, built by the first great High Renaissance architect.

c. 1480 *Adoration* by **Andrea della Robbia** (1435–1525), Chiesa Maggiore, La Verna; influential large-scale glazed terracotta work.
c. 1481–96 *Equestrian Monument to Bartolommeo Colleoni* by **Verrocchio** (1435–88), Campo SS. Giovanni e Paolo, Venice; famous bronze, model sent to Venice in 1481.
c. 1485? *Lamentation* by **Niccolò dell'Arca** (1435–94), S. Maria della Vita, Bologna; intensely expressive figures in painted terracotta.
1485–90 *Corbinelli Altar* by **Andrea Sansovino** (c. 1467–1529), S. Spirito, Florence; major work of Florentine sculptor.
1496/7 *Bacchus* by **Michelangelo** (1475–1564), Bargello, Florence; first major work of greatest High Renaissance sculptor.
c. 1498–1500 *Pietà* by **Michelangelo**, St Peter's, Rome; highly finished marble masterpiece.

FRANCE AND SPAIN

1476 *Virgin of the Burning Bush Altarpiece* completed by **Froment** (1425–83/6), Aix-en-Provence Cathedral; every detail has symbolic meaning.
1490 *Pietà of Canon Luis Desplà* by **Bermejo**, Barcelona Cathedral; work by one of the first Spanish painters in oil.
1498/9 *Virgin with Donors* by **Master of Moulins**, Moulins Cathedral, principal work of major artist.

c. 1481–1500 *Tour de Beurre* begun, Rouen Cathedral; extremely ornate flamboyant Gothic tower.
1482–94 *Capilla del Condestable* by **Simon de Colonia** (died pre 1515), Burgos Cathedral; late Gothic octagonal chapel with star vault.
1488 *West Front*, S.-Wulfran Abbéville begun; façade in advanced flamboyant style.
1498 *Hôtel de Cluny*, Paris, begun; built for Abbot of Cluny, with small lierne-vaulted chapel.

1489–93 *Monument to the Infante Alfonso* by **Gil de Siloe**, Cartuja de Miraflores, Burgos; splendid alabaster tomb in German-influenced realistic style.
c. 1493 *Funerary Monument of Philippe le Pot*, Louvre, Paris; work in new spirit of extreme realism, with huge black-robed weepers bearing tomb slab.
1496 *Entombment*, Solesmes; earliest evidence of influence of Italian Renaissance style in French Late Gothic sculpture.

NORTH AND CENTRAL EUROPE

c. 1475 *Portinari Altarpiece* by **Goes** (c. 1440–82), Uffizi, Florence; immense influential masterpiece commissioned for the Medici.
1475 *Madonna of the Rosebower* by **Schongauer** (c. 1435–91), St Martin, Colmar; only dated work of important German painter and engraver.
c. 1483 *Brixen Altarpiece* by **Pacher** (1435–98), Alte Pinakothek, Munich; forcefully naturalistic painting by leading Austrian artist.
1485 *Garden of Delights* by **Bosch** (c. 1450–1516), Prado, Madrid; work of extremely strange and fantastic iconography.
1489 *Shrine of St Ursula* by **Memling** (died 1494), Hôpital S.-Jean, Bruges, dedicated; huge casket with scenes by Flemish painter.
1498 *Self-Portrait* by **Dürer** (1471–1528), Prado, Madrid; famous work of brilliant German painter and engraver influenced by visit to Italy; detailed linear style.

1478 *Nave of S. Jan* in 's-Hertogenbosch begun by **Duhameel** (1449–1509); ornate Gothic design unusual in northern Netherlandish architecture.
1481 *St George's Chapel*, Windsor, begun; Perpendicular lierne-vaulted chapel completed under Henry VII.
1493–1502 *Vladislav Hall*, Hradcany, Prague, by **Benedict Rejt**; huge hall with early double-curved ribbed vault.
1499 *St Anne*, Annenburg, begun; most important of churches with double-curved rib vaulting.

1475–7 *Altar of the Virgin* by **Wesel** (c. 1420–c. 1500) Rijksmuseum, Amsterdam; important example of northern Netherlandish work, wings painted by **Bosch** (c. 1450–1516).
1477–89 *High Altar* by **Veit Stoss** (1438/47–1533), St Mary, Cracow; huge dramatic painted work.
c. 1489 *Altar of St George* completed, by **Notke** (1440–1509), Storkyrka, Stockholm; magnificent ensemble erected by Swedish Regent.
1491–3 *Adam and Eve* by **Riemenschneider**, Mainfränkisches Museum, Würzburg; sandstone figures of great sensitivity, carved for the Marienkapelle.
c. 1493 *Altar of St George*, Louvain, by **Borman the Elder**, Musées Royaux d'Art et d'Histoire, Brussels; earliest known work of outstanding Belgian wood-carver.
1493 *Tabernacle* by **Krafft** (died c. 1509), S. Lorenz, Nuremberg; towering Late Gothic shrine.

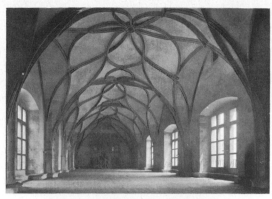

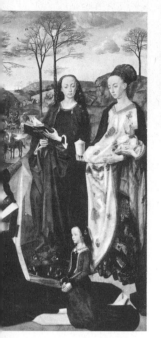

above: *Portinari Altarpiece*.
Detail. **Goes**

above right: *Vladislav Hall*, Prague.
Interior. **Benedict Rejt**

right: *Lamentation*. Detail. **Niccolò
dell'Arca**

below: *Last Supper*. **Leonardo da Vinci**

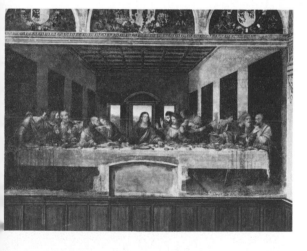

below: *St George's Chapel*, Windsor

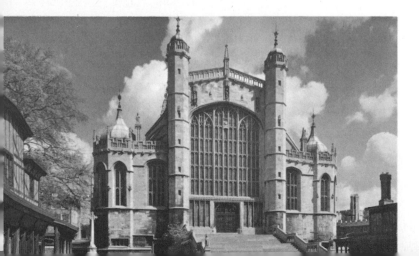

1475 **Jean Clouet I, painter to the Duke of Burgundy, comes from Flanders to France. Hugo van der Goes enters an Augustinian monastery near Brussels** *c.* **1475**. **1475/6 Antonello da Messina** (*c.* 1430–79) **in Venice.**

1477 Louis seizes Burgundy and Artois. **Spanish painter Pedro Berruguete** (*c.* 1450–1503) **working in Urbino.**

1479 **Gentile Bellini** (1429/30–1507) **in Constantinople, paints Sultan's portrait. 1479–93, Gallego** (1440/5–post 1507) **painting ceiling in University of Salamanca (fragments survive).**

1480 Ludovico Sforza, il Moro, Regent in Milan.

1481–3 **Botticelli, Ghirlandaio, Perugino, Signorelli** (*c.* 1441/50–1523) **painting frescos in the Sistine Chapel, Rome for Pope Sixtus IV** (1471–84).

pre 1482 *De Prospectiva Pingendi* by Piero della Francesca.

1482 Peace of Arras; Burgundy is divided by King Louis XI and Emperor Maximilian. War between Alfonso of Naples, Ferrara, Venice and the Pope. *c.* **1482 Francesco di Giorgio Martini's** *Trattato di Architettura Civile e Militare.*

1483 Edward V of England succeeds Edward IV; Richard III seizes the throne. 1483–98, Charles VIII of France. Caxton prints the *Golden Legend* by Jacobus de Voragine. **Leonardo da Vinci in Milan.**

1484–92 Pope Innocent VIII. **1484, Bourdichon** (*c.* 1457–1521) **appointed court painter to Charles VIII.**

1485 Richard III defeated and killed at Bosworth; Henry VII reigns, 1485–1509. Caxton prints Malory's *Morte d'Arthur. Danse Macabre* **with woodcuts published in Paris.**

1486 Henry VII marries Elizabeth of York. 1486–1525, Frederick the Wise, Elector of Saxony. French composer Josquin des Prés joins papal chapel in Rome. *Book on Masonry* **by Matthaus Roritzer published.**

1487–1502 **Filippino Lippi** (1457/8–1504) **painting Strozzi Chapel, S. Maria Novella, Florence.**

1488 Flemish towns revolt against Archduke Maximilian. **Mantegna** (1431–1506) **in Rome. Gerard David** (died 1523) **summoned to decorate cell of imprisoned Archduke Maximilian.**

1491 *Schatzbehalter* and Schedel's *Weltchronik* **(1491–3) published with woodcuts by Wolgemut** (1434–1519). **Massys working in Antwerp. Andrea Sansovino in Portugal.**

1492 Columbus discovers San Salvador. Spaniards take Granada from the Moors. 1492–1503, Pope Alexander VI.

1492 **Pinturicchio** (*c.* 1454–1513) **begins decorating the Borgia apartments in the Vatican.**

1493–1519 Emperor Maximilian I.

1494 Spain and Portugal divide the New World. Charles VIII of France invades Italy. Medici expelled from Florence. *Ship of Fools* by Sebastian Brant published. **1494–5, Dürer visiting Italy.**

1495 Charles VIII enters Naples and leaves Italy. Diet of Worms proclaims Perpetual Peace. 1495–1521, Manuel I of Portugal.

1496 **Michelangelo leaves Florence for Rome.**

1499 Amerigo Vespucci and Alonso Hojeda discover Venezuela and Guiana. French expel Ludovico Sforza from Milan. **Signorelli commissioned to complete frescos in Orvieto begun by Fra Angelico** (1387–1455). **Leonardo da Vinci leaves Milan for Florence.**

	Key works: PAINTING	Key works: ARCHITECTURE	Key works: SCULPTURE
ITALY	*c.* 1501 *The Doge Loredano* by **Gentile Bellini** (*c.* 1429/30–1507), National Gallery, London; finest portrait by great Venetian painter. *c.* 1503 *The Mona Lisa* by **Leonardo da Vinci** (1452–1519), Louvre, Paris; portrait imbued with great mystery. 1508 *Sistine Chapel* ceiling frescos by **Michelangelo**, commissioned; heroic achievement; completed unassisted by 1512. 1509 *Disputa, School of Athens, Parnassus and Law*, frescos in the Vatican by **Raphael** (1483–1520); the first of the Stanze of Julius II. 1517 *Madonna of the Harpies*, Uffizi, Florence, by **Andrea del Sarto** (1486–1521); masterpiece by the foremost painter of the High Renaissance in Florence. 1518 *Assunta*, S. Maria Gloriosa dei Frari, Venice, by **Titian** (1485–1576); unveiled; huge Mannerist work made great impact at the time. 1519 *Pesaro Madonna*, Frari, Venice, by **Titian**, commissioned; radically different presentation of a traditional subject.	1502 *Tempietto, San Pietro in Montorio*, Rome, begun, by **Bramante** (1444–1514); one of the first important monuments of the High Renaissance; inspired by the ancient Roman circular temple. 1503 *Cortile of the Belvedere*, the Vatican, designed by **Bramante**; a huge scheme only partly executed, with dominant antique features. 1506 *St Peter's*, Rome, founded; the original centralized design by **Bramante** commissioned by Julius II, subsequently altered. 1508–11 *Villa Farnesina*, Rome, by **Peruzzi** (1481–1536); an unusual design with central loggia and wings; frescos by major artists. 1517 *Villa Madama*, Rome, planned by **Raphael** (1483–1520); completed parts decorated with grotesques derived from newly discovered Roman models. 1524 *Laurentian Library* commissioned from **Michelangelo** (1475–1564); bold Mannerist design in white and dark grey stone, with sculptural staircase in the vestibule.	1501–4 *David*, marble, Accademia, Florence, by **Michelangelo**; colossal figure of great importance in the development of Renaissance sculpture. 1505 *Tomb of Julius II*, San Pietro, Vincoli, Rome; marble; commissioned from **Michelangelo**; originally conceived as huge free-standing monument. 1519 *Madonna del Parto*, S. Agostino, Rome, completed by **J. Sansovino** (1486–1570); reflects Roman devotion to classical antiquity at this time. 1520–34 *Tomb of Lorenzo de' Medici*, New Sacristy of San Lorenzo, Florence, by **Michelangelo**; marble; although unfinished the Sacristy contains the largest sculptural ensemble completed by Michelangelo.
FRANCE AND SPAIN	*c.* 1500–5 *Portrait of Pierre Sala* by **Perréal**, in *Énigmes*, manuscript of Sala's poems, British Museum, London; outstanding example of Pérreal's style. 1506–11 *Altarpiece for Lamego Cathedral*, Lamego Museum, by **V. Fernandez** (*c.* 1475–1521); artist of Portuguese school of Viseu. 1508 *Hours of Anne of Brittany* by **Bourdichon** (*c.* 1457–1521), Bibliothèque Nationale, Paris; a work with Gothic and Italian elements.	1502–16 *Monastery of the Hieronymites*, Belem, Portugal, by **Boytac** (active 1490–1525?); church and cloister in the richly decorated Manueline style. 1506 *Capilla Real of Granada Cathedral* by **de Egas** (*c.* 1455–1534); early Plateresque chapel for King Ferdinand and Queen Isabella. 1507 *West front of Troyes Cathedral* designed by **Chambiges** (died 1532); late work of Flamboyant Gothic. 1515–24 *Court façade of Château de Blois*; commissioned by Francis I; features a famous spiral staircase. 1519 *Château de Chambord* by **Nepveu** (died 1538), begun; built on vast symmetrical plan. 1519–23 *Escalera Dorada in Burgos Cathedral* by **D. de Siloe** (*c.* 1495–1563); staircase derived from design by Bramante for the Belvedere.	1502–7 *Tomb of Francis II of Brittany*, Nantes Cathedral, designed by **Perréal** (*c.* 1455–1530), executed by **Colombe** (*c.* 1430–1512); essentially Gothic sculpture with Italian ornament. 1515–31 *Funeral Monument of Louis XII*, S.-Denis, Paris, by **G. Giusti** (1485–1549); royal patronage advances the Italian style in France. 1517 *West Portal of church of Belem*, Portugal, by **Chantereine** (active 1517–51); introduces French Renaissance work to Portugal. 1519 *Trascoro of the Choir Screen in Barcelona Cathedral* by **Ordoñez** (*c.* 1490–1520); Italian influence remarkable. 1521 *Altar for the Royal Chapel*, Granada, by **Vigarny** (*c.* 1470–1543); one of first Mannerist works in Spain.
NORTH AND CENTRAL EUROPE	1504 *Adam and Eve* single-plate engraving by **Dürer** (1471–1528); outstanding among artist's many masterpieces. 1511 *Adoration of the Trinity* by **Dürer**, Kunsthistorisches Museum, Vienna; painted for the chapel of a small asylum. 1514 *Henry the Pious of Saxony* by **Cranach the Elder** (1472–1553), Gemäldegalerie, Dresden; sets the fashion for full-length portraits in Europe. 1515 *Isenheim Altarpiece* by **Grünewald** (died 1528), Colmar; depicts intensely emotional religious fantasy. 1516 *Neptune and Amphitrite* signed and dated by **Mabuse** (died *c.* 1533), Staatliche Museen, Berlin; introduces classical mythology in the North as fashionable subject.	1503–19 *Henry VII's Chapel* at Westminster; masterpiece of Perpendicular architecture. 1508–15 *King's College Chapel*, Cambridge completed; one of most imposing Perpendicular monuments. 1515 *Hampton Court* begun for Cardinal Wolsey; influence of the Italian Renaissance confined to ornament.	1507–19 *Shrine of St Sebaldus*, Nuremberg; bronze and wood, by the **Vischer family**; in course of execution Italian ornament was increasingly used. 1508–33 *Family Mausoleum of Emperor Maximilian*, Hofkirche, Innsbruck, bronze; major example of Austrian Renaissance sculpture. 1518 *Funeral Monument of Henry VI* completed by **Torrigiano** (1472–1528), Westminster Abbey, bronze; introduction of pure Renaissance work to England. 1520–23 *Bamberg Altar*, Bamberg Cathedral, by **Veit Stoss** (1438/47–1533); unpainted wood; late Gothic sculpture reflecting influence of Dürer. 1521 *Bordesholm Altarpiece*, Schleswig Cathedral, by **Hans Brüggemann** (*c.* 1480–*c.*1540); gigantic late Gothic carving in ebony.

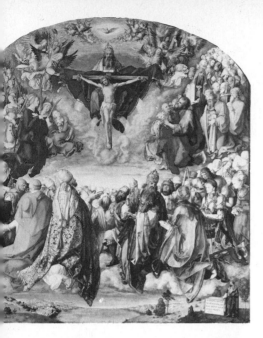

left: *Adoration of the Trinity*. **Dürer**

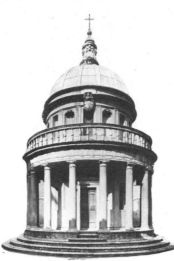

above: *Tempietto, San Pietro in Montorio*. **Bramante**

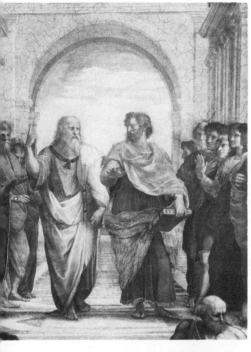

left: *School of Athens*. Detail. **Raphael**

above: *David*. **Michelangelo**

left: *The Mona Lisa*. **Leonardo da Vinci**

1500 Great Jubilee Year announced by Alexander VI. Academy in Venice for Greek studies founded. *Revelations of St Brigitta* published in Nuremberg with woodcuts by Dürer.

1501 French enter Rome. Persecution of Moors in Spain. Erasmus' *Enchiridion Militis Christiani*.

1502 France and Spain at war. Cesare Borgia takes Urbino. Wittenberg University founded. The *Complutensian Polyglot* begun in Spain.

1503 Julius II elected Pope. Nostradamus born.

1504 France cedes Naples to Aragon. John Colet appointed Dean of St Paul's. **Fra Bartolommeo (*c*.1474–*c*.1517) becomes head of San Marco workshop in Florence. Cranach the Elder called to Wittenberg by Frederick the Wise of Saxony. Leonardo at work on the cartoon for the Battle of Anghiari.**

1505 Basil III, Grand Duke of Moscow. **Dürer revisits Italy. Michelangelo completes cartoon for Battle of Cascina (destroyed).**

1506 Pope Julius takes Bologna. Reuchlin's *Rudiments of Hebrew*. Erasmus' *In Praise of Folly*. **Excavation and identification of the Laocoön in Rome.**

1507 Margaret of Austria appointed Governor of the Netherlands. Henry VII appoints Polydore Vergil as historiographer royal. **Warehouse of the German merchants in Venice frescoed externally by Titian and Giorgione.**

1508 Maximilian I assumes title of Emperor. Luther made Professor of Divinity at Wittenberg. Poems by Dunbar printed in Edinburgh. **Mabuse visits Italy. Raphael arrives in Rome c. 1508.**

1509 Henry VII succeeded by Henry VIII. League of Cambrai at war with Venice. *De Divina Proportione* by Pacioli published. Earthquake in Constantinople.

1510 Synod at Tours, called by Louis XII, condemns Julius II. Erasmus made Professor of Greek in Cambridge. **Anatomical studies by Leonardo da Vinci.**

1512 French expelled from Italy. Medicis restored in Florence. Fifth Lateran Council begins.

1513 Leo X becomes Pope. French invade Milan. Treaty of Mechlin made. Scots defeated at Flodden. **Leo X forms sculpture gallery at the Vatican.**

1515 Emperor abdicates, Philip II gains Spanish dominions. Leo X (Medici) enters Florence in triumph. Wolsey made Cardinal. **Raphael appointed Superintendent of Roman Antiquities by Leo X.**

1516 Francis I signs Treaty of Freiburg giving Swiss peace. Erasmus edits the New Testament. *Utopia* of Thomas More printed. *Orlando Furioso* by Ariosto. Machiavelli dedicates *The Prince* to the younger Lorenzo de' Medici. **Leonardo da Vinci leaves Italy for France.**

1517 Protest of Luther against sale of Indulgences.

1518 Peace of London devised by Wolsey. Melanchthon Professor of Greek at Wittenberg. **Andrea del Sarto goes to Fontainebleau on invitation of Francis I.**

1519 Charles of Spain elected Emperor. Zwingli preaching Protestantism in Zurich. Cortes conquers Mexico. First circumnavigation of the world by Magellan.

1521 Diet of Worms, Luther cross-examined.

1524 Spanish surrender Milan to the French. Assembly called at Ratisbon to reform the church. Peasants' rebellion in Southern Germany. **Giulio Romano (1492–1546) goes to Mantua.**

	Key works: PAINTING	Key works: ARCHITECTURE	Key works: SCULPTURE
ITALY	1526–30 *The Assumption*, fresco on dome of Parma Cathedral by **Correggio** (1489/94–1534); created a striking effect of perspective. 1527 *Andrea Odoni*, Royal Collection, Hampton Court, by **Lotto** (*c.* 1480–1556); Odoni, a collector of antiquities, kept this portrait in his bedroom. 1528 *Descent from the Cross*, S. Felicità, Florence, by **Pontormo** (1494–1556); his masterpiece, an early Mannerist work. 1532–4 *The Fall of the Giants*, fresco in the Palazzo del Té by **Giulio Romano** (1492–1546); dramatic presentation of destruction; greatly admired by Vasari. 1535–41 *Last Judgement*, fresco in the Sistine Chapel, by **Michelangelo** (1475–1564), begun; massive composition of nude figures, causes sensation in 1541. *c.* 1535 *La Madonna del Colle Lungo*, Uffizi, Florence, by **Parmigianino** (1503–40); masterpiece of elegant Mannerism. 1545 *Venus, Cupid, Time and Folly*, National Gallery, London, by **Bronzino** (1503–72); sent by Cosimo I de'Medici, Grand Duke of Tuscany, to Francis I. 1548 *The Miracle of the Slave*, Scuola di S. Marco, by **Tintoretto** (1518–94); the work that established the artist's reputation.	1526–41 *Palazzo del Té*, Mantua, by **Romano** (1492/9–1546); great Mannerist work; rejects strictly classical rules of architecture. 1532–6 *Palazzo Massimo alle Colonne*, Rome by **Peruzzi** (1481–1536); unorthodox design with curved façade. 1532 *Library of S. Marco*, Venice, begun by **J. Sansovino** (1486–1570); first large High Renaissance building in Venice; strictly classical. 1534–45 *Palazzo Farnese*, Rome, by **A. Sangallo** (1485–1546); completed by **Michelangelo** (1475–1564); most monumental of Italian Renaissance palaces. 1546 *Basilica at Vicenza* by **Palladio** (1508–80); building that establishes Palladio's reputation, though slowly built.	1534 *Hercules and Cacus*, marble, Piazza della Signoria, Florence, by **Bandinelli** (1493–1560), completed; arouses ridicule because of its lumpy anatomy. 1536 *Fountain of Hercules and Antaeus* executed; designed for the Villa Castello near Florence by **Tribolo** (1500–50); one of two important fountains by the sculptor. 1539 *The Royal Salt*, Kunsthistorisches Museum, Vienna, designed by **Cellini** (1500–71); completed in 1543 for Francis I. 1545–54 *Perseus*, bronze, Loggia dei Lanzi, Florence by **Cellini**; received with popular acclaim.
FRANCE AND SPAIN	*c.* 1525 *Francis I on Horseback*, Louvre, Paris, by **Jean Clouet** (1486–*c.* 1540); attributions to this famous court portraitist are often uncertain. 1533–40 Frescos and stucco reliefs of the *Gallery of Francis I*, Fontainebleau, by **Rosso Fiorentino** (1494–1540); Rosso and Primaticcio (1504/5–70) bring Italian Mannerist painting to France. 1549 *Cardinal Granvella*, Kunsthistorisches Museum, Vienna, by **Moro** (*c.* 1519–76); Moro's work sets the style for European court portraiture.	1527 *Palace of Charles V*, Granada, designed by **Machuca** (died 1550); unique example in Spain of Italian High Renaissance architecture. 1528 *Palace of Fontainebleau* begun; decorated by Mannerist painters summoned from Italy by Francis I. 1528 *Granada Cathedral* begun by **D. de Siloe** (*c.* 1495–1563); important example of the ornate Spanish Plateresque style. 1546 *Square Court, The Louvre*, Paris, begun by **Lescot** (1500/15–78); working with the sculptor Goujon, Lescot developed the French Renaissance Style. 1547 *Château of Anet* begun by **de L'Orme** (*c.* 1515–70); built for Diane de Poitiers, mistress of Henri II.	1526–31 *Tomb of Philibert le Beau of Savoy*, Brou, alabaster, supervised by **Conrad Meit** (1485–1544); one of a number of tombs commissioned by Margaret of Austria. 1537 *Great Portal of St-Michel*, Dijon, completed; dated by inscription. 1543–4 *The Nymph of Fontainebleau* by **Cellini** (1500–71), bronze, Louvre, Paris; produced by Cellini during his second stay in France. 1543–8 *Transfiguration* in Toledo Cathedral, by **Berruguete** (*c.* 1488–1561), alabaster; major work of the most important Spanish sculptor of the century. 1548–59 *Tomb of Francis I*, S-Denis, Paris, by **Bontemps** (died after 1563); one of greatest sculptural ensembles of the period.
NORTH AND CENTRAL EUROPE	1529 *Battle of Alexander the Great and Darius at Issus*, Alte Pinakothek, Munich, by **Altdorfer** (*c.* 1480–1538); dramatic panorama painted for Duke Wilhelm IV of Bavaria. 1533 *The Ambassadors*, National Gallery, London, by **Holbein** (1497–1543); double portrait which includes a perspective puzzle. 1532 *Portrait of Charles V*, Kunsthistorisches Museum, Vienna, by **Seisenegger** (1505–68); sent to Titian by the Emperor as a model for another portrait.	1527 *Portia Palace*, Spittal, begun; one of few Italianate palaces in Austria. 1531–1612 *Heidelberg Castle* built for the Elector Palatine, Frederick II; Flemish craftsmen produced the lavish classically inspired ornament. 1535–7 *The Greffe, Bruges* built; building of mixed traditional and Renaissance motifs; features a magnificent chimney-piece. 1536 *Palace of Landshut*; most purely Italian building in Germany at the time.	1525–30 *Virgin and Child*, marble, SS. Michel et Gudule, Brussels, by **Conrad Meit** (1485–1544); work commissioned by the Flemish sculptor's patroness, Margaret of Austria. 1532 *Apollo Fountain*, bronze, Pellerhaus, Nuremberg, by **Flötner** (*c.* 1485–1546); prolific sculptor in Italianate style. *c.* 1546–7 *Resurrection*, alabaster, Collégiale de S. Waudru, Mons, by **de Broeucq** (1505–84); signed relief, fragment of partly destroyed masterpiece.

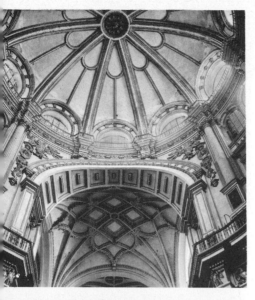

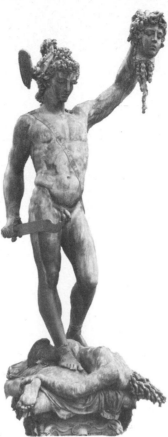

left: *Granada Cathedral*. Interior. **Diego de Siloe**

above: *Perseus*. **Cellini**

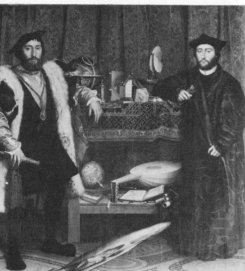

left: *The Ambassadors*. **Holbein**

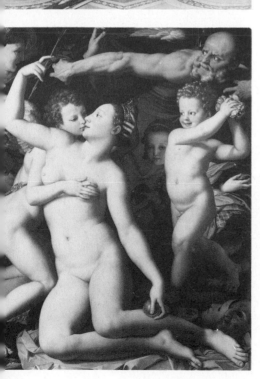

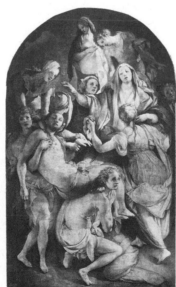

above: *Descent from the Cross*. **Pontormo**

left: *Venus, Cupid, Time and Folly*. **Bronzino**

1525 Francis I captured at the Battle of Pavia.

1526 **Holbein visits England.**

1527 Sack of Rome by armies of Charles V. Republic in Florence restored. **Andrea Sansovino (c. 1467–1529) goes to Venice.** *Il Cortegiano* by Castiglione (1478–1529) published by A. Manutius.

1528 **Dürer (1471–1528) *Four Books on Human Proportions* published.**

1529 The siege of Florence; the Medici restored.

1530 Melanchthon's *Apologia*. **Rosso Fiorentino arrives at Fontainebleau, first important Italian artist at French court.**

1531 Henry VIII recognized as supreme head of the English Church.

1532 Pizarro begins conquest of Peru. **Primaticcio arrives at Fontainebleau.**

1533–84. Ivan the Terrible of Russia.

1534 Pope Paul III (Farnese) succeeds Clement VII. The Jesuit Order founded by Loyola (1491–1556). *Gargantua* by Rabelais. **Michelangelo returns to Rome.**

1535 Charles V occupies Milan. Thomas More (1478–1535) beheaded.

1536 Erasmus dies.

1537 Murder of Alessandro de' Medici. Reign of Cosimo (1537–74). Guicciardini's *History of Italy* (1537–40). **Books III and IV of *L'Architettura* by Serlio. Cellini visits France.**

1538 Henry VIII's palace at Nonesuch (destroyed) begun. Destruction of Becket's shrine at Canterbury during outburst of anti-papal iconoclasm. *Dance of Death* first published, in Latin and French.

1540 Thomas Cromwell beheaded. *Orazia*, a comedy, by Aretino. **Paris Bordone (1500–71) visits German court at Augsburg. Cellini in France 1540–45.**

1541 Calvin (1509–64) organizes church in Geneva. Tallis enters Chapel Royal. **Serlio appointed Painter and Architect at Fontainebleau.**

1542 Imperial expedition against Turks fails. 1542–52, mission of Xavier to Japan.

1543 Copernicus, *De Revolutionibus Orbium Celestium*. *De Corporis Humani Fabrica* by Vesalius.

1544 English invade Scotland. Neri founds Congregation of the Oratory.

1545–63 Council of Trent.

1546 Scottish revolt against Rome. Luther dies.

1547 Death of Francis I; accession of Henri II. **De L'Orme appointed official architect to French court. Somerset House, the Strand begun.**

1548 Loyola's *Spiritual Exercises* published. **Titian visits Imperial Court at Augsburg.**

1549 First Prayer Book of Edward VI. Henri II enters Paris in triumph.

ITALY

Key works: PAINTING

1553 *Venus and Adonis* by **Titian** (*c*.1485–1576), Prado, Madrid; one of a mythological series for Philip II

1564 Series depicting the *Life of the Virgin, Life of Christ,* and *Scenes of the Passion* begun by **Tintoretto** (1518–94) for the Scuola di S. Rocco; completed 1587.

1565 *Alexander and the Family of Darius* by **Veronese** (*c*. 1528–88), National Gallery, London; painted for the Pisani family.

1570–3 Decoration of the *Studiolo of Francesco I,* Palazzo Vecchio, by **Vasari** (1511–74); scheme devised by the scholar Borghini.

1573 *The Feast in the House of Levi* by **Veronese**, Accademia, Venice; criticized by the Inquisition for intrusion of everyday details in a religious work.

Key works: ARCHITECTURE

1551–5 *Villa di Papa Giulio,* Rome, by **Vignola** (1507–73); elaborate complex with courts and gardens, and heavily rusticated triumphal arch; built for Julius III.

1558–62 *Casino of Pius IV,* Vatican Gardens, by **Ligorio** (*c*. 1500–83); elegant Mannerist folly by architect of Villa d'Este.

1558–60 *Dome of St Peter's,* Rome, designed by **Michelangelo** (1475–1564); altered and completed by **della Porta** (*c*. 1537–1602).

1560 *Uffizi,* Offices of the Grand Duchy, Florence, begun, by **Vasari** (1511–74); his outstanding architectural creation.

1550 *Villa Rotunda* near Vicenza, by **Palladio** (1508–80); most famous of his villas; symmetrical on both axes.

1568 *Il Gesù,* Rome, Jesuit church, begun by **Vignola** and **della Porta**; both plan and façade of great influence.

Key works: SCULPTURE

1554–67 *Mars and Neptune* by **J. Sansovino** (1486–1570), Doge's Palace, Venice; earliest gigantic statues in Venice, commissioned by the Senate.

1560–3 *Tomb of Gian Giacomo de' Medici,* Milan Cathedral, by **Leone Leoni** (1509–90); influence of Michelangelo clear.

1564 *Rondanini Pietà* by **Michelangelo** (1475–1564), Castello, Milan; intensely emotional work; unfinished at artist's death.

1567 *Neptune Fountain,* Bologna, completed by **Giambologna** (1529–1608); an advanced design, the first of a series of fountains.

c. 1569 *St Jerome* by **Vittoria** (1525–1608), Chiesa dei Frari, Venice; marble; his best-known work.

FRANCE AND SPAIN

Key works: PAINTING

c. 1550 *Eva Prima Pandora* by **Cousin the Elder** (*c*. 1490–*c*. 1561), Louvre, Paris; perhaps first great female nude of School of Fontainebleau.

*c.*1550 *Diana the Huntress,* artist unknown of School of Fontainebleau, Louvre, Paris; nude, possibly portrait of Henri II's mistress, Diane de Poitiers.

1554 *Queen Mary Tudor* by **Moro** (*c*. 1519–76), Prado, Madrid; painted for Philip II of Spain to celebrate their marriage.

1560 *Eurydice and Aristaeus* by **dell'Abbate** (*c*. 1512–71), National Gallery, London; large mythological landscape by leading artist of School of Fontainebleau.

1561 *Pierre Quthe* by **F. Clouet** (1510–72), Louvre, Paris; earliest signed and dated work of Court Painter.

1571 *Anne of Austria* by **Sánchez Coello** (1531/2–88), Kunsthistorisches Museum, Vienna; principal portraitist of Philip II of Spain.

Key works: ARCHITECTURE

1557 *Cloister of the Cristo Monastery,* Tomar, by **de Torralva** (1500–66); important example of High Renaissance work in Portugal.

1563 *The Escorial* designed by **de Toledo** (died 1567), completed by **de Herrera** by 1584; built by Philip II in gratitude to St Lawrence for his victory at St Quentin.

1569 *Palace of Aranjuez* by **de Herrera** (*c*.1530–97); best example of his majestic Italianate style.

1572 *Town Hall,* Arras; typical example of crowded decorative effects urrent in France.

Key works: SCULPTURE

1550–1 *Caryatids* supporting a musicians' gallery in the Salle of the Louvre, by **Goujon** (*c*. 1510–64/8); influence of classical sculpture well assimilated.

1557 *Altarpiece in Chapel of the Benavente,* S. Maria, Medina de Rioseco, by **Juan de Juni** (*c*. 1507–77); strongly expressive work in polychrome.

1560–3 *Three Graces,* marble, Louvre, Paris, by **Pilon** (*c*. 1530–90); from the monument to the heart of Henri II.

NORTH AND CENTRAL EUROPE

Key works: PAINTING

1550 *Feast of the Gods,* Musée des Beaux-Arts, Antwerp, by **Frans Floris** (1516–70); Ovidian myth by leading exponent of mannerism in Flanders.

1550 *Portrait of Sir John Luttrell,* Courtauld Institute Galleries, London, by **Hans Eworth** (active 1545/9–75); one of his earliest dated pictures; a fantastic allegory.

1551 *Butcher's Shop* by **Aertsen** (1508/9–75), Uppsala University; genre scene with the Flight into Egypt in the background.

1563 *The Tower of Babel* by **Bruegel the Elder** (*c*. 1525/30–69), Kunsthistorisches Museum, Vienna; one of earliest of Bruegel's moralizing pictures.

*c.*1567–8 *Wedding Feast* by **Bruegel the Elder,** Kunsthistorisches Museum, Vienna; famous example of increasingly popular subject.

Key works: ARCHITECTURE

1555–60 *Cathedral of St Basil, Moscow*; an original plan comprising several sanctuaries, built by Russian architects.

1561–5 *Town Hall,* Antwerp, by **C. Floris** (1514–75); conceived as a Roman palace; its richness reflects Flemish prosperity.

1569–71 *Antiquarium,* Munich, commissioned by Albert V, Elector of Bavaria; built for his collections.

1569 *Town Hall,* Cologne, by **Vernuken** (died 1607); a classical arcaded loggia was added to the Hall, and the façade walls decorated with a sort of strapwork.

1572 *Longleat House,* England, by **Smythson** (*c*. 1536–1614); one of most regular and purely classical Elizabethan buildings.

Key works: SCULPTURE

1550–2 *Tabernacle of St Leonard,* Léau, marble, by **C. Floris** (1514–75); ten-storey spire bearing statues and reliefs.

c. 1561 Marble reliefs for *Tomb of Maximilian,* Hofkirche, Innsbruck by **Colin** (1527–1612); events of the Emperor's life depicted.

1569 *Figure of St Bartholomew*(?), bronze, by **van den Broecke,** called Paludanus (1530–80), Kunsthistorisches Museum, Vienna; flayed nude shows masculature.

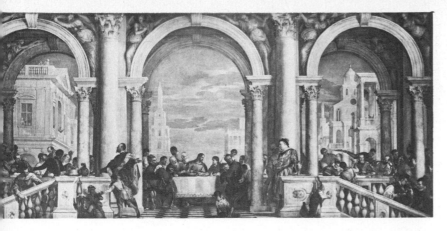

above: *The Feast in the House of Levi*. **Veronese**

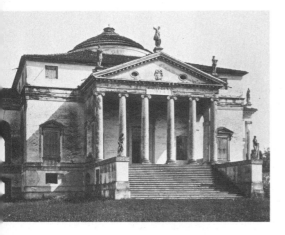

above: *Villa Rotunda*, near Vicenza. **Palladio**

right: *St Jerome*. **Vittoria**

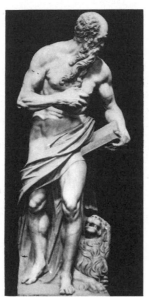

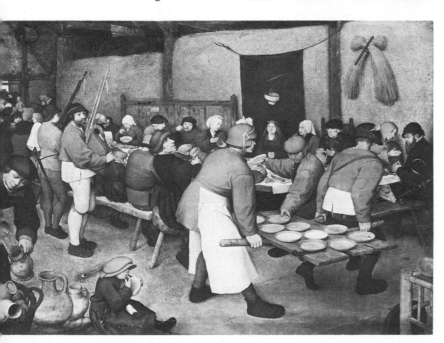

Wedding Feast. **Bruegel the Elder**

1550 Pope Julius III elected. England cedes Boulogne to France. **First edition of *Lives of the Painters* by Vasari (1511–74).**

1551 Edict of Châteaubriand issued against Calvinism in France. Palestrina (1526–94) appointed Director of Music at St Peter's, Rome.

1552 Battle of Kazan ends Mongol domination of Russia. *Amours* by Ronsard (1524–85).

1553 Queen Mary succeeds Edward VI of England. *Anglica Historia* by Polydore Vergil (*c*.1470–1555). Sachs' (1494–1576) *Tristan und Isolde*.

1554 Mary marries Philip Hapsburg. Henry II ravages part of the Netherlands. **Moro appointed Court Painter to Queen Mary.** *L'Antichità di Roma* by Palladio (1508–80).

1555 Pope Paul IV elected. Charles V abdicates. Plantin establishes his Press at Antwerp.

1556 Philip II succeeds to throne of Spain (1556–98).

1557 England declares war on France. Spanish defeat French at St Quentin. **Sánchez Coello becomes Court Painter to Philip II.**

1558 French take Calais. Mary I of England succeeded by Queen Elizabeth. **Cellini's *Autobiography* (1558–62).**

1559 Peace of Câteau-Cambrésis between Henri II and Philip II. Guise family seize control of French government.

1560 Charles IX of France under Regency of Catherine de' Medici.

1561 Mary, Queen of Scots arrives in Edinburgh. *Book of Discipline* by Knox establishes church constitution in Scotland.

1562 Huguenot wars begin in France. **Foundation of Accademia del Disegno in Florence. Influential *Treatise on Architecture* by Vignola.**

1563 Decrees affecting the arts promulgated by the Council of Trent. *Book of Martyrs* by Foxe. *Règle d'Architecture* by Bullant (*c*.1520–78). *First and Chief Groundes of Architecture* by Shute (died 1563).

1564 Ferdinand I succeeded by Maximilian II. Birth of Shakespeare. **Death of Michelangelo.**

1565 Malta defended against the Turks. Edicts of Philip II opposed in the Netherlands by William of Orange and others.

1566 Pope Pius V elected. Nostradamus dies.

1567 Second Huguenot war in France begins. *Traite de l'Architecture* by de L'Orme (*c*. 1515–70).

1568 Mary, Queen of Scots flees to England. Don Carlos, son of Philip II, dies. Moorish revolt in Granada crushed by Philip II.

1569 Cosimo de' Medici created Grand Duke of Tuscany.

1570 Peace of S. Germain-en-Laye ends civil war in France with amnesty granted to Huguenots. **1570–2, El Greco in Rome. *Quattro Libri dell, Architettura* by Palladio published.**

1571 Turks defeated at Lepanto.

1572 Massacre of French Protestants on St Bartholomew's Day in Paris. Dutch war of liberation begins. Drake attacks Spanish harbours in America. Society of Antiquaries founded in London.

1573 **Veronese called before the Inquisition in Rome.**

1574 Charles IX succeeded by Henri III (1574–89).

ITALY

PAINTING

1575–9 *Madonna del Popolo* by **Barocci** (*c.* 1535–1612), Uffizi, Florence; his soft, sweet style was admired by St Philip Neri.
1588 *Paradise*, Sala del Maggior Consiglio, Doge's Palace, Venice, by **Tintoretto** (1518–94); huge painting.
1595 Frescos in the *Camerina and the Galleria of the Palazzo Farnese*, Rome, by **Annibale Carracci** (1560–1609); commissioned; giant mythological scenes; early Baroque style.
1597–1601 *The Calling of St Matthew*, Contarelli Chapel, San Luigi dei Francesi, Rome, by **Caravaggio** (1571–1610); one of three scenes from the life and martyrdom of St Matthew.

ARCHITECTURE

1576–92 *Il Redentore*, Venice, by **Palladio** (1508–80); last of his Venetian churches; very highly regarded.
1580 *Teatro Olimpico*, Vicenza, begun by **Palladio**, stage set added by **Scamozzi** (1552–1616); one of most influential theatre designs.
1590–5 *Fort Belvedere*, Florence, by **Buontalenti** (1536–1608); architect is the first of a distinguished line of military engineers.
1593 *Palazzo Zuccaro*, Rome by **F. Zuccaro** (1542–1609); façade adorned with grotesque Mannerist sculpture; housed Zuccaro's own Academy.
1598 *Villa Aldobrandini*, Frascati, by **della Porta** (*c.* 1537–1602); designed with splendid gardens.

SCULPTURE

1576 *Fountain of Neptune*, Piazza della Signoria, Florence, by **Ammanati** (1511–92); marble statue, with bronze figures by several sculptors.
1580 *The Medici Mercury*, Museo Nazionale, Florence, by **Giambologna** (1529–1608); famous bronze, widely copied.
1581–5 *The Tortoise Fountain* by **Landini** (*c.*1550–96), Piazza Mattei, Rome; naturalistic forms anticipate fountains of the Baroque.
1583 *The Meleager Group* by **Bandini** (1540–98), Prado, Madrid, commissioned by Francesco Maria I of Urbino; given prize place in his collection.

FRANCE AND SPAIN

PAINTING

1575 *Augustus and the Sibyl* by **Caron** (*c.* 1520–*c.* 1600), Louvre, Paris; work crammed with antique detail; artist chiefly patronized by Catherine de' Medici.
1577 *El Espolio*, Toledo Cathedral, by **El Greco** (1541–1614); altarpiece ordered in 1577; the painter copied it many times, heightening the emotional effects.
1579 *Martyrdom of St Lawrence* in the Escorial, by **Navarrete** (*c.*1526–79); artist studied under Titian; commissioned by Philip II to decorate interior of Escorial.
1579 *Drawing of the Three Coligny Brothers* by **Duval** (*c.*1530–81), Cabinet des Estampes, Paris; one of few works ascribed to official painter to Catherine de'Medici and Charles IX.
1586 *Burial of Count Orgaz*, S. Tomé, Toledo, by **El Greco**; artist's style departing more and more from Mannerism.

ARCHITECTURE

1576 *Gallery of Chenonceaux* by **Bullant** (*c.* 1520–78); only surviving work of his for Catherine de' Medici.
1582–1605 *São Vicente de Fora*, Lisbon, by **Terzi** (1520–97); novel elevation served as prototype for many Portuguese and Brazilian churches.
1584 *Hôtel d'Angoulême*, Paris, possibly designed by **J. B. du Cerceau the Elder** (*c.* 1545–*c.* 1590); king's architect whose style was close to Bullant's.
1585 *Valladolid Cathedral* designed by **de Herrera** (*c.* 1530–97); his designs only partly executed but of great influence.

SCULPTURE

1576–87 *Tomb of Don Fernando de Valdes* by **P. Leoni** (*c.* 1533–1608) in Collegiate Church of Salas; Grand Inquisitor's tomb; based on a triumphal arch.
1584 *Tomb of Valentine Balbiani*, by **Pilon** (*c.*1530–90), Louvre, Paris; in bronze and marble with a relief depicting the skeleton of the deceased.
1595–8 *The Risen Christ* in Hospital of St John the Baptist, Toledo, by **El Greco** (1541–1614); painted wooden statue; a study for a painting.
1598 *Philip II and his Family*, Great Chapel, S. Lorenzo, the Escorial, by **P. Leoni**; realistic bronze figures; perhaps conceived after design of Emperor Maximilian's tomb at Innsbruck.

NORTH AND CENTRAL EUROPE

PAINTING

1575–80 *Hercules and Omphale* by **Spranger** (1546–1611), Vienna, Kunsthistorisches Museum; painted on copper; for Rudolf II in Prague.
1581 *Portrait of Drake* by **Hilliard** (1547–1619), National Maritime Museum, Greenwich; one of few dated works of greatest English miniaturist.
1588 *Judgement of Midas* by **van Coninxloo** (1544–1607), Dresden; tiny figures in huge landscape; work of distinguished Flemish painter.

ARCHITECTURE

1577–85 *The Courtyard, Burghley House*; Elizabethan adaptation of Roman arch with Flemish decoration.
1580–8 *Wollaton Hall*, Nottingham, by **Smythson** (*c.* 1536–1614); a novel symmetrical plan; the architect's masterpiece.
1581–6 *The Grottenhof* of the Munich Residenz, probably designed by **Sustris** (1524–91/9?); derived from Florentine Mannerist style, notably of Vasari.
after 1592 *Jesuit church of St Michael*, Munich, rebuilt by **Sustris**; architect's most important work; with sophisticated Italian decoration.

SCULPTURE

1578 *Monuments to the Counts of Württemberg*, Stiftskirche, Stuttgart, begun; statues of armoured knights in active poses in Renaissance arcade.
c. 1579 *Mercury* by **van der Schardt** (*c.* 1530–after 1581), Stockholm, Nationalmuseum; statue that crowned fountain; gift of Frederick of Denmark to Tycho Brahe.
1592 Figure of *St Michael* on façade of St Michael's, Munich, by **Gerhard** (1540–1620); colossal bronze figure by great Mannerist sculptor.
1594 *Augustus Fountain*, Ludwigsplatz, Augsburg, by **Gerhard**; marble with bronze figures; influenced by Giambologna.
1596 *Hercules Fountain*, Augsburg, by **de Vries** (*c.* 1546–1626); symbol of resistance; sculptor trained under Giambologna.

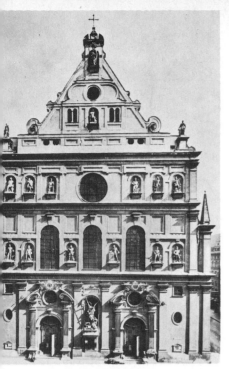

above: *Jesuit church of St Michael,* Munich. **Sustris**

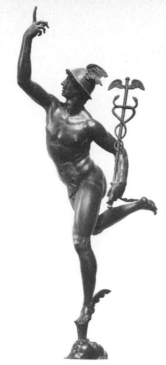

above: *The Medici Mercury.* **Giambologna**

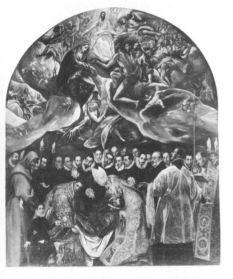

above: *Burial of Count Orgaz.* **El Greco**

below: *Paradise.* **Tintoretto**

above: *Augustus Fountain,* Augsburg. Detail. **Gerhard**

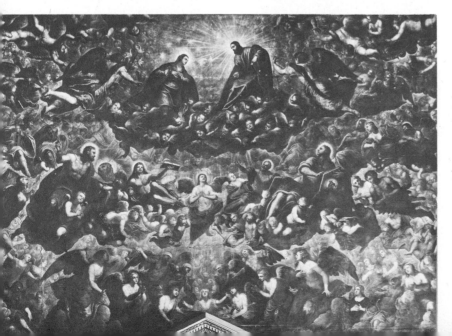

1575 Henri III crowned at Reims. Tycho Brahe builds an observatory for the King of Denmark.

1576 Spaniards sack Antwerp. Provinces of the Netherlands unite. Maximilian succeeded by Emperor Rudolf II. *Les Plus Excellents Bâtiments de France* by J. du Cerceau the Elder.

1577 Fire in the Doge's Palace, Venice. *Chronicles* by Holinshed.

1578 Philip II appoints A. Farnese, Governor of the Netherlands, on death of Don John of Austria. **Catacombs of Rome discovered by accident.**

1579 English College founded at Rome.

1580 Spanish conquest of Portugal. Drake completes circumnavigation of the world. **Paul Brill (1554–1626), Flemish painter, joins his brother Mattheus (1550–83) in Rome.**

1581 Tasso's *Gerusalemme Liberata.* **Vernukken (died 1607) employed on stucco decoration of Golden Hall of Kassel castle** (since destroyed).

1582 Gregorian Calendar introduced, at first only in Roman Catholic countries. Death of St Teresa. Bishop Paleotti's *Discourse on Sacred and Profane Images.*

1583 William of Orange accepts sovereignty of the Northern Netherlands.

1584 League of Joinville against the Huguenots. Cardinal Carlo Borromeo, champion of the Counter-Reformation, dies.

1585 Sixtus V plans to modernize Rome. **The Carracci, family of painters, establish an Academy in Bologna. J. Du Cerceau the Elder, French Protestant architect flees Paris.**

1586 Cardinal Granvella, patron, dies. *Britannia,* compiled by Camden, published.

1587 Mary, Queen of Scots executed. Drake sacks Cádiz.

1588 Defeat of the Spanish Armada. *Essais* by Montaigne published.

1589 Henri III assassinated. Henri IV renounces Protestantism. Catherine de' Medici dies.

1590 Henri IV besieges Paris. Spenser's *The Faerie Queene.* Marlowe's *Tamburlaine the Great.* **Lomazzo (1538–1600), *Idea del Tempio della Pittura.***

1591 Maurice of Nassau defeats the Duke of Parma. Trinity College, Dublin, founded.

1592 Pope Clement VIII (Aldobrandini) elected.

1593 Swedish Protestantism defended. Henri IV of France becomes Catholic. **Academy of St Luke founded in Rome by F. Zuccaro.**

1594 Last stronghold of the Catholic League in France captured. Earl of Tyrone leads rising in Ireland.

1595 Henri IV declares war on Spain. **Annibale Carracci leaves Bologna for Rome.**

1596 Spanish capture Calais. Turks defeat the Imperial army. **Isaac Oliver (died 1617) in Venice.**

1597 Protestant princes oppose the Emperor at the Diet of Ratisbon. James VI of Scotland writes *Demonologie.* Shakespeare's *Romeo and Juliet.*

1598 Edict of Nantes gives Huguenots political equality. Philip III succeeds as King of Spain. **Complete edition of Dietterlin's *Architecture and the Treatment of the Five Orders* published.** *Le Guides des Arts et Sciences* by **Mareschal.**

1599 Outbreak of plague in Spain.

ITALY

1600-1 *Conversion of St Paul* and *Crucifixion of St Peter*, by **Caravaggio** (1571–1610), Cerasi Chapel, S. Maria del Popolo, Rome; unusual realism shocked contemporaries.

1609 *Flight into Egypt* by **Elsheimer** (1578–1610), Alte Pinakothek, Munich; famous night piece painted on copper; by German landscape painter in Rome.

1614 *Communion of St Jerome*, Vatican Museum, by **Domenichino** (1581–1641); for long considered one of the world's greatest paintings.

1621-5 *The Assumption* by **Lanfranco** (1582–1647) S. Andrea della Valle; influential Baroque dome painting.

1603 *Façade of S. Susanna*, Rome, completed by **C. Maderno** (1556–1629); begun in 1597; the first truly Baroque façade.

1605 *Cappella Paolina*, Sta. Margia Maggiore, Rome; built for Pope Paul V (Borghese) who summoned **Bernini** and others to decorate the chapel.

1606–26 *Nave and façade of St Peter's*, Rome, by **C. Maderno**; involved alteration of Michelangelo's centralized plan.

1622 *Dome and façade of S. Andrea della Valle* completed by **C. Maderno**; important example of dome pierced by windows.

1624 *Façade of S. Bibiana*, Rome, by **Bernini** (1598–1680); commissioned by Pope Urban VIII.

1600 *Statue of St Cecilia*, S. Cecilia, Rome, by **S. Maderna** (c. 1576–1636); marble; commissioned by Clement VIII in 1599.

1609 *Annunciation group* in Orvieto Cathedral, by **Mochi** (1580–1654); work of major Roman sculptor; has been called first piece of Baroque sculpture.

1615–24 *Four bronze slaves* by **Tacca** (1577–1640); on base of Monument to Grand Duke Ferdinand I at Leghorn; best-known work of sculptor to Grand Dukes of Tuscany.

1622-4 *Apollo and Daphne* by **Bernini** (1598–1680), Galleria Borghese, Rome; marble; commissioned by Cardinal Scipione Borghese.

1624 *Baldacchino*, above tomb of St Peter, St Peter's, Rome, by **Bernini**; huge canopy completed in 1633.

FRANCE AND SPAIN

c.1610 *The Last Supper* by **Ribalta** (1565–1628), Valencia Museum; one of several altarpieces for the College of Corpus Christi by important Spanish realist.

c.1613 *The Immaculate Conception* by **El Greco** (1541–1614), Museum of S. Vicente, Toledo; late painting; the subject of especial significance to the Counter-Reformation.

c. 1619 *The Water-Carrier* by **Velázquez** (1599–1660), Wellington Museum, London; a genre study painted before Velásquez left Seville for Madrid.

c.1620-5 *Penitent St Jerome* by **G. de La Tour** (1593–1652), National Museum, Stockholm; figure depicted with startling tenebrism characteristic of de La Tour.

1622-5 *Medici cycle* by **Rubens** (1577–1640), Louvre, Paris; vast canvases devoted to life of Marie de'Medici; created for the Luxembourg Palace.

1613 *Luxembourg Palace*, Paris, begun by **de Brosse** (1571–1626); huge palace built for Marie de' Medici, later enlarged and altered.

1614 *Palace and Church of Lerma* designed by **de Mora** (c.1546–1610); commissioned by the Duke of Lerma, a favourite of Philip III.

1616–21 *St-Gervais*, Paris, probably by **de Brosse**; typical French classicism in its pre-Baroque phase.

1624 *Pavillon de l'Horloge*, Louvre, begun by **Lemercier** (1585–1644); followed Lescot's earlier work.

1624 *Hôtel de Sully*, Paris, by **du Cerceau** (c.1590–after 1649); rich sculptural detail on polychrome edifice.

1603–6 *Christ of Clemency*, Seville Cathedral, by **Martínez Montañés** (1568–1649), painted wooden crucifix; sculptor followed donor's precise instructions.

1609–12 *Adoration of the Shepherds* from altarpiece in S. Isidoro del Campo, Santiponce, by **Martínez Montañés**; highly emotive work of Sevillian school.

1609–14 *Philip III*, by **Tacca** (1577–1640), Plaza Mayor, Madrid; bronze equestrian statue, with horse rearing.

1617 *Pietà* by **G. Fernández** (1576–1635), Museo Provincal, Valladollid; lifesize, painted wooden figure; representative of dramatic taste of Spanish Baroque.

NORTH AND CENTRAL EUROPE

1611–14 *The Descent from the Cross* and *The Raising of the Cross* by **Rubens** (1577–1640), Antwerp Cathedral; paintings which introduced a fully developed Baroque style to northern Europe.

1616 *Richard Sackville, Earl of Dorset*, by **Oliver** (died 1617), Victoria and Albert Museum, London; traditional formal Tudor portrait in watercolour.

1616 *The Company of St George* by **Hals** (1580–1666), Frans Hals Museum, Haarlem; first of series of group portraits.

1617 *The Rape of the Daughters of Leucippus* by **Rubens**, Alte Pinakothek, Munich, completed; dramatic work; composition inspired by Leonardo's Battle of Anghiari.

1620-5 *The Four Evangelists* by **Jordaens** (1593–1678), Louvre, Paris; influence of Rubens, whom Jordaens sometimes assisted, is clear.

1624 *The Laughing Cavalier*, by **Hals**, Wallace Collection, London; famous lively portrait.

1614 *Salzburg Cathedral* begun by **Solari** (1576–1646); first fully Italianate church in Germanic lands; modelled on Il Gesù, Rome.

1615–20 *Town Hall*, Augsburg, by **Holl** (1573–1646); advanced work; damaged in World War II but rebuilt.

c.1620 *St Charles Borromeo*, Antwerp, by **Aguillon** (died 1617) and **Huyssens** (1577–1637); finest church of the period; reconstructed after fire in 1718.

1620 *Westerkerk*, Amsterdam, begun by **de Keyser** (1565–1621); sober architecture which directly precedes Dutch classicism.

1619–22 *Banqueting House*, Whitehall, London, by **Inigo Jones** (1573–1652); first English building entirely in classical style.

1610–11 *Spring*, by **Krumper** (1586–1647), Bayerisches National Museum, Munich; one of three seasons sculpted for the Grotto of the Residenz.

1613–19 *Annunciation group* in Church of Überlinger by **Zürn** (c.1583–1635); painted limewood; his best-known altarpiece.

1614–22 *Tomb of Prince William the Silent* by **de Keyser** (1565–1621), Delft, Nieuwe Kerk; bronze; commissioned thirty years after the Prince's death.

1622 *Monument to Francis Holles*, by **Stone** (1583–1647), Westminster Abbey, London; modelled on Michelangelo's tomb for Giuliano de' Medici.

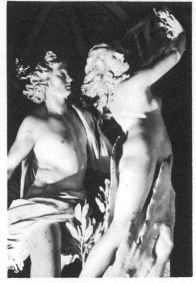

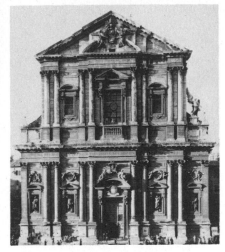

bove: *Apollo and Daphne*. Detail. **Bernini**

above *Façade of S. Andrea della Valle*, Rome. **Carlo Maderno**

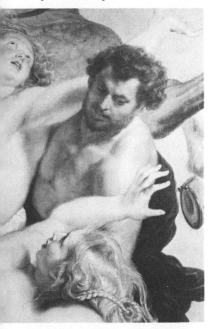

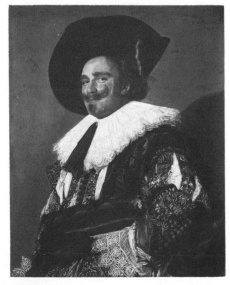

above left: *The Rape of the Daughters of Leucippus*. Detail. **Rubens**

above: *The Laughing Cavalier*. **Hals**

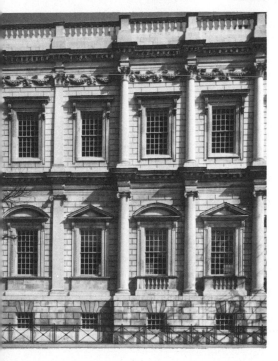

left: *Banqueting House*, London. Detail. **Inigo Jones**

1600 Maurice of Nassau defeats the Spanish at Nieuport. Charles IX persecutes Catholics in Sweden. **Rubens goes to Italy. Elsheimer settles in Rome.** *Treatise concerning the Art of Limning* by Hilliard (*c*.1547–1619).

1601 Revolt and execution of the Earl of Essex. *Everyman out of his Humour* by Jonson.

1602 Protestants persecuted in Bohemia and Hungary. Jesuits ordered to leave England.

1603 Death of Elizabeth I and accession of James I of England (James VI of Scotland). Shakespeare's *Hamlet*, the bad quarto. **Rubens in Spain.**

1604 Spinola captures Ostend. *The Painter's Book* by **Van Mander published.**

1605 Election of Paul V Borghese. The Gunpowder Plot. *Don Quixote de la Mancha* by Cervantes.

1607 Announcement of Spanish national bankruptcy. *Orfeo*, early opera by Monteverdi. **Caravaggio leaves Italy for Malta.**

1609 Spain and Holland sign Truce which marks political separation of the Netherlands. *Introduction à la Vie Dévote* by St François de Sales published. **Frans Pourbus II (1569–1622) appointed Painter to Marie de' Medici.**

1610 Assassination of Henri IV. Marie de' Medici becomes Regent to Louis XIII.

1611 Accession of Gustavus Adolphus of Sweden. *The Authorised Version* of the Bible. Donne's *An Anatomy of the World*. Middleton's *The Roaring Girl*.

1612 Death of Rudolf II and election of Emperor Matthias. **1612–15, Inigo Jones in Italy.**

1614 Prince of Condé and allies rebel against the Regent in France. Raleigh's *The History of the World*. Jonson's *Bartholomew Fayre*.

1615 Second Condé rebellion. Emperor Matthias signs Peace with the Turks. *Idea del'Architettura Universale* by Scamozzi (1552–1616). **Van Campen, Dutch architect, in Italy.**

1616 Richelieu becomes Minister in French government. Deaths of Shakespeare and Cervantes. **Ribera settles in Naples. Terbrugghen (1588–1629) settles in Utrecht and leads the School there.**

1617 Raleigh's expedition to Guiana in search of gold. **Bernini in service of Cardinal Scipione Borghese.**

1618 Thirty Years War begun. Maurice of Nassau succeeds as Prince of Orange. Richelieu exiled. **F. Duquesnoy (1594–1643) leaves Belgium for Rome.**

1620 Pilgrim Fathers leave from Plymouth for North America. **G. de La Tour settles in Lunéville, possibly after a visit to Rome and/or Holland.**

1621 Philip IV of Spain begins his reign. Huguenots rebel against Louis XIII. Burton's *Anatomy of Melancholy*. **Guercino leaves Bologna for Rome. Van Dyck (1599–1641) in Italy.**

1622 Count Olivares becomes Chief Minister in Spain. John Pym arrested for criticism of royal policy. *Historia Naturalis et Experimentalis* by Bacon.

1623 Urban VIII elected Pope. Webster's *Duchess of Malfi*. Shakespeare's *First Folio*. **Velázquez leaves Seville, given court appointment in Madrid. Group of Dutch painters in Rome, the Schildersbent formed.**

1624 England declares war on Spain. Dutch settle in New Amsterdam. **Petel settles in Antwerp. Poussin leaves France for Rome.**

	Key works: PAINTING	Key works: ARCHITECTURE	Key works: SCULPTURE
ITALY	1629 *Allegory of Divine Wisdom* by **Sacchi** (1599–1661), Barberini Palace, Rome; work of prime exponent of Roman Baroque classicism. c.1629 *The Rape of the Sabines* by **Pietro da Cortona** (1596–1669), Capitoline Gallery, Rome; one of first examples of secular High Baroque painting. 1631 *The Kingdom of Flora* by **Poussin** (1593/4–1665), Gemäldegalerie, Dresden; story from Ovid painted for a Sicilian dealer by French artist living in Rome. 1639 *Seaport at Sunset* by **Claude Lorrain** (1600–82), Louvre, Paris; one of four works commissioned by Pope Urban VIII from French artist living in Rome. c.1640 *St John the Baptist* by **Guido Reni** (1575–1642), Dulwich Picture Gallery, London; highly idealized work of very popular artist.	1625 *Palazzo Barberini*, Rome, begun by **C. Maderno** (1556–1629); completed and altered by **Bernini** (1598–1680); major Baroque palace. 1627 *Collegio Elvetico*, Milan, by **Ricchino** (1583–1658) designed; early example of concave façade. 1631 *Sta. Maria della Salute*, Venice, begun by **Longhena** (1598–1682); church dedicated to the Virgin as a votive offering following an outbreak of plague in 1630. 1635 *SS. Martina e Luca*, Rome, begun by **Pietro da Cortona** (1596–1669); first entirely Baroque church. 1638 *S. Carlo alle Quattro Fontane*, Rome, by **Borromini** (1599–1667); miniature church on oval plan; façade added in 1667. 1642–50 *S. Ivo della Sapienza*, Rome, by **Borromini**; highly unusual plan based on a six-pointed star, with spiral dome.	1629–33 *St Susanna* in S. Maria di Loreto, Rome, by **F. Duquesnoy** (1594–1643); marble; inspired by antique statuary; major work of Flemish sculptor in Rome. 1640 *St Philip Neri* in S. Maria, Vallicella, Rome by **Algardi** (1598–1654); imaginative portrait of founder of the Congregation of the Oratory, canonized in 1622. 1645 *Ecstasy of St Theresa* by **Bernini** (1598–1680) in Cornaro Chapel of S. Maria della Vittoria, Rome; masterpiece of sculpture, painting and architecture dramatically fused. 1646 *Meeting of Leo I and Attila* by **Algardi**, Vatican Museum, Rome; important relief executed for Innocent X. 1648 *Fountain of the Four Rivers*, Piazza Navona, Rome, by **Bernini**; grandest of all his fountains.
FRANCE AND SPAIN	1628 *The Martyrdom of St Serapion* by **Zurbarán** (1598–1664), Wadsworth Atheneum, Hartford Conn.; tenebrist work; for Mercedarian Convent of Seville. c.1628 *Time Conquered* by **Vouet** (1590–1649), Prado, Madrid; artist who dominated official French painting in his time. c. 1635 *Cardinal Richelieu* by **P. de Champaigne** (1602–74), National Gallery, London; famous portrait of great French statesman. 1635 *The Vision of St John the Evangelist* by **Cano** (1601–67), Wallace Collection, London; one of a series of apocalyptic paintings for St Paula, Seville. c. 1638 *The Surrender at Breda* by **Velázquez** (1599–1660), Prado, Madrid; great painting of Spanish victory of 1625. c.1648 *Death of St Bruno* by **E. Le Sueur** (1616/7–55), Louvre, Paris; one of twenty-two works for the Charterhouse of Paris.	1625–34 *St-Paul-St-Louis*, Paris, by **Martellange** (1568–1641), completed by **Father Derand** (1588–1644); most important Jesuit church in France. 1633 *Palais Royal*, Paris, designed, by **Lemercier** (1585–1654); work of Cardinal Richelieu's private architect. 1638 *Façade of the Sorbonne*, Paris, by **Lemercier**, endowed by Richelieu; reflects influence of Roman Baroque. c.1640 *Chapel of San Isidro*, Church of San Andrés, Madrid; work that marks transition from Mannerist to Baroque architecture in Spain. 1642–50 *Maisons-Lafitte*, near Paris by **Mansart** (1598–1666); most complete construction by first great architect of elegant French classicism. c.1645 *Church of Val-de-Grâce* designed by **Mansart**; for monastery founded by Anne of Austria in 1638; completed by **Lemercier**, who replaced Mansart in 1646.	1629 *Altarpiece of S. Maria*, Lebrija, by **Cano** (1601–67); Virgin and Infant Jesus, from Cano's early Seville period. 1636–8 *Eight Caryatids*, on the Pavillon d'Horloge, Louvre, Paris, by **Sarrazzin** (1588–1660); work closely imitates the antique. 1642 *The Four Corners of the World* by **Guérin** (1609–78), Palais de Chaillot, Paris; reliefs commissioned for the vestibule of the Château of Maisons. 1647 *Statue of Queen Anne of Austria*, from Pont-au-Change Monument, Louvre, Paris, by **Guillain** (1581–1658); erected in the honour of the young Louis XIV. 1648–52 *Tomb of Henri II de Montmorency*, Chapel of the Lycée, Moulins, by **F. Anguier** (1604–69) and **M. Anguier** (1612/3–86); major work of Roman-trained sculptors.
NORTH AND CENTRAL EUROPE	c. 1626 *The Smoker* by **Brouwer** (1605–38), Louvre, Paris; typical of subjects chosen by genre painter. 1632 *The Anatomy Lesson* by **Rembrandt** (1606–69), Mauritshuis, The Hague; monumental group portrait which established the artist as a fashionable painter in Amsterdam. 1634 *Still-Life* by **Claesz Heda** (1594–1682) Boymans-van-Beuningen Museum, Rotterdam; early example of popular subject of the period. 1635 *Ceiling of the Banqueting House*, Whitehall, London by **Rubens**; his only surviving ceiling painting. c. 1638 *Charles I on Horseback* by **Van Dyck** (1599–1641), National Gallery, London; famous portrait by Flemish painter to the Court of Charles I. 1642 *The Night Watch* by **Rembrandt**, Rijksmuseum, Amsterdam; highly original presentation of the fashionable group portrait.	1625–9 *Wallenstein Palace*, Prague; built by three Milanese architects; one of first Baroque buildings in Central Europe. 1629 *St Peter's*, Ghent, architect unknown; original and ambitious design with domed West end. 1633 *The Mauritshuis*, The Hague, by **van Campen** (1595–1657), executed by **Post** (1608–69); Dutch variation on Palladian plan. 1642 *The Riddarhus*, Stockholm, by **S. de Vallée** (died 1643), completed by J. de Vallée in 1674; one of first buildings in the classical style in Scandinavia. 1648–65 *Royal Palace* (former Town Hall), Amsterdam, by **van Campen**; his most important work; on a scale without precedent in the Netherlands.	c. 1627–8 *Salt Cellar*, Royal Palace, Stockholm, by **Petel** (1601–34); executed in ivory on a silver-gilt base, following a design by Rubens. 1630–1 *Ecce Homo*, wood carving for Augsburg Cathedral by **Petel**; major work of foremost German sculptor of the period. 1630 *Mannekin-Pis*, Musée Communal, Brussels, by **J. Duquesnoy the Elder** (c.1570–1641/2); second version of bronze statuette replacing a medieval figure. 1648–9 *Crucifixion group* from the Heinrich altar, Bamberg Cathedral, by **Glesker** (c.1610/20–78); gilt limewood; part of Baroque redecoration of the Cathedral after the Thirty Years War. 1648–65 *Justice and Prudence*, Town Hall, Amsterdam, by **Quellin the Elder** (1609–68); part of large scheme of interior decoration which he supervised.

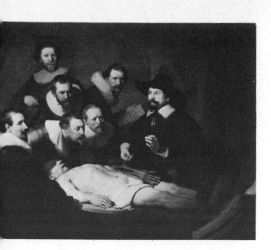

above: *The Anatomy Lesson*. **Rembrandt**

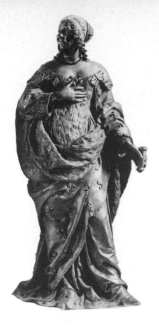

above: *Statue of Queen Anne of Austria*. **Guillain**

below: *The Surrender at Breda*. **Velázquez**

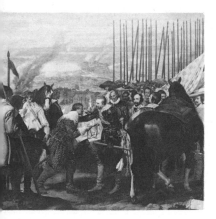

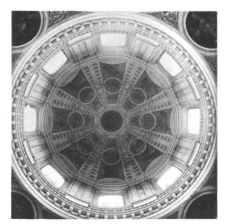

above: Church of *the Sorbonne. Interior.* **Lemercier**

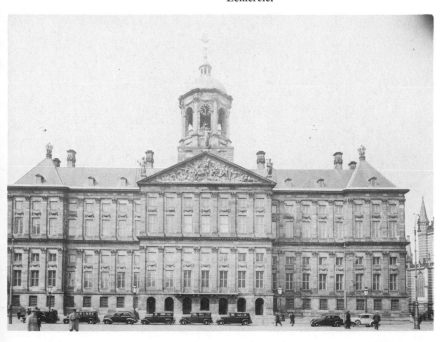

Royal Palace, Amsterdam. **Van Campen**

1625 Spinola captures Breda. Charles I succeeds James I. **Claude Lorrain in France, 1625–7. Mytens appointed** (*c.* 1590–pre 1648) **court painter to Charles I.**

1626 Ordinance of Nantes requires fortresses and castles of France to be dismantled. Dowland dies.

1627 England and France at war. De Mendoza's *The War of Granada* published posthumously. **Vouet appointed Court Painter to Louis XIII.**

1628 La Rochelle taken by the French. Petition of Right presented in parliament. Ignatius Loyola canonized. **Rubens in Spain, meets Velázquez. Honthorst (1590–1656) visits England.**

1629 The Edict of Restitution promulgated by Ferdinand II. Corneille's *Mélite*, a comedy. **Bernini made architect of St Peter's. Velázquez in Italy. Rubens in England, knighted.**

1631. Sack of Magdeburg and Halle by Emperor's army.

1632 Gustavus Adolphus killed at Lützen. Essay on solar system by Galileo. **Van Dyck appointed Court Painter to Charles I of England.**

1633 Rising in Brussels suppressed by the Spanish. Swedish army defeated by Wallenstein. Galileo condemned at Liège for heresy. *Misères de la Guerre*, **engravings by Callot (1592/3–1635) published. Brouwer imprisoned in Belgium for his political activities.**

1634 Swedes defeated at Nördlingen. Milton presents *Comus* at Ludlow. **Zurbarán visits Madrid.**

1635 Peace of Prague between Ferdinand and the Elector of Saxony. Académie Française founded by Richelieu.

1636 Harvard College founded at Cambridge, Mass. **Mignard (1612–95) in Rome. Rubens appointed Court Painter to Philip IV.**

1639. Swedish army lay siege to Prague. **Artus Quellin settles in Antwerp. Poussin officially invited to Paris to work in the Louvre.**

1640 Threat of Scots' invasion in England. The Great Elector succeeds George William of Brandenburg. **Puget (1620–94) in Rome. Algardi becomes head of the Academy of St Luke.**

1641 Mary, daughter of Charles I, marries William of Orange. Mazarin made Cardinal. Descartes' *Méditations Métaphysiques*. John Evelyn begins his Diary.

1642 Mazarin becomes Chief Minister in France on death of Richelieu. English Civil War begins. Prince Rupert wins victory at Worcester. Hobbes' *De Cive*. **Le Brun (1619–90) in Italy meets Poussin.**

1643 Reign of Louis XIV begins. Fall of Count Olivares in Spain. **Lely (1618–80) in England.**

1644. Innocent X elected Pope. *Déscartes' Principiae Philosophicae*. **Claude Lorrain begins his *Liber Veritatis* to guard against forgery.**

1645 Cromwell defeats Royalists at Naseby. Montrose finally defeated, escapes to the Continent. **Girardon (1628–1715) visits Rome.**

1646 Charles I captured by the Roundheads.

1648 Peace of Munster, a triumph for Holland. Peace of Westphalia marks end of Thirty Years War. 1648–51, Civil War in England. 1648–59, War between France and Spain. **Academie de Peinture et Sculpture founded in Paris.** *Livre de Portraiture* by Boulogne the Elder (1609–74).

1649 Charles I executed. French court returns to Paris. Treaty of Ruel marks end of first Fronde in France. *Treatise on Painting* by Pacheco (1564–1654) **published. Velázquez in Italy.**

	Key works: PAINTING	Key works: ARCHITECTURE	Key works: SCULPTURE
ITALY	1650 *Pope Innocent X* by **Velázquez** (1599–1660), Galleria Doria-Pamphili, Rome; inspired by Raphael's Pope Leo X, painted in Rome. 1650 *Nativity* by **Maratta** (1625–1713), S. Giuseppe dei Falegnami, Rome; painting that establishes Maratta, a pupil of Sacchi. 1652 *Clubfooted Boy* by **Ribera** (1591–1652), Louvre, Paris; cheerful unidealized picture by Spanish artist living in Naples since 1616. 1667 *The Four Hours of the Day* by **Claude Lorrain** (1600–82), Hermitage, Leningrad; characteristic paintings of biblical subjects in landscapes; late works of French artist living in Rome.	1653 *Façade of S. Agnese*, Piazza Navona, Rome, by **Borromini** (1599–1667); church begun by **Rainaldi** (1611–91) in 1652; curved façade commissioned by Pope Innocent X. 1657–70 *Piazza San Pietro*, Rome, by **Bernini** (1598–1680); colossal oval defined by two colonnades. 1664 *Palazzo Chigi-Odescalchi*, Rome, begun by **Bernini**; original scheme which provided a model for palaces all over Europe. 1667 *S. Maria in Campitelli*, Rome, completed by **Rainaldi**; most notable work of the architect; begun in 1663. 1667 *Cappella della Santa Sindone*, Turin Cathedral, by **Guarini** (1624–83); chapel of the Holy Shroud; first of architect's extraordinary domed structures.	1656 *Cathedra Petri*, St Peter's, Rome, by **Bernini** (1598–1680); a huge reliquary of marble, bronze, stucco and stained-glass. 1660 *St Agnes on the Pyre*, S. Agnese, Rome, by **Ferrata** (1610–86); typical of more restrained work of late seventeenth century. 1662–5 *Stucco decoration* of Bernini's S. Andrea al Quirinale, almost entirely the work of **Raggi** (1624–86); St Andrew, twelve putti and twenty-eight cherubs; sculptor was frequently an assistant to Bernini in his projects. 1667 *The Ecstasy of St Catherine*, by **Caffa** (1635–67/8), S. Caterina da Siena, Rome, completed; late Baroque sculpture in coloured marble.
FRANCE AND SPAIN	1650 *Denial of St Peter* by **G. de La Tour** (1593–1652), Musée des Beaux-Arts, Nantes; only surviving dated work; painted for the Duc de la Ferté. c.1650 *The Rokeby Venus* by **Velázquez** (1599–1660), National Gallery, London; only surviving female nude by Velásquez. 1656 *Las Meniñas* by **Velázquez**, Prado, Madrid; famous group portrait of complex composition with the Infanta Margarita posing for the artist. c.1660 *Immaculate Conception* by **Murillo** (1617–82), Prado Madrid; soft and idealized presentation of subject by popular artist. 1662 *Ex Voto* by **de Champaigne** (1602–74) Louvre, Paris; painted for the Jansenists at Port Royal to commemorate the miraculous cure of the artist's daughter. 1672 *Finis Gloriae Mundi* by **Valdés Leal** (1622–90) in La Caridad, Seville; one of his last and most famous works, a still-life with a moral significance.	1655 *St-Sulpice, Paris,* begun by **Gittard** (1625–86); characteristic of French classical churches of basilical plan. 1657–61 *Château of Vaux-le-Vicomte* by **Louis Le Vau** (1612–70); splendid High Baroque house; architect's first collaboration with Le Nôtre (1613–1700) and Le Brun (1619–90). 1660 *Collège des Quatre Nations*, Paris, designed by **Louis Le Vau**, endowed by Cardinal Mazarin; now the Institut de France. c.1664 *Façade of Granada Cathedral* designed by **Cano** (1601–67); first masterpiece of Spanish Baroque; built posthumously. 1668 *Versailles*, first enlargement begun by **Le Vau**; huge palace with gardens by **Le Nôtre** and decoration supervised by **Le Brun**; for Louis XIV. 1670–7 *Hôtel des Invalides*, Paris, by **Bruant** (c.1635–97); hospice with several courts; its plan and severity recall the Escorial.	1653 *Louis XIV Crushing the Fronde*, Musée Condé, Chantilly; group sculpted for the Hôtel de Ville, Paris. 1664 *The Virgin of Bethlehem* by **Cano** (1601–67) in Cathedral Museum, Granada; painted cedarwood figure; crowning point of a lectern. 1665 *Portrait bust of Louis XIV* by **Bernini** (1598–1680), Versailles; work executed in Paris; completed in forty days. 1668 *Apollo and the Nymphs* by **Girardon** (1628–1715), Versailles; strongly classical work by outstanding sculptor of the palace gardens. 1669 *Entombment* by **P. Roldan** (1624–1700), la Caridad, Seville; wooden reredos painted by **Valdés Leal** and **Murillo**. 1672–82 *Milo of Croton* by **Puget** (1620–94), Louvre, Paris; the Baroque style of Puget was only accepted at court briefly.
NORTH AND CENTRAL EUROPE	1651–2 *The Triumph of Frederick Hendrik* by **Jordaens** (1593–1678) Orange Room, Huis ten Bosch, near the Hague; masterpiece of mural art. 1654 *Bathsheba* by **Rembrandt** (1606–69), Louvre, Paris; signed and dated portrait of his mistress, Hendrickje Stoffels, as Bathsheba contemplating David's letter. 1658 *Courtyard of a House* by **de Hooch** (1629–83), National Gallery London; famous masterpiece of Dutch realism. 1661 *Landscape with a Watermill* by **J. Ruisdael** (1628/9–82), Rijksmuseum, Amsterdam; work of one of the first Dutch artists to paint pure landscapes. c.1665–8 *The Lacemaker* by **Vermeer** (1632–75), Louvre, Paris; one of the most exquisite of the few known works of the greatest Dutch genre painter. 1669 *Self-Portrait* by **Rembrandt**, National Gallery, London; last-known in long series of self-portraits.	1650–71 *Jesuit church of St Michael*, Louvain, by **Father Hesius** (1601–90); finest example of Jesuit architecture in Belgium. 1662 *Drottningholm Palace* begun by **Tessin the Elder** (1615–81); major work of leading Baroque architect in Sweden; completed by his son. 1662–9 *King Charles Building* at Greenwich, by **John Webb** (1611–72); one of few surviving works of pupil of Inigo Jones. 1663–90 *Church of the Theatines* Munich, for the Jesuits, by **Barelli** and **Zuccalli**; practically a Roman import, with rich stucco decoration of the period. 1664 *Sheldonian Theatre*, Oxford, by **Wren** (1632–1723); early work of great structural ingenuity. 1668 *Passau Cathedral* rebuilding begun by **Lurago** (c. 1618–84); shallow vaults built, which offered broader areas for decoration.	1654 *Funerary Monument of Bishop Triest*, Cathedral of St Bavon, Ghent, completed by **J. Duquesnoy the Younger** (1602–54); one of best-known works of Flemish sculptor, friend of Poussin's. c.1658 *St Peter*, part of memorial stone to Saboth, in St André, Anvers, by **Verhulst** (1624–98); the model for the statue still exists in Brussels. 1669 *Pulpit in St-Gudule*, Brussels, by **H. F. Verbrugghen** (1654–1724); complex Baroque sculpture features Adam and Eve banished from Paradise. 1673 *Bust of Sir Christopher Wren* by **Pierce** (c.1635–95), Ashmolean Museum, Oxford; splendid portrait of the architect, probably occasioned by his knighthood.

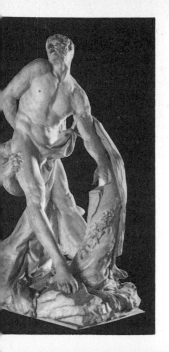

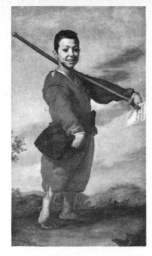

above: *Clubfooted Boy*. **Ribera**

left: *Milo of Croton*. **Puget**

below: *The Lacemaker*. **Vermeer**

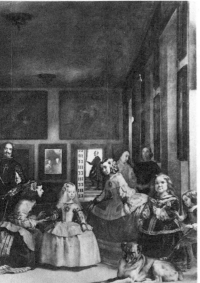

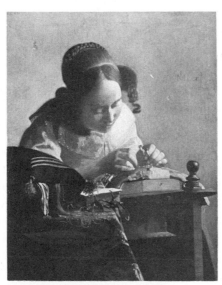

above left: *Las Meniñas*. **Velázquez**

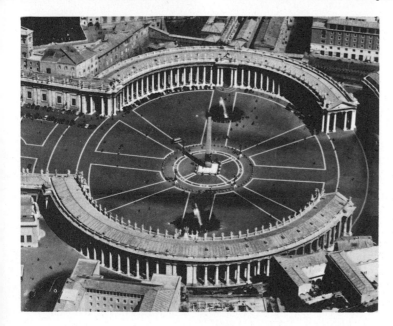

Piazza San Pietro, Rome. **Bernini**

1650 Leaders of the second Fronde imprisoned. Montrose executed. *Parallèle de l'Architecture Antique à la Moderne* by Fréant de Chambray published; advocates strict adherence to Vitruvian principles.

1651 Louis XIV attains his majority; dances in his first court ballet. Mazarin flees France. Hobbes' *Leviathan.*

1652 Leading Frondeurs exiled. Mazarin recalled. English declare War on the Dutch.

1653 Cromwell, Lord Protector of the Commonwealth of England, Scotland and Ireland. Middleton's *The Changeling.* Walton's *The Compleat Angler.*

1654 Christina of Sweden abdicates. Delft powder explosion destroys works of art. Orthodox Church in Russia decrees destruction of images not conforming with its canons. Cyrano de Bergerac's comedy *Le Pédant Joué.*

1656 Sweden and Brandenburg take Warsaw. Anglo-Spanish War begins. **Brussels Academy founded. Rembrandt bankrupt.**

1657 Interregnum; Louis XIV lays claim to the Holy Roman Empire. Poland resigns sovereignty of Prussia to Brandenburg. **Zurbarán moves to Madrid.**

1660 Charles II restores Stewart monarchy in England. Peace of Oliva and Peace of Copenhagen end hostilities in the North. Pepys begins his Diary. *Theatrum Pictorum* by Teniers (1610–90) produced; engravings of 244 paintings from Archduke Willhelm Leopold's collection.

1661 Appointment of Colbert as chief adviser to Louis XIV. **French Academy founded at Rome. Lely (1618–80) becomes Principal Painter to Charles II.**

1662 Gobelins, tapestry workshop, becomes a royal factory. Pascal dies. **Royal Society, London, founded.**

1663 Turks declare war on Leopold I. **Antwerp Academy founded by Teniers and Philip IV. Valdés Leal becomes Head of Academy in Seville.**

1664 Turks defeated at St Gotthard. English take New York from the Dutch. *Le Tartuffe* by Molière performed. *La Thébaïde* by Racine.

1665 Carlos II of Spain. **Wren in Paris, meets Bernini. Bernini in France;** his visit recorded by patron Chantelou in *Journal du Voyage en France du Cavalier Bernini.*

1666 Great Fire of London. Quadruple Alliance formed to protect Dutch from France. **Pratt, May and Wren appointed to rebuild city of London. Guarini settles in Turin.**

1667 War of Devolution begins. French attack Spanish Netherlands. Milton's *Paradise Lost.* Racine's *Andromaque.* Cosimo III de' Medici in Amsterdam and **visits Rembrandt.**

1669 Venetians surrender Crete. Pepys' Diary ends.

1670 Pope Clement X elected. Académie Royale de l' Opéra founded. **1670–89, Fischer von Erlach (1656–1723) studies in Italy.**

1672 William of Orange becomes Stadholder of Holland. **Van de Velde and son settle in England.** *The Idea of the Painter, Sculptor and Architect* by Bellori published in Rome.

1673 Coalition against France. **Wren knighted.**

1674 French troops devastate the Palatinate. **Kneller (1646/9–1723) arrives in England. Solimena (1657–1747) settles in Naples.**

ITALY

1674–9 *Adoration of the Name of Jesus*, fresco by **Baciccia** (1639–1709), Il Gesù, Rome; huge illusionistic fresco covering nave vault by most daring of Baroque decorators.
1680 *Parnassus* by **Claude Lorrain**, (1600–82), Boston Museum of Fine Arts; late work; signed and dated; painted for Prince Colonna.
1682–3 *Apotheosis of the Medici* by **Giordano** (1632–1705), ceiling of the ball-room, Palazzo Medici-Riccardi; huge painting by prolific Neapolitan artist.
1691–4 *Glory of St Ignatius* by **Pozzo** (1642–1709), ceiling of S. Ignazio, Rome; late Baroque illusionistic masterpiece.
1693/5 *Madonna* by **Maratta** (1625–1713), Vatican Gallery, Rome; painting almost ten feet high; artist hailed as greatest painter of the age.

1679–85 *Palazzo Carignano*, Turin, by **Guarini** (1624–83); unfinished work with oval salon; inspired by Bernini's first design for the East Front of the Louvre (1664).
1682 *Façade of S. Marcello al Corso* Rome, begun by **Fontana** (1634–1714); best example of Fontana's work; the façade was imitated throughout Europe.
1687 *S. Lorenzo,* Turin, completed by **Guarini**; crowned with dome of interlocking arches possibly inspired by dome of Mosque at Cordoba.
1683 *Façade of S. Maria degli Scalzi,* Venice, by **Sardi** (1680–1753); typically Venetian Baroque creation; an elaborate frame for sculpted figures.

1676 *The Ascension and Vision of St Andrew Corsini* by **Foggini** (1652–1725), Sta. Maria del Carmine, Florence; one of three reliefs sculpted with the assistance of German sculptor Permoser (1651–1732).
1689–94 *Reliquary* by **Parodi** (1630–1702), Cappella del Tesoro, S. Antonio, Padua: marble and stucco shrine with dancing and gesturing figures.
1690–6 *Charity* by **Serpotta** (1656–1732), Oratorio di S. Lorenzo, Palermo; smiling life-size figure in stucco.
1695–9 *Religion scourging Heresy* by **Le Gros** (1666–1719), part of Altar of St. Ignatius, Il Gesù, Rome; work of French sculptor executed to design of Pozzo (1642–1709).

FRANCE AND SPAIN

1675 *Beggar Boys throwing Dice* by **Murillo** (1617–82), Alte Pinakothek Munich; sentimental genre picture characteristic of Murillo's late work.
1679–84 *Scenes from the Life of Louis XIV* by **Le Brun** (1619–90), Hall of Mirrors, Versailles; work of Academy President responsible for strict set of rules for painting.
1685 *Charles II adoring the Blessed Sacrament* by **C. Coello** (1642–93), Sacristy of the Escorial; masterpiece by king's Painter; in typical complex and overcrowded style.
1691 *Marquise de Seignelay as Thetis* by **Mignard** (1612–95), National Gallery, London; work of fashionable portraitist and rival of Le Brun's.
c.1692–4 *Ceiling of the Grand Staircase*, the Escorial, frescoed by **Giordano** (1632–1705); among major works of Neapolitan painter commissioned by Charles II.

1677–1706 *Church of St Louis des Invalides*, Paris, by **Hardouin-Mansart** (1646–1708); centralized church with great dome; mixed classical and Baroque elements.
1678 *East Front of the Louvre* completed by **Perrault** (1613–88); classical colonnaded façade chosen by Louis XIV after rejection of Bernini's design.
1687 *Grand Trianon* at Versailles begun by **Hardouin-Mansart**; little palace of pink marble and limestone; built for afternoon refreshments.
1699 *Royal Chapel* at Versailles begun by **Hardouin-Mansart**, completed by **de Cotte** (1656–1735); traditional type of Palace chapel with exuberant exterior decoration, verging on the Rococo.
1699 *San Luis*, Seville built by the **da Figueroa family**, completed in 1731; richest and finest Baroque church in Seville.

1675 *Tomb of Cardinal Richelieu* begun by **Girardon** (1628–1715), the Chapel of the Sorbonne, Paris; marble; work of one of principal sculptors at Versailles.
1678 *Bust of Louis XIV in Roman Dress* by **Coysevox** (1640–1720), Versailles; originally occupied central niche in the Escaliers des Ambassadeurs.
1679 *Bust of Le Brun* by **Desjardins** (1640–94), Louvre, Paris; marble sculpted after clay model exhibited in the Salon of 1676.
1689 *The Seine and the Marne*, by **Le Hongre** (1628–90), Parterre d'Eau, Versailles; famous group; one of eight representing the rivers of France.
1693 *High Altar of San Esteban*, Salamanca, designed by **Churriguera** (1665–1725); huge construction of gilt and polychromed wood; often imitated.

NORTH AND CENTRAL EUROPE

c.1675 *Nell Gwyn* by **Lely** (1618–80), National Portrait Gallery, London; actress and mistress of Charles II; artist most fashionable portraitist of Restoration London.
c.1677 *Duke of Monmouth* by **Kneller** (1646/9–1723), Goodwood, Sussex; first masterpiece; establishes Kneller's reputation.
1686 *The Port of Amsterdam* by **Van de Velde the Younger** (1633–1707), Rijksmuseum, Amsterdam; dated work by seascape painter who settled in England.
1689 *The Avenue, Middelharnis* by **Hobbema** (1638–1708), National Gallery, London; one of most famous Dutch landscapes.

1675–1710 *St Paul's Cathedral*, London, by **Wren** (1632–1723); intended to rival St Peter's, Rome; replaced Gothic building burned down in Great Fire of 1666.
1686–1705 *Monastery of St Florian* by **Carlone** (1686–1708); masterpiece of Italian working in southern Germany and Austria; richly stuccoed.
1690 *Castle of Stockholm* rebuilt by **Tessin the Younger** (1654–1728); based on Roman palace but in austere style preferred by Charles XII.
1694–8 *Staircase of Prinz Eugen Stadtpalais*, Vienna, by **Fischer von Erlach** (1656–1723); early work of leading Baroque architect in Austria; features huge atlantes.
1696 *Greenwich Hospital* begun by **Wren**; grandest and most Baroque of Wren's many works.
1699–1726 *Castle Howard* by **Vanbrugh** (1664–1726); huge, ostentatious creation for the Earl of Carlisle.

1677–81 *Monument to de Ruyter, Admiral of the Dutch Fleet*, New Church, Amsterdam, by **Verhulst** (1624–98); magnificent tomb sculpture.
1682 *Tomb of Thomas Thynne*, Westminster, by **Artus Quellin III** (1653–86); most important work of Flemish sculptor in studio of Stone in England.
1682 *The Cosimo Panel* by **Grinling Gibbons** (1648–1721), Museo Nazionale, Florence: limewood panel sent by Charles II of England to Cosimo III de' Medici.
1697 *Equestrian Statue of the Great Elector* by **Schlüter** (1660–1714), in front of Schloss Charlottenburg, Berlin; bronze; influenced by Giambologna's statue of Henri IV.
1697 *Mount Calvary* by **Willem Kerricx** (1652–1719) and **Willem Ignatius Kerricx** (1682–1745) and others, St Paul, Antwerp; vast creation in sandstone comprising sixty-three figures; completed after 1740.

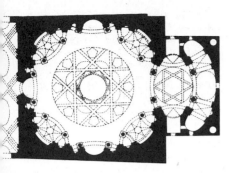

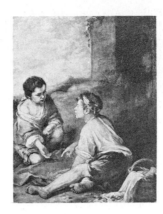

above: Plan of *S. Lorenzo,* Turin. **Guarini**

right: *Beggar Boys throwing Dice.* **Murillo**

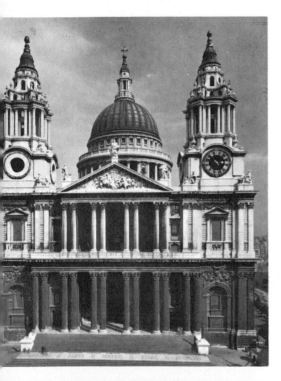

left: *St Paul's Cathedral,* London. **Wren**

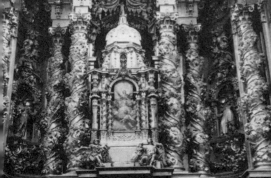

left: *High Altar of San Esteban.* **Churriguera**

1675 Battle of Colmar. Turenne defeats Great Elector. Newton's *Opticks*. Work on displaying pictures, the *Polygraphice*, published in several editions. **Hardouin-Mansart appointed Royal Architect.**

1676 Innocent XI elected Pope.

1677 Great Elector takes Stettin and pursues Swedes as far as Riga. *Ethics* by Spinoza.

1678 Peace of Nijmegen, between France and Holland. Popish Plot discovered in England. Death of poet, Marvell. Bunyan's *Pilgrim's Progress.*

1679 Peace of St Germain-en-Laye, between Sweden and Brandenburg. **Château of Marly begun,** since destroyed.

1680 Charles XI of Sweden declares himself absolute monarch. Comédie Française formed. Purcell appointed organist at Westminster.

1681 European Congress meets at Frankfurt.

1682 Government and court of Louis XIV move to Versailles. **Elias Ashmole (1617–92) founds his museum at Oxford. Hyacinthe Rigaud awarded the Prix de Rome.**

1683 Vienna besieged by the Turks, who are defeated. League of The Hague formed against Louis XIV. **C. Coello becomes Painter to the King of Spain.**

1684 Truce between Louis XIV and Leopold I. Holy League at war with Turkey. Death of Corneille.

1685 James II succeeds Charles II. The Revocation in France. **Equestrian statue of Louis XIV by Bernini sent to France;** its destruction ordered by the King.

1686 The League of Augsburg. **The engravings of Guarini's *Treatise on Architecture* published.**

1687 Venetians bombard Athens **and badly damage the Parthenon. *c.* 1687–90, Earl of Shaftesbury, art theoretician, on Grand Tour in Italy.**

1688 Frederick III succeeds the Great Elector of Brandenburg. The Glorious Revolution in England. William of Orange enters London. Louis XIV begins war with the Empire. Purcell's *Dido and Aeneas* staged.

1690 Peter the Great of Russia. William and Mary become joint rulers of Britain. Battle of Killiecrankie, Scots Covenanters defeated.

1690 William III defeats James II at the Battle of the Boyne. **Von Hildebrandt (1668–1745), Austrian architect, in Rome to study under Fontana *c.* 1690.**

1691–1700 Pope Innocent XII.

ITALY

PAINTING

1703–11 *The Tame Raven* by **Magnasco** (1667–1749), Uffizi, Florence; best-known work of Court Painter to Grand Dukes of Tuscany.

c. 1712 *The Sacraments* by **G. M. Crespi** (1665–1747), Dresden; famous series for Cardinal Ottoboni; painted in Bologna.

1715–17 *Massacre of the Giustiniani at Chios* by **Solimena** (1657–1747), Museo di Capodimonte, Naples; oil sketch for picture commissioned by the Genoese Senate.

ARCHITECTURE

1717–31 *La Superga*, near Turin, by **Juvarra** (1678–1736); church of unusual design; the dome placed over the entrance; built as a thanks offering for a victory by Duke Vittorio Amadeo.

1719 *Stupinigi Palace*, Turin, begun by **Juvarra**; masterpiece built in the form of a cross; a hunting-lodge for the Duke of Savoy.

1720–38 *Staircase of the Palazzo Serra di Cassano*, Naples, by **Sanfelice** (1675–1745); splendid creation in granite and marble on novel plan.

1723–5 *The Spanish Steps*, Rome, by **de Sanctis** (1693–1740); grandiose stairway to church of Sta. Trinità dei Monti.

SCULPTURE

1708–13 *St John the Evangelist* in S. Giovanni, Laterano, Rome, by **Rusconi** (1658–1728); one of four marble apostles in a restrained Late Baroque style.

1714–17 *Fortitude* by **Serpotta** (1656–1732), in the Oratorio del Rosario di S. Domenico, Palermo; life-size stucco; the Virtue presented as a smiling lady in contemporary dress.

1716 *The Flaying of Marsyas* by **Foggini** (1652–1725), Private Collection, Great Britain; inscribed bronze; a gift from Cosimo III to the French painter, Rigaud.

1721 *Virginity*, S. Maria del Carmine, Venice, by **Corradini** (1668–1752); graceful figure recalls tradition of Late Mannerism.

FRANCE AND SPAIN

PAINTING

1701 *Louis XIV* by **Rigaud** (1659–1740), Louvre, Paris; famous stately portrait originally intended as a gift for Philip V of Spain.

1703 *La Belle Strasbourgeoise* by **Largillière** (1656–1746), Musée des Beaux-Arts, Strasbourg; masterpiece of Flemish-trained portraitist.

1715 *Mezzetin* by **Watteau** (1684–1721), Metropolitan Museum, New York; famous picture of comic but pathetic figure by short-lived artist

1717 *The Embarkation for Cythera* by **Watteau**, Louvre, Paris; courtly scene which brought official recognition to the fête galante as a category of painting.

ARCHITECTURE

1716 *Interior decoration of Palais Royal*, Paris, by **Oppenord** (1672–1742); major example of Rocaille style of Court Architect.

1717 *Palace-Monastery of Mafra* by **Ludovice** (1670–1752); huge building in Late Baroque style; built for John V of Portugal.

1717 *Hôtel de Bourvallais*, Paris, by **de Cotte** (1656–1735); one of few surviving decorated Parisian houses by important early Rococo architect.

1724–34 *West entrance to S. Telmo*, Seville by **L. da Figueroa** (*c.*1650–1730); extremely ornate example of Sevillian Baroque.

SCULPTURE

1708–14 *St-Louis-en-l'-Ile*, Notre-Dame, Paris, by **de Cotte** (1656–1735), **Coysevox** (1640–1720) and **Coustou** family; immense marble decoration; greatest sculptural ensemble of the century.

1710 *Statue of Marie-Adelaïde of Savoy as Diana* by **Coysevox**, Louvre, Paris; first of the mythological portraits which became increasingly popular.

1721–32 *Transparente Altar*, Toledo Cathedral, by **Narciso Tomé** (*c.*1690–1742); magnificent setting for reliquary made of marble, wood, stucco and gilded bronze in Churrigueresque style.

NORTH AND CENTRAL EUROPE

PAINTING

1702 *Portrait of Newton* by **Kneller** (1646/9–1723), National Gallery, London; one of forty-two portraits of uniform size called the Kit Cat series painted during 1702 and 1717.

1704–7 *Ceiling of Salon in the Summer Palace*, Liechtenstein, by **Pozzo** (1642–1709); work of great influence in development of Austrian Rococo.

1714 *The Marriage of Elector William* by **Pellegrini** (1675–1741), the Palace Schlessheim; one of fourteen Allegories by Venetian decorative painter.

1715–17 *Scenes from the Life of St Paul* by **Thornhill** (1675/6–1734), the Dome of St Paul's, London; work of only English decorator in grand Baroque tradition.

ARCHITECTURE

1702 *Benedictine Abbey of Melk* begun by **Prandtauer** (1660–1726); best-known work of Austrian specialist in monastic architecture; built on spectacular site.

1705 *Blenheim Palace* begun by **Vanbrugh** (1664–1726); huge palace presented by the nation to the Duke of Marlborough after the Battle of Blenheim (1704).

1709–22 *The Zwinger*, Dresden, built by **Pöppelmann** (1662–1736); part of a new plan for the town and palace by the Elector Augustus the Strong; a sumptuous pleasure-palace.

1714 *Christ Church*, Spitalfields, London, by **Hawksmoor** (1661–1736) begun; one of the churches commissioned by the Act of 1711.

1716–25 *Karlskirche*, Vienna, designed by **Fischer von Erlach** (1656–1723); extraordinary creation founded by Charles VI; consecrated as a Monument to the Empire in 1737.

1716 *The Pagodenburg* by **Effner** (1687–1745) at Schloss Nymphenburg, near Munich; one of several small pavilions; with a chinoiserie interior.

1720 *Villa Amerika*, Prague by **K. I. Dientzenhofer** (1689–1751); theatrical little house with two-tiered roof; early work in Rococo style.

1721–3 *Upper Belvedere*, Belvedere Palace, Vienna, by **Hildebrandt** (1668–1745); masterpiece of Austrian Baroque; built for Eugene of Savoy.

SCULPTURE

1700 *Heads* by **Schlüter** (*c.* 1660–1714) on the Hof des Zeughauses, Berlin, completed; twenty-two faces expressing the glories and miseries of war.

*c.*1700 *King Ferdinand IV* by **Strudel** (1648–1708), National Library, Vienna; marble armoured figure; one of series of statues of ancestors of Leopold I.

*c.*1717–18 *Three Satyrs* by **Permoser** (1651–1732), Zwinger, Dresden; huge sandstone supporting-figures; part of scheme of architectural sculpture.

1718–22 *The Assumption of the Virgin* by **E..Q. Asam** (1692–1750), Monastery church of Rohr, Bavaria; dramatic composition of life-size painted stucco figures.

1721 *The Apotheosis of Prince Eugene* by **Permoser**, completed, Austrian Baroque Museum, Vienna; famous work of highly individual sculptor of the Late Baroque.

1721 *High Altar of Weltenburg* by **E. Q. Asam**; polychromed stucco creation; perfectly framed in walls of church built by C. D. Asam (1686–1739).

1723–4 *The Triumph of Faith* by **Goetz** (1696–1760), Chapel of the Holy Trinity, Paura, near Lambach; heresy is shown as a bearded Protestant clutching a bust of Luther; a work inspired by Pozzo's St Ignatius altar in Rome.

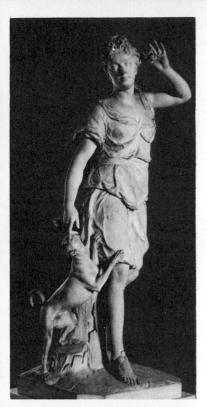

left: *Marie-Adelaide of Savoy as Diana.* **Coysevox**

below: *The Embarkation for Cythera.* **Watteau**

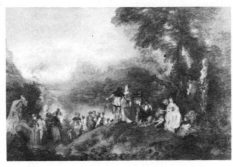

below left: *Transparente Altar.* **Narciso Tomé**

below: The Sacrament of Confirmation, from *The Sacraments.* **Giuseppe Maria Crespi**

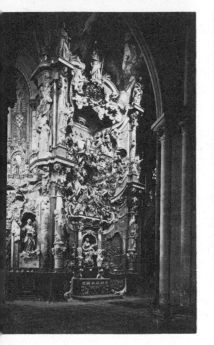

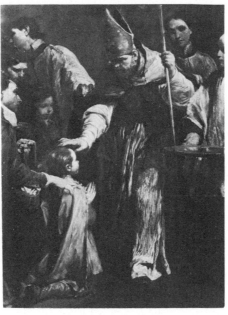

1700–46 Philip V, first Bourbon king of Spain. Pope Clement XI (1700–21). Outbreak of great Northern War.

1701 Frederick of Brandenburg assumes title of King of Prussia. Prince Eugene defeats French at Chiara and Carpi. **1701–3, S. Ricci travelling painter in Vienna.**

1702 Queen Anne of England succeeds William III. Charles XII takes Warsaw. **Padre Pozzo (1642–1709) settles in Vienna. Watteau settles in Paris.**

1703 Peter the Great of Russia founds the new city of St Petersburg **and summons Tressini (1670–1734) to be architect.**

1704 Marlborough wins Battle of Blenheim. Stanislaus Lesczinski elected King of Poland. **Fischer von Erlach (1656–1723) appointed Court Architect at Vienna.**

1705 Accession of Emperor Joseph I.

1706 Elector Max Emmanuel sends Effner to Paris to train under Boffrand.

1707 Union of England and Scotland.

1708 French defeated at Oudenarde. **1708–27, Thornhill painting at Greenwich Hospital.**

1709 Battle of Malplaquet. **Charles XII in correspondence with the architect Tessin the Younger (1654–1728). 1709–19, Kent (1685–1748) studies painting in Rome.**

1710 Handel settles in London. **Pöppelmann, German architect, in Italy to study. Meissen factory founded by Augustus the Strong of Saxony.**

1711 Accession of Emperor Charles VI, claimant to Spanish throne. **Hawksmoor appointed Surveyor under the Act for Building Fifty New Churches, and builds six. Kneller founds Academy of Painting in St Martin's Lane.**

1712 Peace Congress opens at Utrecht. Pope's *The Rape of the Lock*. **1712–16, S. Ricci in London.**

1713 Treaties signed at Utrecht. **Pellegrini leaves England.**

1714–27 George I of England. *La Monadologie* by Leibnitz influences the philosophy of the Enlightenment. **1714–15, Lord Burlington (1694–1753) visits Italy for the first time.**

1715 Regency of Philippe d'Orléans for the young Louis XV begins. The Stewart rebellion in Scotland defeated. *Vitruvius Britannicus* **published, by Colin Campbell (1673–1729), Palladian architect. Town of Karlsruhe planned.**

1717 Peter the Great visits Paris. Handel's *Water Music* performed. **Fischer von Erlach's influential treatise on architecture published. Nattier (1685–1766) in Amsterdam painting the Csar and his court. S. Ricci returns to Venice *c.* 1717.**

1718 Quadruple Alliance formed. *Oedipe* by Voltaire. **German architect Neumann (1687–1753) returns to Würzburg after visiting Milan and Vienna.**

1719 Liechtenstein established as principality within the Empire. Defoe's *Robinson Crusoe*. **Watteau visits London. Lord Burlington revisits Italy to study Palladio.**

1720 Treaties of Stockholm end Northern wars. The South Sea Bubble begins to burst. Pope's translation in verse of Homer completed. **Cuvilliés (1695–1768) sent to Paris to study. Flemish sculptor Rysbrack in England *c.* 1720.**

1722 Richardson and his son write popular *Guide Book* for the Grand Tour.

1723–74 Reign of Louis XV. **French architect Boffrand visits Würzburg. Neumann visits Paris.**

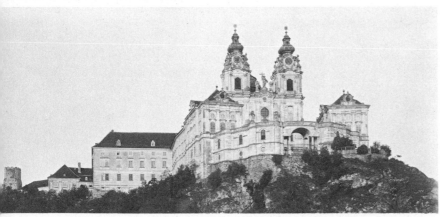

Benedictine Abbey of Melk. **Prandtauer**

1725–1749	Key works: PAINTING	Key works: ARCHITECTURE	Key works: SCULPTURE
ITALY	c. 1728–30 *The Bucintoro returning to the Molo, Venice*, by **Canaletto** (1697–1768), Royal Collection, Windsor; detailed and static record of busy ceremony by most famous of all Vedute painters. c.1730 *Faustina Bordoni* by **Rosalba Carriera** (1675–1757), Ca' Rezzonico, Venice; portrait; Venetian pastellist famous in courts of Vienna, Paris and Dresden. pre-1750 *The Banquet of Anthony and Cleopatra* by **Tiepolo** (1696–1770) Palazzo Labia, Venice; famous fresco by Venetian master of decorative painting.	1733–6 *Façade of S. Giovanni* in Laterano, Rome, by **Galilei** (1691–1736); Galilei won a competition for this huge work with a severely classical design. 1736 *Palazzo Corsini*, Rome, begun by **Fuga** (1699–1782); sophisticated design of classicizing Late Baroque architect. 1738–9 *Santuario della Visitazione di Maria* at Vallinotto near Carignano, by **Vittone** (1704/5–70); early masterpiece of very unusual construction featuring a triple vault.	1732 *The Trevi Fountain*, Piazza di Trevi, Rome, designed by **Salvi** (1697–1751); a masterpiece of Late Baroque; combines a fountain and palace façade; executed by **Bracci** (1700–73). 1739 *Monument to Pope Benedict XIII* by **Marchionni** (1702–86), S. Maria sopra Minerva, Rome; marble tomb executed in collaboration with **Bracci**. 1739–42 *Tomb of Queen Maria Clementina Sobieski* by **Bracci** (1700–73), St Peter's, Rome; allegorical composition with figure of Charity holding the Queen's portrait.
FRANCE AND SPAIN	1728 *The Rayfish* by **Chardin** (1699–1779), Louvre, Paris; still-life shown at the Exposition de la Jeunesse. 1732 *Mlle de Lambesc* by **Nattier** (1685–1766), Louvre, Paris; sitter is softly portrayed as Minerva; one of the artist's first successes. 1740 *The Triumph of Venus* by **Boucher** (1703–70), National Museum, Stockholm; famous picture commissioned by Boucher's chief patron, Mme de Pompadour. 1740 *Benediction* by **Chardin**, Louvre, Paris; scene from ordinary middle-class life depicted with unaffected simplicity. 1742 *Diana resting after her Bath* by **Boucher**, Louvre, Paris; masterpiece painted for the Salon of 1742.	1727 *Sacristy of the Charterhouse* at Granada by **Arévalo** and **Manuel Vasquez**; typically Spanish rich ornamentation inspired by New World. 1732–48 *S. Pedro dos Clerigos*, Oporto, by **Nazzoni** (died 1773); highly decorated Portuguese church by Italian architect. 1736–64 *Royal Palace*, Madrid, designed by **Juvarra** (1678–1736), built by **Sacchetti** (1700–64); Sacchetti enlarged his teacher's original plan. 1738–50 *Façade of Santiago Cathedral* by **Casas y Novoa** (died 1751); elaborate ensemble of architectural sculpture. 1737–9 *Hôtel de Soubise*, Paris, decorated by **Boffrand** (1667–1754); masterpiece of Rococo interior decoration.	1731 *Marie Leczinska as Juno* by **G. Coustou** (1677–1746), Louvre, Paris; charming statue of the French Queen as goddess. 1733–7 *Neptune calming the Storm* by **Adam** (1700–59), Louvre, Paris; work derived from design for the Trevi Fountain, Rome. c.1745 *Virgin and Child and little St John* by **Salzillo** (1707–83), Cathedral Museum, Murcia; sweet and delicately painted group by one of last important polychrome sculptors in Spain. 1747–50 *Cupid with his Bow* by **Bouchardon** (1698–1762), Louvre, Paris; marble; made for Louis XV from clay model exhibited in the Salon of 1739.
NORTH AND CENTRAL EUROPE	1726–30 *Ceiling in the Karlskirche*, Vienna, by **Rottmayr** (1654–1730); work in Italianate manner by leading Austrian painter. 1728–31 *Assumption of the Virgin* by **J. B. Zimmermann** (1680–1758), pilgrimage church of Steinhausen; Rococo work of decorative painter, brother of the church's architect. 1740 *Captain Coram* by **Hogarth** (1697–1764), Foundling Hospital, London; fine portrait of the founder presented by the artist to the hospital. 1745 *Shortly after the Marriage* by **Hogarth**, National Gallery, London; one of the famous moralizing series, *Marriage à la Mode*.	c.1725 *Chiswick House*, London, by **Lord Burlington** (1694–1753); villa based on Palladio's Rotonda by great patron of English Palladianism. 1733 *St John Nepomuk*, Munich, begun by **E. Q. Asam** (1692–1750) and **C. D. Asam** (1686–1739); private chapel, a masterpiece of Rococo religious architecture. 1734–9 *The Amalienburg* by **Cuvilliés** (1695–1768) at Schloss Nymphenburg, Munich; charming Rococo pavilion decorated by **Boffrand** (1667–1754). 1737–49 *Radcliffe Camera*, Oxford, by **James Gibbs** (1682–1754); circular domed library, the architect's masterpiece. 1743–72 *Vierzehnheiligen*, near Bamberg, by **Neumann** (1687–1753); pilgrimage church of highly complex design based on groups of ovals. 1744–67 *Benedictine Abbey of Ottobeuren*, Bavaria, by **Fischer** (1692–1766); masterpiece of South German architect; its stucco decoration supervised by Feuchtmayr. 1745–54 *Wieskirche* near Steingaden, by **D. Zimmermann** (1685–1766); Bavarian Rococo at its peak. 1749–56 *Great Palace, Tsarskoe Selo* (Pushkino), by **Rastrelli** (1700–71); masterpiece of leading Rococo architect in Russia; palace with exquisite little pavilions.	1727 *High Altar of the Monastery of Melk* designed by **Mattielli** (c.1682/8–1748); carved by German sculptor from designs of important Italian sculptor in Austria. 1731 *Monument to Isaac Newton* by **Rysbrack** (1694–1770), Westminster Abbey; classicizing work of Flemish born sculptor collaborating with architect Kent (1685–1748). 1737–9 *River Enns* by **Donner** (1693–1741) Barockmuseum, Vienna; lead figure from Neuer Markt Fountain replaced by bronze copy. 1738–40 *St Martin's Altar*, St Martin near Graz, by **Stammel** (1692–1765); large-scale narrative sculpture featuring three saints and their horses. 1743–6 *Pulpit in Onze Lieve Vrouwe van Hanswijk*, Malines, by **Verhaegen** (1701–59); huge creation in oak in form of a gnarled tree teeming with carved figures. c.1745 *An Angel in Flight* by **Ignaz Günther** (1725–75), German National Museum, Nuremberg; wooden model for angel for Altar of Knobel Chapel, Munich, early work of great Rococo sculptor. 1748 *St Elizabeth* by **Feuchtmayr** (1696–1770), Birnau Pilgrimage Church; weirdly expressive life-size stucco statue.

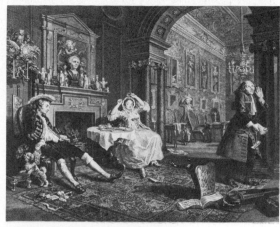

1725 Peter the Great of Russia dies. **Courtonne (1671–1739) the architect produces his *Traité de la Perspective*. Bahr (1666–1738) begins the now destroyed Frauenkirche, Dresden.**

1727 George II succeeds George I. Anglo-Spanish War. **Boucher visits Italy. Kent publishes designs of Inigo Jones (1573–1652).**

1728 Convention of Prado ends Anglo-Spanish War. Congress of Soissons fails to find peace. *The Beggar's Opera* by Gay first performed. **Chardin admitted to the Académie.**

1730 Pope Clement XII elected. **Official taste in Rome moves sharply towards the classical. Venetian painter Amigoni (1682?–1752) arrives in London.**

1731 Threat of general war over the Italian Duchies averted by the Treaty of Vienna. Protestants expelled from the Archbishopric of Salzburg.

1734 Spanish take Naples. Emperor's forces in Italy defeated. Reign of Charles VII of the Two Sicilies begins. **Pope Clement XII opens Europe's first public museum. 1734–53, French painter Vernet (1714–89) in Rome. French architect Soufflot (1713–80) in Rome until 1738.**

1735 Spaniards besiege Mantua. Russian army reaches the Rhine. Rameau's ballet *Les Indes Galantes*. **Italian architect Juvarra goes to Madrid. French sculptor Roubiliac (1705–62) settles in England. Engravings of Hogarth's *A Rake's Progress* published.**

1736 Abdication of King Stanislaus of Poland. **Scottish portrait painter Ramsay (1713–84) visits Rome. 1736–7, German architect Knobelsdorff in Italy.**

1737 End of Medici rule in Tuscany. **Italian architect Vittone publishes edited *Architettura Civile* by Guarini (1624–83). A. Bibiena (1687–1769) begins building the since destroyed Opera house in Mannheim. The Salon is established as a biennial event in Paris.**

1738 Russia and the Empire at war with Turkey. *Le Discours sur L'homme* by Voltaire. **Herculaneum discovered.**

1740 Death of Charles VI. Succession of Maria Theresa disputed. Frederick the Great of Prussia begins the Silesian War. **Piranesi (1720–78) arrives in Rome. The designs of G. G. Bibiena (1696–1757) *Architettura e Prospettive* published.**

1741 War of Austrian Succession begins. *Vedute* (1741/4) etchings by Canaletto (1697–1768), issued. German painter Mengs (1728–79) in Rome. *Gothic Architecture Restored and Improved* by Batty Langley (1696–1751).

1742 Charles VII crowned Emperor. **Scottish painter Gavin Hamilton (1723–98) goes to Rome. Gabriel (1698–1782) becomes Chief Architect to Louis XV.**

1743 Maria Theresa crowned at Prague. **First collection of engravings of views by Piranesi.**

1744 Frederick the Great invades Bohemia. France declares war on Britain and Austria. **1744–59, painter Mengs in Dresden.**

1745 Bonnie Prince Charlie lands in Scotland. **Piranesi's engraved *Carceri d'Invenzione* published.**

1746 Jacobites defeated at Culloden. **Canaletto arrives in London.**

1747 View-painter Bellotto (1720–80) in Dresden. Amigoni (1682?–1752) goes to Madrid as Court Painter. 1747–53, G. G. Bibiena in Dresden; designs the interior of the theatre at Bayreuth in 1748.

1749 **Pigage (1723–96) becomes architect to the Elector Palatine in Mannheim.**

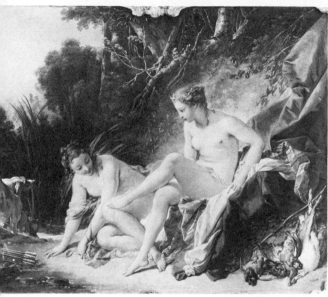

above left: *The Banquet of Anthony and Cleopatra*. **Tiepolo**

above: *Shortly after the Marriage*. **Hogarth**

left: *Diana resting after her Bath*. **Boucher**

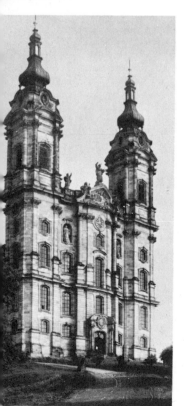

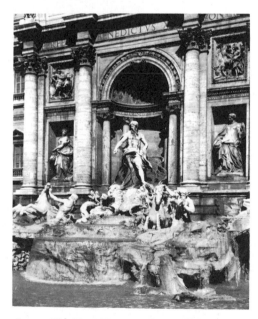

above: *The Trevi Fountain*, Rome. **Salvi**

left: *Vierzehnheiligen*, near Bamberg. Façade. **Neumann**

	Key works: PAINTING	Key works: ARCHITECTURE	Key works: SCULPTURE
ITALY	1751 *The Rhinoceros* by **P. Longhi** (1702–85) Ca' Rezzonico, Venice; best-known work of Venetian genre painter. 1757 *Ancient Rome* and *Renaissance Rome* by **Pannini** (*c*.1691–*c*.1768) Metropolitan Museum, New York; pair of huge pictures by view-painting specialist. 1761 *Parnassus* by **Mengs** (1728–79), Villa Albani, Rome; Neoclassical fresco by friend of Winckelmann, his best-known work. 1763 *Election of Doge Alvise IV Mocenigo* by **F. Guardi** (1712–93), Louvre, Paris; dated set of pictures by Venetian Vedute painter. 1766 *General Gordon* by **Batoni** (1707–87), Fyvie Castle, Scotland; portrait of kilted Scotsman set against the Colosseum.	1751 *Palace of Caserta* by **Vanvitelli** (1700–73) commissioned; vast Baroque palace with chapel and garden vistas clearly inspired by Versailles; built for Charles VII. 1752 *Albergo dei Poveri*, Naples, by **Fuga** (1699–1782); huge classicizing work of Roman architect summoned to Naples by Charles VII. 1761 *Church of the Annunciation*, Naples, by **Vanvitelli**; colossal church commissioned by Charles VII. 1764–6 *S. Maria del Priorato*, Rome, by **Piranesi** (1720–78); building in antique manner; only work of great architectural theorist and engraver.	1750–62 *Allegory of Disenchantment* by **Queirolo** (1704–62) Cappella Sansevero dei Sangro, Naples; figure of Man being freed from net of delusion by spirit of Wisdom. 1766 *St Bruno* by **Houdon** (1741–1828) S. Maria degli Angeli, Rome; work which established the artist's reputation. 1770–80 *Diana and the Nymphs* by **Vanvitelli** (1700–73) and assistants, Caserta; group of over life-size figures; one of many in the palace gardens.
FRANCE AND SPAIN	1752 *Madame de Pompadour* by **M. Q. de La Tour** (1704–88), Louvre, Paris; famous portrait in pastel. 1752 *Young Girl Resting* by **Boucher** (1703–70), Alte Pinakothek, Munich; playful nude which scandalized Diderot. 1754 *Port de Marseilles* by **Vernet** (1714–89), Musée de la Marine, Paris; first of fourteen pictures of French ports commissioned by the Marquis de Marigny. 1755 *Grandfather reading the Bible to his Family* by **Greuze** (1725–1805), Hermitage, Leningrad; popular moralizing and sentimental work; acclaimed at the Salon of 1755. 1764–6 *Apotheosis of the Spanish Monarchy* by **Tiepolo** (1696–1770), Royal Palace, Madrid; frescos in the Queen's Ante-room; part of huge programme for Charles III. 1766 *The Swing* by **Fragonard** (1732–1806), Wallace Collection, London; thoroughly Rococo masterpiece.	1751 *École Militaire*, Paris, begun by **J.-A. Gabriel** (1698–1782); important Neoclassical building for Louis XV. 1752 *Palace of Queluz* completed by **Vicente de Oliveira** (1710–86); Portuguese palace; highly decorated façade by leading Rococo architect. 1753–5 *Place de la Carrière*, Nancy, by **Héré** (1705–63); outstanding example of Rococo town-planning for the Duke of Lorraine. 1755 *Panthéon*, Paris, planned by **Soufflot** (1713–80); Neoclassical centralized church with dome inspired by St Paul's Cathedral. 1762 *Petit Trianon*, Versailles, by **J.-A. Gabriel**; most purely classical work by king's architect; built for Mme de Pompadour. 1775 *Grand Théâtre*, Bordeaux, begun by **Victor Louis** (1731–1800); masterpiece of architect trained in French Academy in Rome.	1753 *Tomb of Languet de Gergy* by **Michelangelo Slodtz** (1705–64), St-Sulpice, Paris; three figures in dramatic attitudes in marble and bronze. 1753 *Tomb of the Maréchal de Saxe*, St-Thomas, Strasbourg, by **Pigalle** (1714–85); sculptor's masterpiece; the deceased shown about to enter coffin while France tries to detain him. 1754 *The Agony in the Garden* by **Salzillo** (1707–83), Museo Salzillo, Murcia; group of life-sized figure in wood to be carried in the Holy Week processions. 1758 *Love and Friendship* by **Pigalle**, Louvre, Paris; marble; commissioned by Mme de Pompadour, the king's mistress and great patroness of the arts. 1767 *Venus Bathing* by **Allegrain** (1710–95), Louvre, Paris; marble; commissioned by Louis XV for Mme du Barry; exhibited in the Salon of 1767. 1773 *Bust of Mme du Barry* by **Pajou** (1730–1809), Louvre, Paris; work of sculptor to Louis XVI greatly admired in the Salon of 1773.
NORTH AND CENTRAL EUROPE	c.1750 *Robert Andrews and his Wife* by **Gainsborough** (1727–88), National Gallery, London early portrait with gentle landscape. 1753 *Europe* by **Tiepolo** (1696–1770), Residenz, Würzburg; famous fresco by Venetian painter in the Kaisersaal of the palace. c.1755 *The Painter's Wife* by **Ramsay** (1713–84), National Gallery of Scotland; best-known work of Italian-trained Scottish painter. 1770 *White Horse frightened by a Lion* by **Stubbs** (1724–1806), Walker Art Gallery, Liverpool; one of three dramatic paintings of the lion and horse fighting. c.1773 *Self-Portrait* by **Reynolds** (1723–92), Royal Academy, London; work of major English Academician in imitation of a Rembrandt self-portrait.	c.1750–70 *Strawberry Hill*, Twickenham, enlarged by **Horace Walpole** (1717–97); established fashion for Gothic Style. 1751 *Music Room of Palace of Sanssouci*, Potsdam, completed by **Knobelsdorff** (1699–1753); part of private retreat of Frederick the Great of Prussia; shows Chinese influence. 1760–9 *Syon House, London,* by **Robert Adam** (1728–92); one of grandest and most complete of his Neoclassical houses. 1763 *Abbey Church of Rott-am-Inn* by **Fischer** (1692–1766) completed; last work of prolific South German Rococo architect. 1767–75 *Royal Crescent*, Bath, by **John Wood the Younger** (1728–81); widely-copied, open-planned crescent in Palladian style.	1750–60 *Statue of Emperor Francis I* by **Moll** (1717–85), Barockmuseum, Vienna; figure in informal pose and Roman dress. c.1755 *Chinese Gentlemen having Tea* by **Heymüller** (*c*.1710/15–63), Sanssouci, Potsdam; gilt sandstone figures seated around columns of the tea-house. 1761 *The Nightingale Monument* by **Roubiliac** (1705–62), Westminster Abbey, London; chilling representation of Death in action. 1763 *Tobias and the Angel* by **Ignaz Gunther** (1725–75), Bürgersaal, Munich; charming painted wooden figures portrayed in movement. c.1770 *Character Head* by **Messerschmidt** (1736–83), Barockmuseum, Vienna; one of sixty-nine lead busts showing great range of facial expressions.

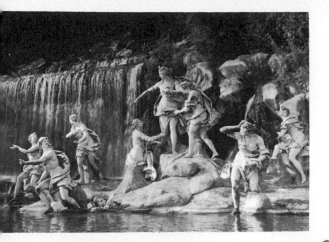

left: *Diana and the Nymphs.* **Vanvitelli**

below: *Panthéon, Paris.* **Soufflot**

below left: *Tomb of the Maréchal de Saxe.* **Pigalle**

1751 **Conca (1680–1704) commissioned to decorate the destroyed church of Sta Chiara, Naples. James Stuart (1713–88) visits Athens. Marquis de Marigny appointed Surveyor of Royal Works by Louis XV.**

1753–7, **French architect Peyre (1730–88) studying in Rome.** *Analysis of Beauty* **by Hogarth (1697–1764).**

1754 Charles VII of the Two Sicilies becomes King of Spain. **Articles attacking the Rococo style appear in the Mercure de France. 1754–65, Robert (1733–1808) in Rome. 1754–8, Robert Adam on the Grand Tour.**

1755 **Winckelmann (1717–68) settles in Rome and publishes his** *Reflections on the Imitation of Greek Works of Art in Painting and Sculpture.*

1756 Seven Years' War begins. **Canaletto (1697–1768) returns to Venice. 1756–61, Fragonard in Rome. Piranesi (1720–78) publishes** *Le Antichità Romane.*

1758 Russian invasion of Prussia repulsed. **Le Roy's** *Les Ruines des Plus Beaux Monuments de la Grèce.* **Imperial Academy of Fine Arts founded in Russia.**

1759–70 **Sculptor Nollekens (1737–1823) in Rome.** *Treatise on Civil Architecture* **by Chambers (1723–96), becomes standard work.**

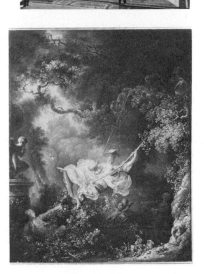

above: *The Swing.* **Fragonard**

1760 George III succeeds George II of Britain. Russian and Imperial troops occupy and burn Berlin. *Enquiry into the Beauties of Painting* by D. Webb.

1761 Franco-Spanish Family Compact renewed. **Charles III of Spain invites Tiepolo and the German painter Mengs to Madrid. 1761–2, Piranesi's** *Della Magnificenza ed Architettura de' Romani.*

1762 Peter III assassinated; succeeded by Catherine II. French capitulate at Cassel. Rousseau's *Du Contrat Social.* Macpherson's *Fragments of Ancient Poetry* (Ossian). **Mengs'** *Treatise on Beauty.* **The Antiquities of Athens, first volume by Stuart and Revett.**

1763 Peace of Paris between Britain, France, Spain and Austria ends the Seven Years' War. **American painter West (1739–1820) settles in London.**

1764 Walpole's *Castle of Otranto.* **Winckelmann's** *The History of Ancient Art.* **1764–8, French sculptor Houdon (1741–1828), in Rome.**

1765 Accession of Joseph II as Emperor. **German sculptor Messerschmidt visits London and Rome.**

1766 British troops retreat from Boston. **Angelica Kauffmann (1741–1807), painter, arrives in London. Diderot's** *Essays on Painting* **published.**

1768 Turkey declares war on Russia. Corsica ceded to France. **Reynolds becomes first President of the Royal Academy, founded by George III. Sterne's** *Sentimental Journey.* **Adam brothers embark on the ruinous Adelphi plan, houses now destroyed.**

1771 Accession of Gustavus III of Sweden. First edition of the *Encyclopaedia Britannica* completed. Mackenzie's *The Man of Feeling.* **Goya (1746–1828) in Rome.** *Anecdotes of Painting in England* completed by Vertue (1684–1756).

1772 Goethe's *Von Deutscher Baukunst* published. **Mengs working in the Vatican. 1772–9, Banks in Rome.**

1773 Jesuits expelled from the Empire by Joseph II. The Polish Diet accept Partition. The Boston Tea Party. **Wedgwood sets up new pottery at Etruria. James Adam (1732–94) and Robert Adam (1728–92) publish first volume of** *Works in Architecture.* **Ledoux becomes French royal architect.**

1774 Accession of Louis XVI. Peasant revolt in Austria. Rebellion in Russia against Catherine II. Goethe's **The Sorrows of Werther. Romney (1734–1802) goes to Rome. Gainsborough comes to London. David (1748–1825) wins the Prix de Rome.**

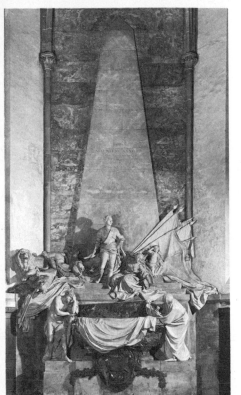

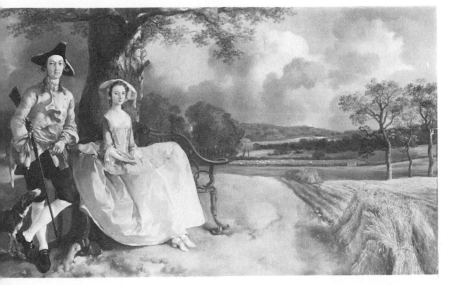

Robert Andrews and his Wife. **Gainsborough**

ITALY

c.1780 *View of S. Maria della Salute and the Dogana* by **F. Guardi** (1712–93), Wallace Collection, London; famous scene painted in impressionistic manner characteristic of the artist.
1784 *The Oath of the Horatii* by **David** (1748–1825), Louvre, Paris; one of key works in the history of Neoclassicism; painted in Rome and acclaimed at the Salon of 1785.
1792 *The Sleeping Endymion* by **Girodet** (1767–1824), Louvre, Paris; romantic picture of moonlit youth in eternal sleep by pupil of David in Rome.

1776 *The Rotonda*, Museo Vaticano, Rome, by **Simonetti** (1724–81); commissioned by Pope Pius VI for the display of antiquities.
1776–8 *Teatro della Scala*, Milan, by **Piermarini** (1734–1808); most famous work by Neoclassical architect; severe façade and rich interior decoration.
1793 *Villa Belgioioso*, Milan, by **Pollak** (1751–1806); splendid Neoclassical villa with frescos by **Appiani** (1754–1817).

1778 *Thetis and her Nymphs* by **Banks** (1735–1803), Victoria and Albert Museum, London; marble relief showing careful study of antique models.
1782–7 *Monument to Pope Clement XIV* by **Canova** (1757–1822), SS. Apostoli, Rome; first major work by leading Neoclassical sculptor.
1787–93 *Cupid and Psyche* by **Canova**, Louvre, Paris; famous statue of idealized figures in lovers' embrace.
1791–2 *The Fury of Athamas* by **Flaxman** (1755–1826), Ickworth House, England; dramatic work of English Neoclassical sculptor in Rome; inspired by the Laocoön.

FRANCE AND SPAIN

1775 *Self-Portrait* by **Chardin** (1699–1779), Louvre, Paris; masterpiece in pastel; one of two self-portraits exhibited in the Salon of 1775.
c.1777 *The Sunshade* by **Goya** (1746–1828), Prado, Madrid; famous painting; one of a series of designs for tapestries for the Royal Palace.
1786 *Demolition of Houses on the Pont Notre-Dame* by **Robert** (1733–1808), sometimes called Robert des Ruines, Musée Carnavalet, Paris; artist fascinated by architectural painting.
1793 *The Murdered Marat in his Bath* by **David** (1748–1825), Musées Royaux des Beaux-Arts, Brussels; a memorial to Marat, assassinated in 1793.
c.1797–1800 *Maja Nude* by **Goya**, Prado, Madrid; one of two famous pictures portraying Maja nude and clothed.

1777 *Bagatelle* by **Bélanger** (1745–1818), Bois de Boulogne, Paris; Neoclassical masterpiece set in English gardens; built in sixty-four days.
1780 *Le Hameau* by **Mique** (1728–94), at Versailles; miniature rustic village for Queen Marie Antoinette.
1780 *La Palma del Condado* by **A. M. Figueroa** (c.1734–96?); elegant campanile built by member of famous family of architects.
1783 *Façade of Pamplona Cathedral* by **Rodriguez Tizon** (1717–85); late Baroque work of architect's austere phase.
1784 *Barrière de la Villette*, Paris, by **Ledoux** (1736–1806); one of four Neoclassical toll-houses.
1785 *The Queen's Dairy*, Château de Rambouillet, possibly designed by **Robert** (1733–1808); Arcadian dairy comprising a domed room and a grotto.

1776 *Nude Statue of Voltaire* completed by **Pigalle** (1714–85), Louvre, Paris; realistic work begun in 1770; first of long series of nude portrait statues.
1778 *Seated Statue of Voltaire* by **Houdon** (1741–1828) Comédie Française, Paris; famous statue of draped figure.
c.1780–90 *Cupid and Psyche* by **Clodion** (1738–1814), Victoria and Albert Museum, London; fine work of specialist in charming statuettes.
1782–90 *Psyche Abandoned* by **Pajou** (1730–1809), Louvre, Paris; masterpiece which scandalized the Salon.
1786–7 *The Nymph Amalthea* by **Julien** (1731–1804), Louvre, Paris; previously part of the sculptural decoration of the Dairy at Rambouillet.

NORTH AND CENTRAL EUROPE

1781 *Sir Brooke Boothby* by **Wright of Derby** (1734–97), National Gallery, London; one of best-known portraits by painter who specialized in lighting effects; subject shown lying in a glade reading Rousseau.
1781 *The Nightmare* by **Fuseli** (1741–1825), Goethe Museum, Frankfurt; famous imaginative evocation of Romantic horror.
c.1784 *The Rev. Robert Walker Skating* by **Raeburn** (1756–1823), National Gallery, Edinburgh; famous painting; the attribution to Raeburn uncertain.
c.1785 *The Morning Walk* by **Gainsborough** (1727–88), National Gallery, London; husband and wife portrait; the artist's rapid brush-stroke gives the couple an ethereal quality.
1787 *Goethe in the Campagna* by **Tischbein** (1751–1829), Städel, Frankfurt; painting on which the artist's reputation stands.
1788 *Lord Heathfield* by **Reynolds**, National Gallery, London; one of finest examples of the artist's late style in portraiture.
1795 *Elohim creating Adam* by **Blake** (1757–1827), Tate Gallery, London; highly individual work of visionary painter-poet, in watercolour.

1776–86 *Somerset House*, the Strand, London by **Chambers** (1723–96); eclectic masterpiece by scholarly architect.
c. 1784 *Palace at Haga* begun by **Desprez** (1742–1804); residence for Gustavus III of Sweden; Neoclassical style.
1788 The *Brandenburg Gate*, Berlin, by **Langhans** (1732–1808); huge triumphal arch crowned by a quadriga by Schadow (1764–1850).
1791 *Charlotte Square*, Edinburgh, designed by **Robert Adam** (1728–92); one of several major commissions in architecture and town-planning for the New Town.
1791 *Alexander Palace*, Tsarskoe Selo, by **Quarenghi** (1744–1817); Neoclassical work of Italian architect in Russia; a gift from Catherine II to the future Czar Alexander I.

1790 *Monument to Graf von der Marck*, Berlin, by **Schadow** (1764–1850); tomb of young boy; artist's first major commission.
1790–85 *Monument to Gustavus III*, Stockholm, by **Sergel** (1740–1814); restrained classicizing presentation of great patron of the arts.
1795–1806 *The Emperor Joseph II*, Josefsplatz, Vienna by **Zauner** (1746–1822); equestrian statue of high quality.
1795–7 *The Princesses Luise and Fredericka of Prussia* by **Schadow**, Staatliche Museen, Berlin; marble; full-length portraits of great charm.
1795 *Monument to Lord Chief Justice Mansfield*, Westminster Abbey, London, by **Flaxman** (1755–1826); major work of Neoclassical sculptor employed by Wedgwood.

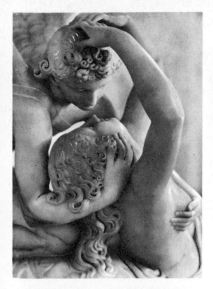

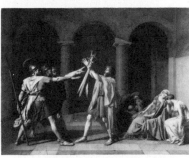

above: *Self-Portrait*. **Chardin**

above left: *Cupid and Psyche*. Detail. **Canova**

left: *The Oath of the Horatii*. **David**

below: *Maja Nude*. **Goya**

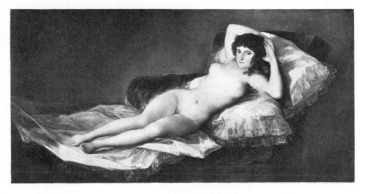

The Brandenburg Gate, Berlin. **Langhans**

1775 American War of Independence begins. *The Barber of Seville* by Beaumarchais. **French painter David arrives in Rome. Ledoux plans the saltworks at Arc-en-Sénans.**

1776 American Declaration of Independence. Adam Smith's *The Wealth of Nations*. **Architect Quarenghi summoned to St Petersburg, settles there.**

1777 Perpetual Alliance between Spain and Portugal.

1779 Charles III besieges Gibraltar. **Sergel, Swedish sculptor, returns from Italy. German painter Tischbein in Italy. Mme Vigée-Lebrun (1755–1842) summoned to Versailles to paint Marie Antoinette.**

1780 Emperor Joseph II succeeds to Austrian throne. **Sculptor Canova visits Rome and Naples, settles in Rome in 1781.**

1781 Edict of Toleration issued by Joseph II. Rousseau's autobiography *Confessions*. Schiller's drama *Die Räuber*. **Reynolds visits Holland.**

1782 Franco-Spanish forces take Minorca from the British. Watt invents the steam-engine. **Architect Chambers appointed Surveyor General to the King.**

1783 Treaty of Versailles ends American War of Independence. Russians take the Crimea.

1784 **Boullée (1728–99) designs his cenotaph for Newton. F. Guardi belatedly elected to the Venetian Academy, *c*. 1784.**

1785–7 **German sculptor Schadow in Rome. Houdon goes to America to make a statue of Washington.**

1786 Death of Frederick the Great. Accession of Frederick William II. Kant's *Metaphysical Rudiments*. **Goya appointed King's Painter in Madrid.**

1787 *Paul et Virginie* by Saint-Pierre. *Don Carlos* by Schiller. Mozart's *Don Giovanni* first performed. **1787–94, English sculptor Flaxman in Rome.**

1789 Washington elected first President of the U.S.A. French Estates General meet at Versailles. The Oath of the Tennis Court taken by the Estates.

1790 Belgian Republic destroyed. Accession of Emperor Leopold II. Kant's *Critique of Judgement*.

1791 Louis XVI imprisoned. Paine's *Rights of Man*. Mozart's *Requiem*.

1792 France declared a Republic. Gustavus III assassinated at the Stockholm Opera-house. **Louvre opened as a public museum. West (1738–1820) appointed President of the Royal Academy on the death of Reynolds. Lawrence (1769–1830) becomes Painter to the King.**

1793 Charles IV declares war on the new French Republic. Execution of Louis XVI and Marie Antoinette. Reign of Terror begins. **In Rome, Flaxman publishes his illustrated editions of the *Iliad* and *Odyssey*.**

1795 Second rising in Paris quelled by Bonaparte. **Mme Vigée-Lebrun in Russia. Architect Latrobe (1764–1820) emigrates to America.**

1796 Death of Catherine the Great of Russia. **Soane's Rotunda for the Bank of England built, now demolished. Beckford's huge Gothic creation Fonthill Abbey begun by James Wyatt (1747–1813), soon collapsed.**

1797 Bonaparte on victorious campaign in northern Italy. **Italian sculptor Canova visits Vienna. German architect Gilly (1772–1800) produces a plan for a National Monument to Frederick the Great.**

1798 French troops sack Rome and found a Roman Republic.

1799 Establishment of the Consulate in France. **Goya's etchings *Caprichos* published.**

1800–1824

	Key works: PAINTING	Key works: ARCHITECTURE	Key works: SCULPTURE
ITALY	1808 *Grande Baigneuse* by **Ingres** (1780–1867), Louvre, Paris; one of earliest in series of nudes by French painter living in Rome. 1819–29 *Tasso Room*, Casino Massimo, Rome, by **Overbeck** (1789–1869) and **Führich** (1800–76); one of three rooms decorated by the German Nazarene painters in their characteristic Quattrocento manner.	1806–38 *Arco della Pace*, Milan, by **Cagnola** (1762–1833); rich Neoclassical work of leading architect during Napoleonic régime in Milan. 1816–37 *Caffè Pedrocchi*, Padua, by **Japelli** (1783–1852); Romantic Neoclassical building with Neo-Gothic wing, exceptional in Italy. 1819 *Tempio Canoviano*, Possagno, begun by **Canova** (1757–1822); sculptured temple completed by **Selva** (1751–1819) following design of the Pantheon.	1808 *Venus Victrix* by **Canova** (1757–1822), Museo Borghese, Rome; marble statue of Princess Pauline Bonaparte Borghese reclining; realistic portrait in imitation of the antique. 1811 *Queen Louise* by **Rauch** (1777–1857), Charlottenburg, Berlin; charming statue executed in Carrara and Rome for mausoleum built in Charlottenburg Park. 1817 *Bust of Giuseppe Bossi* by **Pacetti** (1758–1826), Brera, Milan; portrait of a successful sculptor; regarded as one of the best works of Italian Classicism.
FRANCE AND SPAIN	1800 *Napoleon Crossing the Alps* by **David** (1748–1825), Versailles Museum; exemplary work of heroic official art by Neoclassicist. 1802 *Ossian Receiving the Generals of the Republic* by **Girodet** (1767–1824), Château de Malmaison; Napoleon being welcomed by his favourite author to a mythological heaven. 1804 *Plague at Jaffa* by **Gros** (1771–1835), Louvre, Paris; heroism in the midst of sickness and despair; finest in series of large military paintings. 1808 *Rape of Psyche* by **Prud'hon** (1758–1823), Louvre, Paris; romantic mythological scene by painter at odds with the predominant fashions. 1814 *The Third of May 1808* by **Goya** (1746–1828), Prado, Madrid; contemporary event depicted with shocking realism. 1819 *The Raft of the Medusa* by **Géricault** (1791–1824), Louvre, Paris; important painting based on recent disaster; heightened realism caused an outcry. c. 1820–3 *Saturn Devouring One of his Children* by **Goya**, Prado, Madrid; horrific wall-painting in oil from the Quinta del Sordo.	1806–42 *La Madeleine*, Paris, by **Vignon** (1762–1828); begun as the Temple de la Gloire in appropriate classical style, later adapted for church use. 1806–35 *Arc de Triomphe*, Paris, by **Chalgrin** (1739–1811) and others; major monument in Roman Revival under Napoleon, first of its kind in the century. 1806–7 *Arc du Carousel*, Paris, by **Percier** (1764–1838) and **Fontaine** (1762–1853); arch built by the Emperor's favourite architects, once crowned by the four bronze horses of Venice. 1808 *Bourse*, Paris, by **Brongniart** (1739–1813); vast Neoclassical stock exchange. 1824 *St Vincent-de-Paul*, Paris, by **Hittorf** (1793–1867); classical basilica with Early Christian elements; early example of nineteenth-century polychromy.	1802 *Bust of Napoleon* by **Corbet** (1758–1808), Versailles Museum; one of few sculpted portraits of the period not predominantly influenced by Canova's style.
NORTH AND CENTRAL EUROPE	1805–6 *Rest on the Flight into Egypt* by **Runge** (1777–1810); Kunsthalle, Hamburg; one of two biblical paintings by German mystic. 1812–20 *Head of Princess Lieven* by **Lawrence** (1769–1830), Tate Gallery, London; one in series of portraits of European aristocrats by court painter. 1812 *Hannibal Crossing the Alps* by **Turner** (1775–1851), Tate Gallery, London; bold work conveying the effect of violent forces of nature in action. 1820 *Belshazzar's Feast* by **Martin** (1789–1854), Mellon Collection; best version of sensational work, toured through Britain and the U.S. 1821 *The Hay Wain* by **Constable** (1776–1837), National Gallery, London; famous Naturalistic landscape; greatly admired at the Salon of 1824 in Paris. 1824 *Arctic Shipwreck* by **Friedrich** (1774–1840), Kunsthalle, Hamburg; subject matter breaks new ground.	1806–15 *The Admiralty*, Leningrad, by **Zakharov** (1761–1811); masterpiece of Russian architect; typical example of Alexandrine Classicism. 1809–10 *Women's Prison*, Würzburg, by **Speeth** (1772–1831); building with unusually scaled façade. 1811 *Dulwich Art Gallery*, London, by **Soane** (1753–1837); building notable for absence of various traditional features. 1815–23 *Brighton Pavilion* by **J. Nash** (1752–1835); famous royal residence built in a mixture of oriental styles. 1816–34 *Glyptothek*, Munich, by **Klenze** (1784–1864); Neoclassical museum for antique sculpture; for Ludwig I of Bavaria. 1823–47 *British Museum*, London, by **Smirke** (1780–1867); major English example of the Greek Revival.	1810–23 *Fox Monument* by **Westmacott** (1775–1856), Westminster Abbey, London; outstanding English monumental group by pupil of Canova. 1817–19 *Three Graces and Cupid* by **Thorvaldsen** (1768–1844), Thorvaldsen Museum, Copenhagen; one version of popular group by Danish Neoclassicist mainly in Rome. 1821 *Bust of Goethe* by **Rauch** (1777–1857); marble sculpted at Weimar by most successful German sculptor of the period. 1821 *The Lion of Lucerne* executed by **Ahorn** (1789–1856), Lucerne; symbolic memorial to Swiss guards killed in Paris in 1792; designed by **Thorvaldsen.**

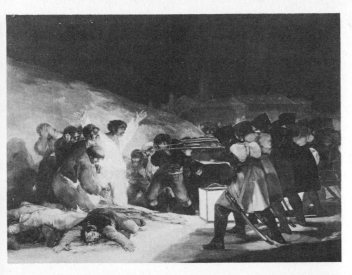

left: *The Third of May 1808.* **Goya**

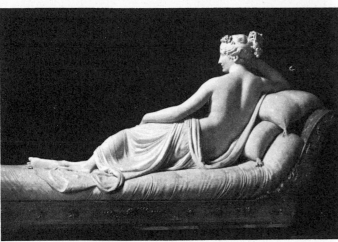

above: *Venus Victrix.* **Canova**

above: *Arc du Carousel*, Paris. Detail. **Percier** and **Fontaine**

above: *Plague at Jaffa.* **Gros**

right: *Arctic Shipwreck.* **Friedrich**

1800 Accession of Czar Alexander I of Russia. French defeat Austrians at Marengo. Schiller's *Maria Stuart.*

1801 Jefferson elected third President of the U.S. *Recueil des Décorations Intérieures* **by Percier and Fontaine. 1801–5, Smirke in Italy and Greece.**

1802 *Precis et Leçons d'Architecture* by Durand (1760–1834). **Canova visits Paris.**

1803 Chatterton's *Collected Works* published posthumously. **J. Crome (1768–1821) founds the Norwich Society.**

1804 Coronation of Emperor Napoleon in Notre-Dame, Paris. Schiller's play *Wilhelm Tell. History of British Birds* illustrated by Bewick (1755–1828).

1805 Austrians defeated by Maréchal Ney. Beethoven's opera *Fidelio.* Wordsworth's poem *The Prelude.*

1806 French enter Berlin, and conquer southern Italy.

1807 Treaty of Tilsit. Beethoven's Fifth Symphony.

1808 Abdication of Charles IV of Spain. First part of Goethe's *Faust* completed.

1809 **Nazarene painters assemble in Vienna.**

1810 **Goya's etchings The Disasters of War executed.** *The Colour Sphere* **by Runge published.**

1811 Prince of Wales becomes Prince Regent.

1812 Napoleon invades Russia. 1812–18, Byron's *Childe Harold.* 1812–16, Hegel's *Logik. The Tour of Dr Syntax* **illustrated by Rowlandson (1756–1827).**

1813 Wellington victorious in Spain. Austen's *Pride and Prejudice.* Hoffman's *Peter Schlemihl.* Shelley's poem *Queen Mab.*

1814 Bourbons restored in France. *The Times* printed by machinery. First efficient steam locomotive constructed. Scott's novel *Waverley.* **Goya retires to France.**

1815 Napoleon's escape from Elba and final surrender. **Schinkel appointed State Architect in Prussia.**

1816 Coleridge's poem *Kubla Khan.* **Elgin marbles bought for the British Museum. Friedrich begins teaching at the Dresden Academy.**

1817 **University of Virginia, Charlottesville begun by Latrobe (1764–1820). Rickman's popular** *Attempt to Discriminate the Styles of English Architecture.*

1818 Charles XIV becomes King of Sweden. Mary Shelley's *Frankenstein.* **Lawrence tours the Continent on commission. Thorvaldsen returns to Denmark.**

1819 Peterloo massacre. Keats's *Ode to a Nightingale.* Telford (1757–1834) builds early suspension bridge over the Menai Straits. **Turner visits Italy.**

1820 Accession of George IV. *Venus de Milo* **discovered. English landscape painter Bonington (1802–28) in Paris. 1820–2, Géricault visits London.**

1821 Greek Wars of Liberation begin. Austrian rule in Lombardy crushed. *Principles of the Electric Motor* published by Faraday. De Quincey's *Confessions of an English Opium Eater.* **Blake (1757–1827) publishes his illustrated** *Jerusalem.*

1822 George IV visits Edinburgh. Turks massacre Greeks at Chios. Schubert's Unfinished Symphony.

1823 Stendhal's *Racine et Shakespeare.* Weber's opera *Euryanthe.*

1824 Hogg's *Confessions of a Justified Sinner.* Beethoven's Choral Symphony. **Rebuilding of Cologne Cathedral begun. Bonington and Constable exhibit at the so-called English Salon of 1824 in Paris.**

ITALY

ARCHITECTURE

1827 *Teatro Carlo Felice*, Genoa, by **Barabino** (1768–1835); theatre in fully developed Romantic Classical style; damaged by bombing in World War II.

SCULPTURE

1831 *Tomb of Pope Pius VII* completed by **Thorvaldsen** (1768–1844), St Peter's, Rome; one of greatest works of Danish Neoclassical sculptor in Rome; begun in 1824.
1837 *Monument to Countess Zamoyski* by **Bartolini** (1777–1850), S. Croce, Florence; work reflects Quattrocento influences.
1838 *Monument to Alessandro Volta*, Como, by **Marchesi** (1758–1858); best-known public work of pupil of Canova.

FRANCE AND SPAIN

PAINTING

1827 *The Death of Sardanapalus* by **Delacroix**, (1798–1863), Louvre, Paris; multiple death scene inspired by Byron, caused an uproar at the Salon.
1830 *Liberty Leading the People* by **Delacroix**, Louvre, Paris; famous painting celebrating the 1830 Revolution; a mixture of realism and allegory.
1834 *Two Sisters* by **Chassériau** (1819–56), Louvre, Paris; fine portrait of intense colour and detailed realism.
1834 *Rue Transnonain, 14 April 1834* by **Daumier** (1808–79), Bibliothèque Nationale, Paris; lithograph depicting an event of brutal violence by great political and social satirist.
1837 *Avenue of Chestnut Trees* by **T. Rousseau** (1812–67), Louvre, Paris; early landscape by central figure of the Barbizon School; rejected by the Salon of 1837.
1847 *Romans of the Decadence* by **Couture** (1815–79), Louvre, Paris; extravagant satirical history painting by popular Salon painter.

ARCHITECTURE

1834–50 *Ste Geneviève Library*, Paris, by **Labrouste** (1801–75); Italian Renaissance style building with exposed internal iron framework.
1836–41 *Law Courts*, Lyons, by **L–P. Baltard** (1764–1846); belated example of Empire style with long row of gigantic Corinthian columns.
1846–57 *Ste-Clotilde*, Paris, by **Gau** (1790–1853); iron-roofed church completed by **Ballu** (1817–74).

SCULPTURE

1830 *The Country Distributing Laurels to her People* by **David d'Angers** (1788–1856), Panthéon, Paris; relief by conventional Romantic sculptor.
1832 *Lion Crushing a Serpent* by **Barye** (1796–1875), Walters Art Gallery, Baltimore; master bronze of famous work used for making countless editions.
1833–6 *La Marseillaise* by **Rude** (1784–1855), Arc de Triomphe, Paris; famous patriotic deep relief depicting the departure of the Volunteers in 1792.
1834 *Massacre* by **Préault** (1810–79), Chartres Museum; bronze bas-relief reflecting socialist ideals of sculptor admired by Romantic writers.
1845 *Napoleon Awakening to Immortality* by **Rude**, Louvre, Paris; dramatic relief commissioned by an admirer of the Emperor.

NORTH AND CENTRAL EUROPE

PAINTING

c. 1825 *Satan Smiting Job* by **Blake** (1757–1827), Tate Gallery, London; tempera on mahogany; illustration by great English mystic.
1829 *The Leaping Horse* by **Constable** (1776–1837), Tate Gallery, London; full-scale sketch for large work in artist's freer later technique.
1830 *Coming from Evening Church* by **Palmer** (1805–81), Tate Gallery, London; one of best-known works of English Romantic.
1837 *The Old Shepherd's Chief Mourner* by **Landseer** (1802–73), Victoria and Albert Museum, London; sentimental work by Queen Victoria's favourite painter.
1838 *The Fighting Temeraire* by **Turner** (1775–1851), National Gallery, London; famous seascape symbolizing the end of an era.
1844 *Rain, Steam and Speed* by **Turner**, National Gallery, London; remarkably Impressionistic work suggesting light and rushing speed.
1845 *Room with an Open Window* by **Menzel** (1815–1905), Staatliche Museen, West Berlin; scene endowed with symbolic overtones by great Naturalistic painter.

ARCHITECTURE

1825 *Altes Museum*, Berlin, by **Schinkel** (1781–1841) begun; distinguished Greek Revival work by greatest German architect of the century.
1825 *Royal High School*, Edinburgh, by **Hamilton** (1784–1858) begun; adaptation of an antique temple.
1826–7 *Cumberland Terrace*, Regent's Park, London, by **Nash** (1752–1835); part of extensive programme in London by court architect.
1831–42 *Valhalla*, near Regensburg, by **Klenze** (1784–1864); strict copy of the Parthenon in honour of the country's worthies.
1840–64 *Houses of Parliament*, London, by **Barry** (1795–1860); commission won in competition; perpendicular Gothic elevation; interior designed by **Pugin** (1812–52).
1845 *Friedenskirche*, Potsdam, by **Persius** (1803–45); picturesque church partly designed by the patron, Frederick William IV.
1847 *Dresden Picture Gallery* by **Semper** (1803–79); built in Italian Renaissance style; one of architect's major works.

SCULPTURE

1833 *Wilberforce Monument* by **Joseph** (1791–1850), Westminster Abbey, London; realistic portrait of subject in informal pose.
1836 *Scott Monument*, Edinburgh, designed by **Kemp** (1795–1847); statue of the novelist crowned by extremely elaborate Gothic canopy.
1839–52 *Monument to Frederick the Great* by **Rauch** (1777–1857), Boulevard of Unter den Linden, Berlin; sculptor's most famous work, but similar to much of the mass-produced statuary of the time.

left: *The Death of Sardanapalus.*
Delacroix

left: *Rue Transnonain, 14 April
1834.* **Daumier**

below: *La Marseillaise.* **Rude**

above: *The Old Shepherd's Chief Mourner.*
Landseer

below: *Cumberland Terrace*, London. **Nash**

1825 Accession of Czar Nicholas I. First passenger railway opens. **Delacroix visits London. 1825–8, Corot (1796–1875) visits Italy.**

1826 ***Grimm's Tales* illustrated by Cruickshank (1792–1878). Bonington (1802–28) tours Italy.**

1827 Serfdom abolished in Prussia. Manzoni's novel *I Promessi Sposi.* Baedeker's Handbooks begin. ***Birds of North America,* Part I illustrated by Audubon (1785–1851). Palmer retires to Shoreham.**

1828 **French edition of Goethe's *Faust* with lithographs by Delacroix.**

1829 Rossini's opera *William Tell.* Mendelssohn visits Scotland. **English architect Upjohn (1802–78) emigrates to America. Daumier issues his first lithographs.**

1830–48 Louis Philippe of France reigns.

1830 Hugo's play *Hernani* performed. **1830–33, architect Semper in Italy and Greece. Four engravings *The English Landscape* by Constable.**

1831 Balzac's *La Peau de Chagrin.*

1832 Republican rising in Paris. Hugo's *Le Roi s'Amuse.* **Daumier imprisoned. Delacroix visits Morocco.**

1834 Houses of Parliament, Westminster, burnt down. **Collins invents machine to reduce sculpture accurately. Thirty-six *Views of Mount Fuji,* colour prints by Hokusai (1760–1849).**

1835 Musset's poems *Les Nuits.* Vigny's *Chatterton.*

1836 First part of the *Pickwick Papers* by Dickens appears. **Pugin's *Contrasts.***

1837 Accession of Queen Victoria. Rebellion in Canada.

1838 **Commission des Monuments Historiques founded in France, directed by Mérimée. 1834–46, Hansen (1813–91) in Athens.**

1839 Queen Victoria marries Albert of Saxe-Coburg. Daguerreotype developed. **Hunt's *The Art of Photography.* Scots painter Wilkie (1785–1841) in the Near East.**

1840–2 **Engravings by Menzel for Kugler's *Life of Frederick the Great.***

1841 Schumann's Spring Symphony. Browning's poem *Pippa Passes.* **1841–68, *The Ecclesiologist* periodical. 1841, Ingres (1780–1867) returns to France.**

1842 Gogol's *Dead Souls.* Macaulay's *Lays of Ancient Rome.* **Cottage Residence by American designer Downing (1815–52). Market Hall, Paris, begun by V. Baltard (1805–74) in iron and glass, since demolished.**

1843 Kierkegaard's *Fear and Trembling.* Wagner's *The Flying Dutchman* performed. J. S. Mill's *System of Logic.* **Modern Painters, Volume I, by Ruskin.**

1845 Electromagnetic theory of light.

1846 Repeal of the Corn Laws. Balzac's *Cousine Bette.* Thackeray begins *Vanity Fair.* **Jongkind (1819–91) moves to Paris.**

1847 Murger's *Scenes of Bohemian Life. Wuthering Heights* by Emily Brontë. **Iron and glass Coal Exchange, London, by Bunning (1802–63), since demolished.**

1848 Revolutions throughout Europe. Marx and Engels' *Communist Manifesto.* **Pre-Raphaelite Brotherhood founded.**

1849 **Ruskin's *Seven Lamps of Architecture. The Stonebreakers* by Courbet (1819–77). Millet (1814–75) settles in Barbizon.**

	Key works: PAINTING	Key works: ARCHITECTURE	Key works: SCULPTURE
FRANCE	1850 *The Sower* by **Millet** (1814–75), Museum of Fine Arts, Boston; first version of famous painting of peasant life; the subject is accorded a new dignity. 1850 *The Burial at Ornans* by **Courbet** (1819–77), Louvre, Paris; large realistic work well-received in the provinces but caused an uproar in Paris because of the supposed ugliness of the citizens depicted. 1855 *The Studio of the Painter* by **Courbet**, Louvre, Paris; subtitled A Real Allegory of Seven Years of My Artistic Life; shows the painter at work and his friends, including Baudelaire. 1856 *Mme Moitessier* by **Ingres** (1780–1867), National Gallery, London; second version of one of painter's most famous portraits. 1859 *The Angelus* by **Millet**, Louvre Paris; most popular of artist's peasant pictures.	1852 *New Louvre*, Paris begun by **Visconti** (1791–1853); foremost monument in Second Empire style; carried out by **Lefuel** (1810–80). 1852 *Marseilles Cathedral* begun by **Vaudoyer** (1803–72); masterpiece inspired by Romanesque and Byzantine building; highly coloured and multi-domed. 1854–5 *St-Eugène*, Paris, by **Boileau** (1812–96); church with iron columns and vaulting ribs; built on low budget.	1850 *Ratapoil* by **Daumier** (1808–79) Louvre, Paris; bronze figure symbolizing the Bonapartist Revival by famous French cartoonist. 1852–3 *Le Maréchal Ney* by **Rude** (1784–1855), Rue de l'Observatoire Paris; bronze statue of warrior, conveying his fighting spirit in a gesture.
NORTH AND CENTRAL EUROPE	1850 *Ecce Ancilla Domini* by **Rossetti** (1828–82), Tate Gallery, London; Pre-Raphaelite Annunciation, for which the artist's sister, Christina, sat. 1852–4 *Ophelia* by **Millais** (1829–96), Tate Gallery, London; Romantic death-scene with minutely detailed riverbank background. 1852–4 *The Awakened Conscience* by **Holman Hunt** (1827–1910), Collection Sir Colin Anderson; painting with strong moral meaning, by leading Pre-Raphaelite. 1854 *The Light of the World* by **Holman Hunt**, Keble College, Oxford; most famous Victorian religious painting. 1856–8 *Derby Day* by **Frith** (1819–1909), Tate Gallery, London; huge detailed panorama of Victorian society at the races.	1855–9 *Pitt-Rivers Museum*, Oxford, by **Deane** (1792–1871) and **Woodward** (1815–61); Neo-Gothic museum with iron and glass roof, caused Ruskin to resign as consultant architect. 1856–79 *Votivkirche*, Vienna by **Ferstel** (1828–83); highly praised Neo-Gothic church in Austria. 1859 *All Saints*, Margaret St, London completed by **Butterfield** (1814–1900); High Victorian Neo-Gothic masterpiece begun by Ecclesiologist architect in 1849. 1859 *The Red House*, Bexley Heath, by **Philip Webb** (1831–1915); house with interior design by Morris (1834–96) considered revolutionary because of its lack of historicism and stress on functional requirements.	1857 *Virtue overcoming Vice* by **Stevens** (1817–75), Tate Gallery, London; plaster model of female figure; study for part of the Wellington Monument, St Paul's Cathedral. 1857 *Bust of Tennyson* by **Woolner** (1825–92), Trinity College Library, Cambridge; conventional portrait by one of the first Pre-Raphaelites. 1858 *Lions*, base of Nelson's Column, Trafalgar Sq., London; designed by **Landseer** (1802–73); work of highly popular animal painter; cast by **Marochetti** (1805–67).
SOUTH EUROPE	1858 *Val d'Aosta* by **Brett** (1831–1902), Collection Sir W. Cooper; minutely depicted Italian mountain landscape by English painter influenced by Ruskin. 1859 *Romeo and Juliet* by **Hayez** (1791–1882), Gallery of Modern Art, Milan; much praised work of well-known Italian Romantic.		c. 1850 *Tinted Venus* by **Gibson** (1790–1866), Collection P. J. Dearden; coloured marble nude by English sculptor in Rome; his best-known work. 1857 *Pan and Psyche* by **Begas** (1831–1911), Private Collection, Berlin; Neo-Baroque work in marble by German; sculpted during his first stay in Rome.
NORTH AMERICA	1850 *Raftsmen Playing Cards* completed by **Bingham** (1811–79), City Art Museum, St Louis; one of serene riverscapes which won the painter popularity. 1859 *Thunderstorm with Rocky Mountains* by **Bierstadt** (1830–1902) Museum of Fine Arts, Boston; dramatic landscape by popular German-born painter of the Hudson River School. 1859 *Old Kentucky Home* by **Johnson** (1824–1906), New York Public Library; characteristic realistic genre scene by German-trained painter.	1850–79 *St Patrick's Cathedral*, New York by **Renwick** (1792–1863); most famous building of leading American architect of Gothic Revival. 1859 *Tennessee State Capitol*, Nashville, by **Strickland** (1787–1854); distinguished Neoclassical work by founding member of the American Institute of Architects.	1851 *The Greek Slave* by **Powers** (1805–73), National Gallery, Washington; idealized nude sculpted in 1843; widely revered when exhibited on tour in the U.S. and Britain in 1851. 1853 *Andrew Jackson* by **Mills** (1810–83), Lafayette Sq., Washington; said to be first bronze statue to be entirely an American production.

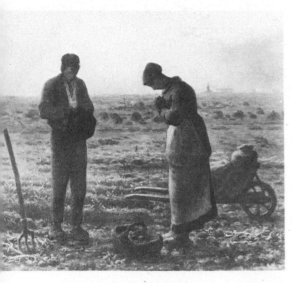

left: *The Angelus*. **Millet**

below: *Le Maréchal
Ney*. **Rude**

above: *Derby Day*. Detail. **Frith**

below: *The Studio of the Painter*. **Courbet**

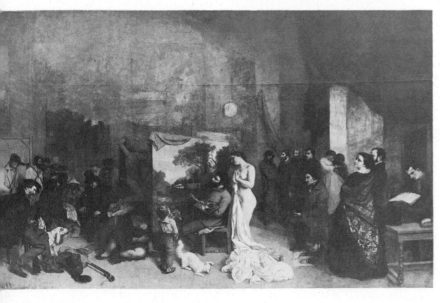

1850 End of Roman Republic. Pope Pius IX returns
to Rome. Turgenev's *A Month in the Country*.
D. G. Rossetti's poem 'Blessed Damozel' appears in
the Pre-Raphaelite publication, *The Germ*.
Dickens' novel *David Copperfield*. Tennyson's
poem 'In Memoriam'. **1850–7, Swiss painter
Boecklin (1827–1901) living in Rome.**

1851 Louis Napoleon takes control of France.
Verdi's opera *Rigoletto*. *Moby Dick* by Melville
published. First International Exhibition held in
London in the **Crystal Palace, built by Paxton
(1801–65), re-erected and later destroyed.**

1852–70, Napoleon III rules The Second Empire of
France. The Mantuan trials in Italy begin,
punishing Republicans. Verdi's *Il Trovatore*. *La
Dame aux Camélias* by Dumas. Musset's *Poésies
Nouvelles*. **Victoria and Albert Museum, London,
opened.**

1853 Napoleon III marries Princess Eugénie.
Ottoman Empire declares war on Russia. Arnold's
poem *The Scholar Gipsy*. **City planner Baron
Haussmann (1809–91) appointed** *Préfet du
Département de la Seine*. **1854–62, French sculptor
Carpeaux studying in Rome.**

1854 Crimean War begins. Risings in Madrid
against Queen Isabella. Tennyson's poem 'The
Charge of the Light Brigade'. Dunlap's *History of
the Arts of Design in America*. **1854–68,**
*Dictionnaire Raisonné de L'Architecture Française du
XIᵉ au XVIᵉ Siècle* **by restoring architect
Viollet-le-Duc (1814–79). Whistler (1834–1903)
expelled from the U.S. army.**

1855 Accession of Czar Alexander II. Paris World
Exhibition. Longfellow's poem 'Hiawatha'.
Whitman's poems *Leaves of Grass*. Balzac's *Contes
Drolatiques* **illustrated by Doré (1832–83). German
Romantic painter Feuerbach (1829–80) visits Italy.
Whistler goes to Paris. Courbet holds his one man
show,** *Le Réalisme*.

1856 Flaubert's *Madame Bovary*. Wagner's *Die
Walküre*. **English sculptor Stevens (1818–75) enters
competition for the Wellington Monument for St
Paul's. Degas (1834–1917) is in Italy. 1856–9,
American painter Bingham is in Germany.**

1857 Indian Mutiny. Irish Republican Brotherhood
founded. Italian National Association founded.
Baudelaire's poems *Les Fleurs du Mal*. **Currier and
Ives, American firm of colour engravers, established.
Frescos in Oxford Union begun by D. G. Rossetti,
Burne-Jones (1833–98) and Morris (1834–96).**

1858 Orsini's plot to assassinate Napoleon III fails.
Brunel's steamship the Great Eastern launched.
Offenbach's comic opera *Orpheus in the Underworld*.
Renoir (1841–1919) training as painter on porcelain.

1859 Austria defeated in Franco-Austrian war.
Gounod's opera *Faust*. J. S. Mill's *On Liberty*.
Darwin's *On The Origin of Species by Means of
Natural Selection*. Fitzgerald translates the
Rubáiyát of Omar Khayyám. Sand's *Elle et Lui*.
**Whistler settles in London. 1859–62, American
architect Richardson (1838–86) studying in Paris.**

Key works: PAINTING	Key works: ARCHITECTURE	Key works: SCULPTURE

FRANCE

c. 1860 *Young Spartans* by **Degas** (1834–1917), National Gallery, London; early history painting by great draughtsman later depicting scenes of Parisian life.

c. 1862 *Third Class Carriage* by **Daumier** (1808–79), Metropolitan Museum of Art, New York; oil painting of poor dejected people; used for one of his many lithographs.

1863 *Le Déjeuner sur l'Herbe* by **Manet** (1832–83), Louvre, Paris; a modern version of Giorgione's *Concert Champêtre* and Raimondi's *Judgement of Paris*; caused a scandal leading to the closure of the Salon.

1865 *Olympia* by **Manet**, Louvre, Paris; realistic nude, inspired by Goya's *La Maja Desnuda*; portrait of well-known model.

1867 *The Family Reunion* by **Bazille** (1841–70), Louvre, Paris; one of his best-known works.

1868–70 *Bridge at Mantes* by **Corot** (1796–1875), Louvre, Paris; famous French view painting by widely appreciated landscape artist.

1869 *The Balcony* by **Manet**, Louvre, Paris; unconventional informal group portrait of Berthe Morisot (1841–95) and Jenny Claus.

1860–7 *St-Augustin*, Paris, by **V. Baltard** (1805–74); church with extraordinary plan; iron extensively used in construction.

1861–74 *L'Opéra*, Paris, by **Garnier** (1825–98); luxuriously decorated, ornate building in Second Empire style; the commission won in competition.

1863–7 *La Trinité*, Paris, by **Ballu** (1817–74); best-known work of architect inspired by French and Italian Renaissance style.

1865–9 *La Danse* by **Carpeaux** (1827–75), Louvre, Paris; terracotta version of marble group for Opéra façade, denounced by some as a monument to sensuality.

NORTH AND CENTRAL EUROPE

1860 *The Shepherd Boy* by **Lenbach** (1836–94), Schackgalerie, Munich; one of the finest German Naturalist works.

1861 *The Drowned Fisherman* by **Israëls** (1824–1911), Tate Gallery London; sentimental work by founder of the Hague School of realist painters.

1863 *The White Girl* by **Whistler** (1834–1903), National Gallery of Art, Washington; melancholy portrait by American settled in London.

1863 *Diana Bathing* by **Marées** (1837–87), Neue Staatsgalerie, Munich; unconventional work of visionary German painter rejecting contemporary realism.

1864–5 *Oriel Chambers*, Liverpool, by **Ellis** (1804–84); thoroughly glazed iron-framed structure by pioneer of the office-building.

1865–74 *St Pancras Station Hotel*, London by **Scott** (1811–78); outstanding Neo-Gothic creation by church restorer and architect of classicizing government buildings.

1866 *Palais de Justice*, Brussels by **Poelaert** (1817–79); huge building of disparate classical elements; entrance through a series of giant porticoes.

1867 *Neuschwanstein*, Bavaria designed by **Riedel** (1813–85); fairy-tale castle; built for Ludwig II.

1864–76 *Albert Memorial*, London, designed by **Scott** (1811–78); elaborate monument comprising a statue and Gothic canopy, with friezes and sculpted groups by several sculptors.

c. 1868 *Clyte* by **Watts** (1817–1904), Tate Gallery, London; statue by artist who became famous in the Late Victorian period.

SOUTH EUROPE

1865 *Insane Ward at S. Bonifazio, Florence* by **Signorini** (1835–1901), Galleria Internazionale d'Arte Moderna, Venice; melancholy realistic work of leading theorist of the *Macchiaioli* painters.

1863 *Mole Antonelliana*, Turin, by **Antonelli** (1798–1888); extraordinary high tower supported internally by iron structure.

1865–77 *Galleria Vittorio Emanuele*, Milan, by **Mengoni** (1829–77); most magnificent of the many shopping arcades in glass and iron; erected by the English City of Milan Improvement Company.

1865–7 *Ugolino and his Sons* by **Carpeaux** (1827–75), Metropolitan Museum of Art, New York; huge bronze, whose brutal realism dismayed the public, by French sculptor studying in Rome.

1865–7 *Monument to Pope Pius VIII* by **Tenerani** (1798–1869), St Peter's, Rome; derivative work of Thorvaldsen's pupil; typical of the time in its lack of originality.

NORTH AMERICA

1865 *The Delaware Valley* by **Inness** (1825–94), Metropolitan Museum of Art, New York; large canvas by one of greatest American landscape painters.

1866 *Prisoners from the Front* by **Homer** (1836–1901), Metropolitan Museum of Art, New York; first important work of painter covering the Civil War for *Harper's Weekly*.

1861–7 *Canadian Houses of Parliament*, Ottawa, by **Fuller** (1822–1908) and **Jones**; huge Neo-Gothic complex rebuilt after a fire; inspired by Scott's designs for a Gothic Foreign Office in London.

1865 *The Capitol*, Washington, completed by **Walter** (1804–87); begun in 1792 according to designs by Thornton (1759–1828), continued by Latrobe (1764–1820) and Bulfinch (1763–1844).

1865 *Freedman* by **Ward** (1830–1910) Atheneum, Boston; highly praised bronze figure, exhibited at the Paris Exposition of 1867.

1869 *The Fugitive's Story* by **Rogers** (1829–1904), Historical Society, New York; bronze group of figures; one of the artist's well-known anti-slavery pieces.

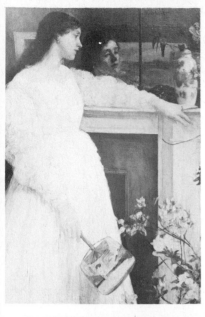

above: *The Capitol*, Washington. **Walter**

left: *The White Girl*. **Whistler**

left: *Le Déjeuner sur l'Herbe*. **Manet**

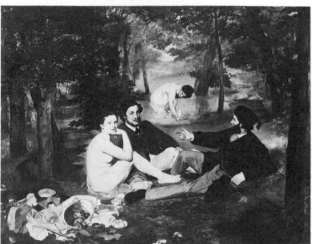

left: *La Danse*. **Carpeaux**

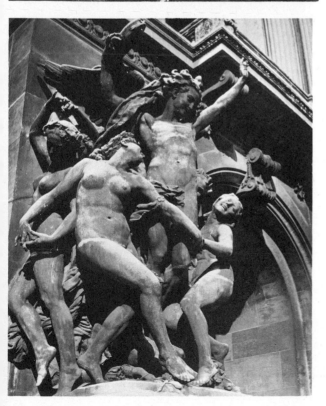

1860 Lincoln elected President of the U.S. Garibaldi and the Thousand capture Sicily and Naples. Collection of Liszt's songs published. Eliot's *The Mill on the Floss*. Wilkie Collins's *The Woman in White*.

1861 Outbreak of American Civil War. Italian Unification. William I becomes King of Prussia. Serfdom abolished in Russia. Turgenev's novel *Fathers and Sons*. **Inferno illustrated by Doré (1832–83), published at his own expense. *Macchiaioli* exhibit in Florence. Morris founds his Manufacturing and Decorating Company. Cézanne (1839–1906) goes to Paris.**

1862 Bismarck appointed Prussian premier. Hugo's **Les Misérables.** Mme de Soye opens Oriental Shop in Paris.

1863 Abolition of slavery proclaimed in the U.S. French troops invade Mexico. J. S. Mill's *Utilitarianism*. **Le Peintre de la Vie Moderne by Baudelaire. *Entretiens,* Volume I, by Viollet-le-Duc (1814–79), on the use of iron in architecture. Napoleon III founds the Salon des Refusés. Boudin (1824–98) painting at Trouville.**

1864–86 Ludwig II of Bavaria. Goncourt brothers begin their novel, *Renée Mauperin*. **Marées and Lenbach (1836–94) visit Italy. Bazille and Monet (1840–1926) painting at Honfleur.**

1865 Assassination of President Lincoln. Florence becomes capital of Italy. Bessemer perfects inexpensive production of steel. Tolstoy's *War and Peace*. *Alice in Wonderland* by Lewis Carroll. Newman's poem 'The Dream of Gerontius'. Wagner's *Tristan und Isolde* first performed. **Du Principe de l'Art et de sa Destination Sociale by Proudhon published posthumously. Monet, Boudin, Courbet and Daubigny (1817–78) painting in Trouville.**

1866 Austro-Prussian War. Brahms' *German Requiem*. *The Trojans* by Berlioz *c.* 1866. *Crime and Punishment* by Dostoyevsky. **Metropolitan Museum of Art, New York, opens. Homer visits France.** Smetana's opera *The Bartered Bride*.

1867 Confederation of the Dominion of Canada. Mexican rebels execute Emperor Maximilian. Garibaldi invades Papal States but is defeated. Nobel produces dynamite. *Das Kapital*, Part I, by Marx. Verdi's *Don Carlos*. Ibsen's *Peer Gynt*. Paris World Exhibition. **American sculptor Saint-Gaudens (1848–1907) goes to Paris. German sculptor Hildebrand (1847–1921) visits Rome.**

1868 Revolution in Spain, abdication of Queen Isabella. Browning's epic poem *The Ring and the Book*. *Little Women* by Alcott. **American painter Mary Cassatt (1845–1926) settles in Paris, Berthe Morisot (1841–95) becomes a pupil of Manet.**

1869 Suez Canal opened. *Principles and Practices of Architecture* published by American architect Jenney (1832–1907). **Munich International Exhibition, paintings by Courbet and Leibl (1844–1900) particularly admired. Austrian painter Makart (1840–84) summoned by the Kaiser to Vienna.**

1870–1879

	Key works: PAINTING	Key works: ARCHITECTURE	Key works: SCULPTURE
FRANCE	1872 *Impression: Sunrise* by **Monet** (1840–1926), Musée Marmottan, Paris; painting gave rise to the term Impressionism when exhibited in 1874. 1872–3 *The House of the Hanged Man* by **Cézanne** (1839–1906), Louvre, Paris; first of the artist's works to be accepted by the Salon. 1874 *The Dancing Class* by **Degas** (1834–1917), Musée de l'Impressionnisme, Paris; famous genre painting of apparently uncontrived informal composition. 1876 *Floods at Port-Marly* by **Sisley** (1839–99), Louvre, Paris; landscape painter's best-known work, in restrained Impressionist manner. 1876 *The Swing* by **Renoir** (1841–1919), Musée de l'Impressionnisme, Paris; one of the best-known works of the first Impressionist to achieve commercial success. 1876 *L'Absinthe* by **Degas**, Louvre, Paris; picture of woman drinking, considered shocking at the time. 1876 *The Apparition* by **Moreau** (1826–98), Louvre, Paris; Salomé transfixed by the vision of the Baptist's severed head; a great success when exhibited.	1876 *Sacré-Coeur*, Montmartre, Paris, begun by **Abadie** (1812–84); famous huge Neo-Romanesque church with impressive cluster of domes.	1874 *Equestrian statue of Joan of Arc* by **Frémiet** (1824–1900), Place des Pyramides, Paris; vigorous image by basically conventional sculptor. 1877 *Age of Bronze* by **Rodin** (1840–1917), Tate Gallery, London; one of many casts of Rodin's first major work; criticized at the time for its unmodified realism.
NORTH AND CENTRAL EUROPE	1871 *Westminster Bridge* by **Monet** (1840–1926), Collection Lord Astor of Hever; work of leading Impressionist visiting England. 1872 *The Artist's Mother* by **Whistler** (1834–1903), Louvre, Paris; famous portrait subtitled *Arrangement in Black and Grey*. 1872 *Newgate—the Exercise Yard* by **Doré** (1832–83); wood-engraving from Jerrold's *London, a Pilgrimage*, sober study of prisoners, by French graphic artist visiting England. 1877 *Nocturne in Black and Gold* by **Whistler**, Institute of Art, Detroit; Impressionistic night scene denounced by Ruskin, who accused the artist of flinging a pot of paint in the public's face.	1870 *Keble College*, Oxford, by **Butterfield** (1814–1900); multi-coloured uninhibited adaptation of Gothic style. 1873–83 *Parliament*, Vienna, by **Hansen** (1813–91); part of grandiose city plan, conceived mainly by the architect. 1873–81 *Natural History Museum*, London, by **Waterhouse** (1830–1905); Neo-Romanesque work by architect responsible for several major commissions. 1874–88 *Burgtheater*, Vienna, by **Semper** (1803–79); huge building in characteristic Second Empire style.	1874 *Mercury and Psyche* by **Begas** (1831–1911), East Berlin; spirited Naturalistic work by sculptor chiefly concerned with official commissions. 1878–80 *The Water-Carrier* by **Hildebrand** (1847–1921), Private Collection, Berlin; bronze figure by famous German sculptor, architectural designer and theoretician.
SOUTH EUROPE	1870 *Spanish Marriage* by **Fortuny** (1838–90), Museo de Arte Moderno, Barcelona; best of genre works by popular Spanish painter. 1879 *The Hesperides* by **Marées** (1837–87), Bayerische Staatsgemalde-sammlungen, Munich; first version of visionary triptych by German painter settled in Italy.	1870 *Finance Ministry*, Rome, begun by **Canevari** (1825–1900); huge but undistinguished government building, part of massive programme following the re-establishment of the capital in Rome.	
NORTH AMERICA	1875 *The Gross Clinic* by **Eakins** (1844–1916), Jefferson Medical College, Philadelphia; realist group painting of a surgery that shocked the public; one of the artist's most important works. 1876 *Breezing Up* by **Homer** (1836–1901), National Gallery, Washington; famous work by Naturalist painter. 1877 *The Bathers* by **Morris Hunt** (1824–79), Worcester Art Museum, Mass.; one of best-known works of European-trained Romantic realist.	1870–8 *Memorial Hall*, Harvard University, Cambridge, Mass. by **Ware** and **Van Brunt**; best example of Victorian Gothic in the U.S. 1871–5 *State, War and Navy Department*, Washington, by **Mullett** (1834–90); representative of the Second Empire style dominating American architecture after the Civil War. 1872 *Trinity Church*, Copley Sq., Boston, by **Richardson** (1838–86); impressive Romanesque building led to brief Romanesque Revival.	1871 *The Dying Centaur* by **Rimmer** (1816–79), Museum of Fine Arts, Boston; plaster figure by foremost American sculptor of the period. 1875 *Minute Man* by **French** (1850–1931), Concord, Mass.; bronze statue which established the reputation of this prolific sculptor.

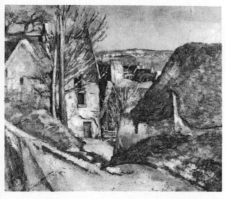

above: *The House of the Hanged Man.*
Cézanne

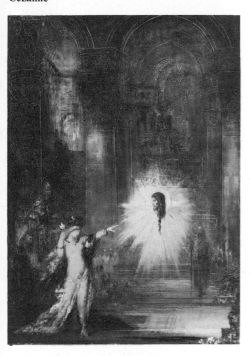

above: *The Apparition.* **Moreau**

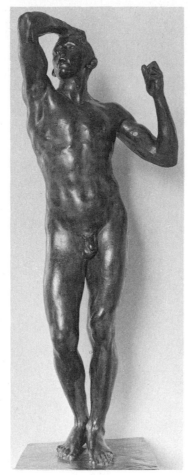

above: *Age of Bronze.* **Rodin**

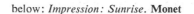

below: *Impression: Sunrise.* **Monet**

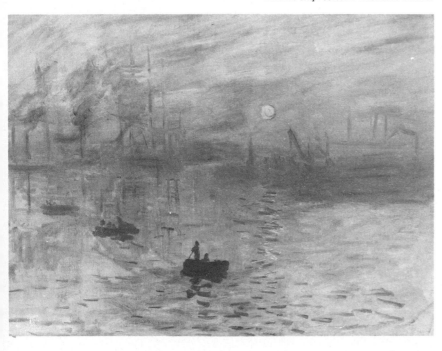

1870 Franco-Prussian War. Siege of Paris. Italian capital returned to Rome. Papal infallibility declared. Brooklyn Bridge, New York, begun. **Pissarro (1830–1903) and Monet take refuge in London. Tissot (1836–1902) settles in England. Alma-Tadema (1836–1912) comes to London.**

1871 Fall of Paris and suppression of the Commune. Darwin's *Descent of Man.* Fire in Chicago leads to major rebuilding. Verdi's *Aïda. Middlemarch* by Eliot. **Sculptor Dalou (1838–1902) escapes to London. Courbet imprisoned. 1871–4, Sisley in London. Sculptor Carpeaux (1827–75) in England.**

1872–6 Spanish Carlist War. Meeting of Emperors in Berlin. **Degas visits relations in New Orleans. Manet visits Holland. Monet works at Argenteuil. Pissarro painting at Pontoise.**

1873 Germans evacuate France. Alliance of Emperors of Germany, Austria-Hungary and Russia. Third Republic constituted in France. Pater's *The Renaissance.* Jules Verne's *Le Tour du Monde en Quatre-vingts Jours.* **Courbet escapes to Switzerland.**

1874 Spanish Monarchy re-established. Hardy's novel *Far From the Madding Crowd.* **First Impressionist show at Nadar's, in Paris. Boecklin (1827–1901), German painter, settles in Florence.**

1875 Bizet's opera *Carmen.* **Rodin visits Italy. Bedford Park, London, earliest garden suburb, designed by Shaw (1831–1912).**

1876 Philadelphia Centennial Exposition. *L'Après-Midi d'un Faune* by Mallarmé. Mark Twain's *Adventures of Tom Sawyer.* **Second Impressionist Exhibition.** *La Nouvelle Peinture* by **Duranty. Whistler begins painting the Peacock Room in London.**

1877 Queen Victoria proclaimed Empress of India. Saint-Saëns' opera *Samson and Delilah.* First production of ballet *Swan Lake,* music by Tchaikovsky. Zola's *L'Assommoir.* Society for the Preservation of Ancient Buildings founded by Morris.

1878 Attempt to assassinate Wilhelm I fails. Congress of Berlin convenes to attend to problems in the Near East. Paris World Exhibition. **1878–81, Muybridge's famous multiple exposure photographs published. Van Gogh (1853–90) preaching among the miners of the Borinage, Belgium.**

1879 Formation of Irish Land League under Parnell. Amnesty for Parisian Communards declared. *Eugene Onegin,* opera by Tchaikovsky. Ibsen's *A Doll's House.* Meredith's *The Egoist.* James' short story *Daisy Miller.* **Society of American Artists founded, Chase (1849–1916) elected President.** *The Dream,* first album of lithographs by Redon (1840–1916) published.

	Key works: PAINTING	Key works: ARCHITECTURE	Key works: SCULPTURE
FRANCE	1881 *The Poor Fisherman* by **Puvis de Chavannes** (1824–98), Louvre, Paris; famous allegorical work by French Symbolist painter. 1881–2 *Bar at the Folies-Bergère* by **Manet** (1832–83), Courtauld Institute Galleries, London; last major work of painter revered by the young Impressionists. c. 1884 *Les Parapluies* by **Renoir** (1841–1919), National Gallery, London; one of artist's most popular pictures, showing change in his style. 1884 *Mme Gautreau* by **Sargent** (1856–1925), Metropolitan Museum of Art, New York; portrait's cynical realism caused an outcry. 1884–6 *Sunday on the Island of La Grande Jatte* by **Seurat** (1859–91), Art Institute, Chicago; famous early Neo-Impressionist work in divisionist technique. 1888 *Jacob Wrestling with the Angel* (*Vision after the Sermon*) by **Gauguin** (1848–1903), National Gallery, Scotland; dramatic work; forms outlined against flat red ground; strong diagonals separating real and dream elements. 1889 *Self-Portrait with Severed Ear* by **Van Gogh** (1853–90), Courtauld Institute Galleries, London; one of last works of great Expressionist; reflects his interest in Japanese prints.	1887–9 *The Eiffel Tower*, Paris, by **Eiffel** (1832–1923); highest structure ever at the time; example of great contribution of engineering developments to modern architecture.	1880 *Gate of Hell* by **Rodin** (1840–1917), commissioned, Musée Rodin, Paris; monumental unfinished work in bronze by sculptor opposing academic tradition. 1880–95 *Le Travail* by **Dalou** (1838–1902), Tate Gallery, London; bronze figure of working man, portrayed in a socialist spirit. 1881 *Fourteen-Year-Old Dancer* by **Degas**, Collection Mr and Mrs Paul Mellon, Virginia; painted wax and fabric study, shown at the Impressionist Exhibition, 1881. 1884 *The Burghers of Calais* by **Rodin**, Musée Rodin, Paris; dramatic bronze group of expressive realism.
NORTH AND CENTRAL EUROPE	c. 1881 *Three Women in Church* by **Leibl** (1844–1900), Kunsthalle, Hamburg; German realist's best-known genre scene. 1884 *King Cophetua and the Beggar-maid* by **Burne-Jones** (1833–98), Tate Gallery, London; picture of story-book romance. 1886 *Bubbles* by **Millais** (1829–96), Pears Soap, Isleworth, Middlesex; famous popular Victorian painting. 1888 *Entry of Christ into Brussels* by **Ensor** (1860–1949), Knokke-Zoute, Casino Communal, Belgium; huge satirical work by Expressionist.	1880 *Bedford Park Church*, West London, by **Shaw** (1831–1912); part of earliest garden suburb, by fashionable architect of restrained historicism. 1881–9 *Central Station*, Amsterdam, by **Cuypers** (1827–1921); major work in revival of Dutch Renaissance style.	1886–1902 *Beethoven* by **Klinger** (1857–1920), Museum der Bildenden Kunst, Leipzig; masterpiece by artist seeking to revive polychrome sculpture in the Greek manner.
SOUTH EUROPE	1880 *The Island of the Dead* by **Boecklin** (1827–1901), Kunstmuseum, Basle; first of five versions of Romantic work by Swiss in Florence. 1885 *The Patrol* by **Fattori** (1825–1908), Collection Marzotto, Rome; boldly painted work of leading Italian Impressionist.	1884–1926 *Sagrada Familia*, Barcelona, by **Gaudi** (1852–1926); unfinished Neo-Gothic church with fantastic spires. 1884 *Victor Emmanuel Monument*, Rome, designed by **Sacconi** (1854–1905); monstrous memorial in Neo-Baroque style.	
NORTH AMERICA	1884 *Toilers of the Sea*, Metropolitan Museum of Art, by **Pinkham-Ryder** (1847–1917), oil on wood; imaginary eerie moonlit scene by moody Romantic painter.	1883–5 *Home Insurance Building*, Chicago, by **Le Baron Jenney** (1832–1907); steel skeleton structure hailed as first sky-scraper. 1886–9 *Auditorium*, Chicago, by **Sullivan** (1856–1924); highly original interior decoration 1889 *Monadnock Building*, Chicago, by **Burnham** (1846–1912) and **Root** (1850–91); traditional load-bearing structure, but severely plain.	1886 *Statue of Liberty*, New York, by **Bartholdi** (1834–1904); cast in copper; gift from France, designed by French sculptor and erected in New York. 1887 *Memorial to Lincoln*, Chicago, by **Saint-Gaudens** (1848–1907); huge bronze; one of artist's many public commissions.

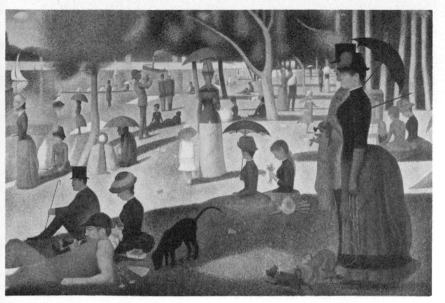

above: *Sunday on the Island of La Grande Jatte.* **Seurat**

below: *Sagrada Familia*, Barcelona. **Gaudi**

bottom: *Self-Portrait with Severed Ear.* **Van Gogh**

below: *Fourteen-Year-Old Dancer.* **Degas**

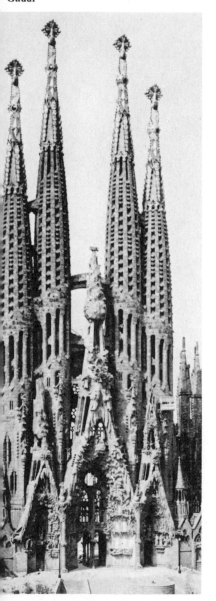

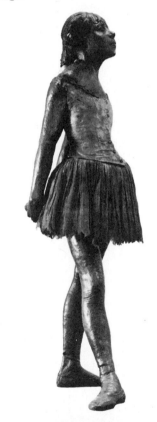

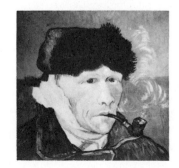

1880 Formation of the Socialist Workers in France. Swan invents the incandescent lamp. Kulturkampf in Germany relaxed. Zola's *Nana. Boule de Suif* by Maupassant. **Royal Canadian Academy founded. American painter Harnett (1848–92) in Europe. Van Gogh dismissed from his post as missionary in the Borinage, Belgium.**

1881 Csar Alexander II of Russia assassinated. U.S. President Garfield assassinated. Gilbert and Sullivan's light opera *Patience.* Verlaine's *Sagesse.* Ibsen's *Ghosts. Portrait of a Lady* by Henry James. French translation of Rood's *Modern Chromatics.*

1882 Triple Alliance of Italy, Austria and Germany. Foundation of Society for Psychical Research, Vienna. Wagner's last opera, *Parsifal.* Founding of the Century Guild in London by the designer Mackmurdo (1851–1942). **Seventh Impressionist Exhibition in Paris.**

1883 Benz and Daimler factories started. Brooklyn Bridge, New York, opened. Nietzsche's *Also Sprach Zarathustra.* Opera by Delibes, *Lakmé.* **Monet (1840–1926) settles at Giverny, where he builds his lily-pond. Renoir given a one-man show by Durand-Ruel. Sickert (1860–1942) is painting in Paris.**

1884 Foundation of the Fabian Society. *The Adventures of Huckleberry Finn* by Mark Twain. *A Rebours* by Huysmans. **First Salon des Indépendants. Whistler (1834–1903) settles in London. Pissarro (1830–1903) settles at Eragny. Manet Memorial Exhibition in Paris.**

1885 Defeat and death of Gordon at Khartoum. Burton's translation of the *Arabian Nights,* Henry's *Une Esthétique Scientifique* published. Zola's *Germinal. Marius the Epicurean* by Pater. **The New English Art Club is founded. American painter Sargent settles in London.**

1886 Rimbaud's poems, *Illuminations* published. **Eighth and Last Impressionist Exhibition held. Italian painter Segantini (1858–99) moves to Switzerland. Van Gogh comes to Paris. Gauguin goes to paint at Pont-Aven. Neo-Impressionist circle forms around Seurat.**

1887 Golden Jubilee of Queen Victoria. Goodwin invents celluloid film. Verdi's opera *Otello. Les Lauriers sont Coupés* by Dujardin. *The Father* by Strindberg. **American-born painter Feininger (1871–1956) goes to Germany. Poster artist Mucha (1860–1939) arrives in Paris.**

1888 Wilhelm II becomes Emperor of Germany. Rimsky-Korsakov's ballet *Schéhérazade.* **Arts and Crafts Society forms in London. The Nabis, brotherhood of Symbolists, convenes in Paris. Gauguin stays with Van Gogh in Arles. Van Gogh cuts off his own ear in a fit of madness.**

1889 Eastman's Kodak camera comes into production using photographic film. *Thaïs* by Anatole France. Paris International Exhibition is field. **Symbolist Revue Blanche appears. Dutert (1845–1906) builds the vast Halle des Machines for the Exhibition, since destroyed. Chéret (1836–1933), early artist of poster design, awarded the Légion d'Honneur for his work.**

Key works: PAINTING	Key works: ARCHITECTURE	Key works: SCULPTURE

FRANCE

1890–1 The Circus by **Seurat** (1859–91), Louvre, Paris; one of the artist's last works; scene of movement with strong surface design.
1893 Jane Avril at the Jardin de Paris by **Toulouse-Lautrec** (1864–1901); famous lithograph by painter and poster-artist of the Parisian *demi-monde*.
1894 La Revue Blanche by **Bonnard** (1867–1947), Bibliothèque Nationale, Paris; poster by member of the Nabis profoundly influenced by Japanese art.
1897 Boulevard Montmartre by **Pissarro** (1830–1903), National Gallery, Washington D.C.; street scene by faithful Impressionist artist.
1898 Grandes Baigneuses by **Cézanne** (1839–1906), Philadelphia Museum of Art; one in series of Bathers; large composition, continuing his study of the relationship of Man to nature.

1894–8 Castel-Béranger, Paris, by **Guimard** (1867–1942); Art Nouveau apartment buildings.
1894–1902 S.-Jean de Montmartre, Paris, by **Baudot** (1834–1915); early building in reinforced concrete in Gothic manner.

1893 Beethoven by **Bourdelle** (1861–1929), Musée Bourdelle, Paris; bronze; by Romantic sculptor whose work was exhibited in L'Art Nouveau.
1897 Study for Balzac in plaster by **Rodin** (1840–1917), Musée Rodin, Paris; commissioned in 1891 by the Société des Gens de Lettres, who refused to accept it in 1898.

NORTH AND CENTRAL EUROPE

c. 1890 Bad Mothers by **Segantini** (1858–99), Walker Art Gallery, Liverpool; weird late work of Italian Symbolist living in Switzerland.
1891 Mrs Cyprian Williams and her Daughters by **Steer** (1860–1942), Tate Gallery, London; one of best-known works of member of the New English Art Club.
1891–5 Weary of Life, Disappointed Souls and *Eurhythmy* by **Hodler** (1853–1918), Kunstmuseum, Bern; famous group of three mural paintings by Swiss Symbolist.
1893 The Cry by **Munch** (1863–1944) Munch Museet, Oslo; lithograph; famous evocation of emotion.
1894 Salome with the Head of John the Baptist by **Beardsley** (1872–98); lithograph for Wilde's *Salomé* by famous *fin de siècle* graphic artist.

1893 6 Rue Paul-Emil Janson, Brussels, by **Horta** (1861–1947); Art Nouveau house; revolutionary in plan and structure.
1895 Bloemenwerf, Uccle, near Brussels, by **Van de Velde** (1863–1957); Art Nouveau house and interior designed by the architect.
1898–1909 Glasgow School of Art by **Mackintosh** (1868–1928); austere, asymmetrical structure with original interior design; internationally admired.
1898–9 Secession Hall, Vienna, by **Olbrich** (1867–1908); cube-like exhibition hall with Art Nouveau dome; built for the *Wiener Sezession*, progressive artists in Austria.
1898 Broadleys, Gill Head, Windermere, by **Voysey** (1857–1941); one of best-known houses by leading English domestic architect.

1891 Wittelsbach Fountain, Munich, designed by **Hildebrand** (1847–1921); best-known of large works in classical tradition by writer on aesthetics.
1892 The Eros Fountain, Piccadilly Circus, London, by **A. Gilbert** (1854–1934); Art Nouveau memorial statue.
1898 Fountain with Kneeling Figures by **Minne** (1866–1941), Folkwangmuseum, Essen; masterpiece in marble by Belgian Symbolist.

SOUTH EUROPE

c. 1896 The Lion of St Mark, Venice, by **Sickert** (1860–1942), Fitzwilliam Museum, Cambridge; characteristically coloured scene by artist who later inspired the Camden Town Group.

1898–1914 Colonia Guell Church, Guell Estate; by **Gaudi** (1852–1926); unfinished work on asymmetrical plan with slanting pillars.

NORTH AMERICA

1890 Washington Arch in Spring, Phillips Collection, Washington D.C., by **Hassam** (1859–1935); work of important American Impressionist.
1892 Old Models, Boston Museum of Fine Arts, by **Harnett** (1848–92); work of meticulous realistic painter of still-life.

1894–5 Guaranty Buildings, Buffalo, New York, by **Sullivan** (1856–1924); most important of architect's skyscrapers.
1894 Marquette Building, Chicago, by **Holabird** (1854–1923) and **Roche**; exposed steel skeleton structure which established the Chicago School style.
1895 Biltmore, Asheville, North Carolina, completed by **Richard Hunt** (1827–95); spectacular Loire Valley château, built for George Vanderbilt.
1897–8 Boston Public Library by **McKim** (1847–1909); restrained classical style, decorated by several famous artists.

1893 Struggle of the Two Natures of Man, Metropolitan Museum of Art, New York, by **Barnard** (1863–1938); Naturalistic marble, bringing fame to the artist.

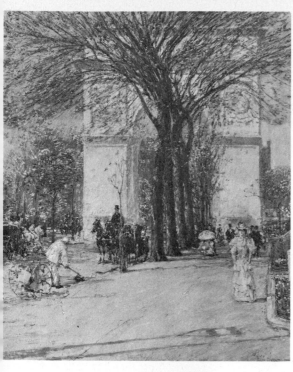

left: *Washington Arch in Spring*. **Hassam**

below left: *Glasgow School of Art*. **Mackintosh**

below: *The Cry*. **Munch**

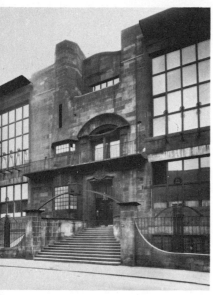

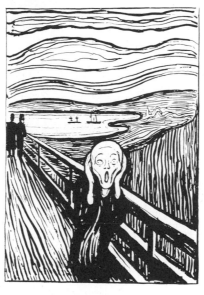

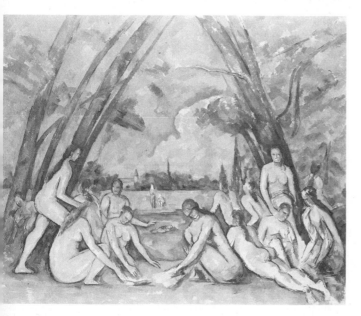

left: *Grandes Baigneuses*. **Cézanne**

1890 Wilhelm II dismisses Bismarck. Mascagni's opera *Cavalleria Rusticana*. *Hedda Gabler* by Ibsen. Whistler's *The Gentle Art of Making Enemies* (1834–1903) published. **Sargent (1856–1925) visits America.**

1891 Pan German League founded. Triple Alliance renewed. General Boulanger commits suicide. Wilde's *The Picture of Dorian Gray*, published. **Moreau (1826–98) becomes Professor at the École des Beaux-Arts in Paris. Gauguin (1848–1903) leaves France for Tahiti. Toulouse-Lautrec designs his first poster.**

1892 Anarchist demonstrations in Paris. Massenet's opera *Werthe*. Leoncavallo's opera *I Pagliacci*. *Der Tod des Tizian* by Hofmannsthal. **Salon de la Rose + Croix opens in Paris. First Exhibition of the Nabis at the Barc de Boutteville Gallery, Paris. Munch Exhibition in Berlin prematurely closed. Munich *Sezession* forms.**

1893 World's Fair at Chicago. *New World Symphony* by Dvořák. Verdi's last opera *Falstaff*. Puccini's opera *Manon Lescaut*. Wilde's *Salomé*. **The Problem of Form in Plastic Art by the sculptor Hildebrandt (1847–1921).**

1894 Dreyfus is found guilty of treason. Lumière invents the cinematograph. *The Triumph of Death* by d'Annunzio. *Trilby* by du Maurier. **Puvis de Chavannes (1824–98) is in America.**

1895 Röntgen discovers X-rays. *Till Eulenspiegel* by Strauss. *The Time Machine* by Wells. **L'Art Nouveau shop opens in Paris. *Moderne Architektur* by Otto Wagner (1841–1918). English painter Sickert is in Venice. Austrian painter Kupka (1871–1957) emigrates to Paris. First major exhibition of Cézanne's work, organized by Vollard.**

1896 Csar Nicholas II visits London and Paris. Marconi demonstrates wireless telegraphy. Puccini's opera *La Bohème*. *The Seagull* by Chekhov. *Ubu Roi* by Jarry. *A Shropshire Lad* by Housman. **The Munich Review *Jugend* appears. *The Savoy* magazine appears in London.** The *Works of Geoffrey Chaucer* is printed at Kelmscott Press by Morris (1834–96), **woodcuts by Burne-Jones (1833–98).**

1897 Diamond Jubilee of Queen Victoria. Universal Suffrage in Austria. *Les Nourritures Terrestres* by Gide. *Divagations* by Mallarmé. **Vienna *Sezession* founded. Dutch painter Van Dongen (1877–1968) settles in Paris.**

1898 Pierre and Marie Curie discover radium. Zeppelin produces his airship. **Howard (1850–1928) publishes his book on town planning, *Tomorrow*. The Ten American Painters, Impressionists group is formed. Gwen John (1876–1939) goes to live in France.**

1899 Boer War begins. Dreyfus pardoned. International Women's Congress in London. Elgar's *Enigma Variations*. *Finlandia* by Sibelius. **Vollard publishes group of lithographs by Redon (1840–1916), The Apocalypse of St John. Signac (1863–1935) publishes *D'Eugène Delacroix au Néo-Impressionnisme*. The Nabis breaks up. Berlin *Sezession* forms, led by Liebermann (1847–1935).**

1900–1909	Key works: PAINTING	Key works: ARCHITECTURE	Key works: SCULPTURE
FRANCE	1905 *Portrait with a Green Stripe* by **Matisse** (1869–1954), Statens Museum for Kunst, Copenhagen; arbitrarily coloured portrait that shocked the public at the first Fauve exhibition. c. 1905 *Two Nudes* by **Rouault** (1871–1958), Metropolitan Museum of Art, New York; portrayal of ugliness by deeply religious painter. 1906–7 *Les Demoiselles d'Avignon* by **Picasso** (1881–1973) Museum of Modern Art, New York; revolutionary work which inspired Cubism; reflects the influence of Iberian Sculpture. 1907 *Virgin Forest at Sunset* by **Rousseau** (1844–1910), Kunstmuseum Basle; one of many imaginary pictures by untrained painter fêted by modern artists. 1908 *Houses at l'Estaque* by **Braque** (1882–1963), Kunstmuseum, Bern; important early Cubist landscape composed of geometrical forms; influenced by the work of Cézanne. 1909–10 *Portrait of Ambroise Vollard* by **Picasso**, Pushkin Museum, Moscow; early Cubist portrait of art-dealer.	1901–4 *Project for the Industrial City* by **Tony Garnier** (1869–1948); designs anticipate modern developments in reinforced concrete. 1902–3 *Rue Franklin Apartment*, Paris, by **Perret** (1874–1954); concrete grid structure clearly visible in the façade design. 1905 *La Samaritaine*, Paris, by **Jourdain** (1847–1935); department store with Art Nouveau ornament.	1901 *Madeleine I* by **Matisse** (1869–1954), Baltimore Museum of Art; bronze portrayal of nude, dominated by curving lines. 1905 *Chained Action* by **Maillol** (1861–1944), Musée de l'Art Moderne, Paris; famous bronze monument to Socialist, Blanqui. 1909 *Sleeping Muse* by **Brancusi** (1876–1957), Musée de l'Art Moderne, Paris; marble version of theme to which artist returns, using increasingly simplified form. 1909 *Head* by **Picasso** (1881–1973), Kunsthaus, Zurich; absolutely unconventional bronze inspired by Negro sculpture.
NORTH AND CENTRAL EUROPE	c. 1900 *Self-Portrait* by **Gwen John** (1876–1939), Tate Gallery, London; realistic; her best-known work. 1907 *Self-Portrait with Model* by **Kirchner** (1880–1938), Kunsthalle, Hamburg; bold Expressionistic work by founder of the *Brücke* group. 1909 *The Last Supper* by **Nolde** (1867–1956), Kunstmuseum, Copenhagen; harsh interpretation of biblical scene by German Expressionist. 1909 *The Kiss* by **Klimt** (1862–1918), Musée des Beaux-Arts, Strasbourg; cardboard mosaic decoration for the Stoclet house, Brussels.	1905–11 *Palais Stoclet*, Brussels, by **Hoffmann** (1870–1956); luxury house by one of founders of the *Wiener Werkstätte*, marble and bronze exterior. 1907 *Wedding Tower*, Darmstadt, by **Olbrich** (1867–1908); centre of artist's colony formed by Grand-Duke of Hessen. 1908–9 *Factory for the AEG gas-turbine plant*, Berlin, by **Behrens** (1868–1940); first German building in glass and steel. 1909–11 *St Jude's*, Hampstead Garden Suburb, London, by **Lutyens** (1869–1944); building of true originality; part of estate planned by Parker and Unwin. 1909–23 *Stockholm City Hall* by **Østberg** (1866–1945); famous hall with decoration typical of the Arts and Crafts movement of Northern Europe.	1905 *Sculptures, Frogner Park*, Oslo by **Vigeland** (1869–1943) begun; huge scheme of Nordic sculpture, arousing long-lasting controversy.
SOUTH EUROPE	1903 *The Old Guitarist* by **Picasso** (1881–1973), Art Institute, Chicago; painted in Barcelona; emaciated figure in linear style of artist's Blue Period.	1900–3 *Palazzo Castiglione*, Milan, by **Sommaruga** (1867–1917); work of leading Art Nouveau architect in Italy.	1906 *Ecce Puer* by **Medardo Rosso** (1858–1928), Collection Mr and Mrs H. L. Winston, Detroit; head sculpted in wax over plaster, by Italian sculptor exploring light and texture.
NORTH AMERICA	1905 *Wrestlers* by **Luks** (1867–1933), Boston Museum of Fine Arts; one of best-known works of ex-wrestler, member of The Eight group. 1907 *The Wake of the Ferry* by **Sloan** (1871–1951), Phillips Collection, Washington D.C.; modern realistic painting by member of The Eight. 1907 *Forty-two Kids* by **Bellows** (1882–1925) Corcoran Gallery of Art, Washington D.C.; cityscape which won popularity.	1903–4 *Carson Pirie Scott Store*, Chicago, by **Sullivan** (1856–1924); masterpiece ornamented in his individual manner. 1905 *Packard Motor Car Factory*, Detroit, Michigan by **Albert Kahn** (1869–1942); first in series of reinforced-concrete factories in America. 1908 *Robie House*, Chicago by **Wright** (1869–1959); most famous of architect's low-lying prairie-style houses.	

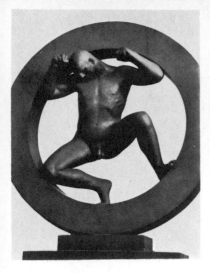

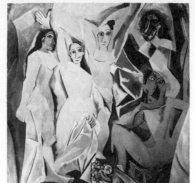

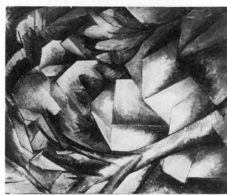

above: *Man in the Wheel, Frogner Park.* **Vigeland**

above right: *Les Demoiselles d'Avignon.* **Picasso**

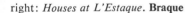

right: *Houses at L'Estaque.* **Braque**

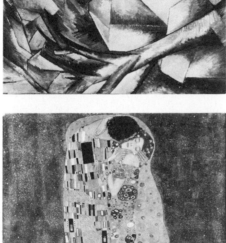

above: *The Kiss.* **Klimt**

left: *Wedding Tower,* Darmstadt. **Olbrich**

below: *Robie House,* Chicago. **Wright**

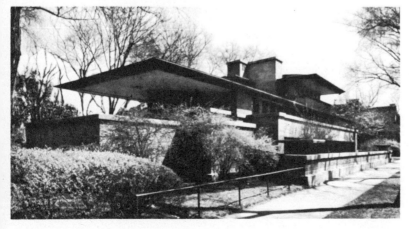

1900 British Labour Party founded. Boxer Rebellion in China. Humbert, King of Italy assassinated. Elgar's *Dream of Gerontius.* Puccini's opera *Tosca. Lord Jim* by Conrad. The Paris Exhibition opened. **Paula Modersohn-Becker (1876–1907) visits Paris.**

1901 Queen Victoria dies. Roosevelt becomes U.S. President. *Dance of Death* by Strindberg. Maeterlinck's *Life of the Bee. Noa Noa,* **autobiography of Gauguin (1848–1903) published. Exhibition at Darmstadt of *Die Sieben* architects. Borglum (1867–1941), sculptor of the colossal, returns to America. Swiss painter Klee (1879–1940) visits Italy.**

1902 Triple Alliance of Germany, Austria and Italy renewed. End of Boer War. *Pelléas and Mélisande* by Debussy. *L'Immoraliste* by Gide.

1903 King of Serbia assassinated. First powered flight of the Wright brothers. Russell's *Principles of Mathematics.* Shaw's *Man and Superman.* **Letchworth, earliest garden city begun by Parker (1867–1941) and Unwin (1863–1940). Salon d'Automne founded in Paris.**

1904 Anglo-French Entente Cordiale. Italian General Strike. Defeat of Russia by Japan. Puccini's *Madame Butterfly.* Barrie's *Peter Pan. The Cherry Orchard* by Chekhov. Freud's *Psychopathology of Everyday Life.* **Pennsylvania Station, New York, built by McKim (1847–1909), since demolished. French-Romanian sculptor Brancusi walks to Paris from Bucharest.**

1905 Unsuccessful Revolutionary protest in Russia. Einstein's *General Theory of Relativity.* Falla's *La Vida Breve.* Strauss's *Salomé.* **Controversial Exhibition of Impressionist works in London. First Fauve Exhibition in Paris. Photographer Stieglitz (1864–1946) opens the 291 Gallery in New York. *Die Brücke* group forms in Dresden. Epstein (1880–1959) settles in London.**

1906 Norway becomes independent. Meeting of the first Duma in Russia. **Loos (1870–1933) opens Free School of Architecture in Vienna. Modigliani (1884–1920) moves to Paris. Severini (1883–1966) moves to Paris. Renoir (1841–1919) settles in Cagnes, southern France. 1906–33, Klee in Germany.**

1907 Triple Entente of France, Russia and Britain. Hague Peace Conference. *Playboy of the Western World* by Synge. *New Poems* by Rilke. **Muthesius (1861–1927) starts the Deutscher Werkbund. The Eight, a group of American painters led by Henri (1865–1929), rebel against academic aestheticism. Retrospective Cézanne Exhibition in Paris.**

1908 Pan Slav Conference in Prague. German Social Democratic Rally at Nuremberg. Mahler's *Das Liede von der Erde.* Loos publishes his *Essay on Ornament and Crime.* **Matisse founds his Academy and publishes *Notes d'un Peintre.* Exhibition of The Eight in the MacBeth Gallery, New York. Russian sculptor Archipenko (1887–1964) moves to Paris.**

1909 Revolutionary rising in Catalonia. Bleriot's flight across the Channel. Diaghilev brings the *Ballet Russe* to Paris. *La Nouvelle Revue Française* appears. **Futurist Manifesto published by Marinetti (1876–1944). German *Brücke* painter Heckel (1883–1970) visits Italy. Schiele (1890–1918) joins the Austrian *Neukunstgruppe.***

1910–1919	Key works: PAINTING	Key works: ARCHITECTURE	Key works: SCULPTURE
FRANCE	1911 *I and the Village* by **Chagall** (b. 1887), Museum of Modern Art New York; dream-like; images from artist's childhood in Russia. 1911 *Le Portugais* by **Braque** (1882–1963), Kunstmuseum, Basle; first *papier collé* with printed letters emphasizing the surface. 1912 *Nude Descending a Staircase No. 2.* by **Duchamp**, Philadelphia Museum of Art; caused a sensation at the Armory Show. 1913 *Udnie* by **Picabia** (1879–1953), Musée de l'Art Moderne, Paris; Dadaist abstract. 1916–26 *Nymphéas* by **Monet** (1840–1926), Orangerie, Paris; large-scale water-lily murals, to which the great Impressionist devoted his last years. *c.* 1917 *Seated Nude* by **Modigliani** (1884–1920), Courtauld Institute Galleries, London; melancholy linear nude by Italian artist in Paris.	1913–16 *Olympic Stadium*, Lyons, by **Tony Garnier** (1869–1948); city architect's advanced design, makes use of concrete and cantilevers.	1910 *The Kiss* by **Brancusi** (1876–1957), Montparnasse Cemetery, Paris; famous work fusing stone form and concept. 1912 *Tomb of Oscar Wilde*, Paris by **Epstein** (1880–1959); powerful direct carving and symbolism shocked the authorities. 1913 *Bicycle Wheel* by **Duchamp** (1887–1968) Museum of Modern Art, New York (third version since loss of original); first in series of ready-mades challenging the traditional concept of art. 1913 *The Boxers* by **Archipenko** (1887–1964), Collection Peggy Guggenheim, Venice; terracotta abstract, suggestive of disjointed movement. 1914 *Horse* by **Duchamp-Villon** (1876–1918), Musée de l'Art Moderne, Paris; pierced bronze dynamic sculpture. 1915 *Glass of Absinthe* by **Picasso** (1881–1973), Collection Kahnweiler, Paris; painted bronze; constructed from a number of ready-made objects.
NORTH AND CENTRAL EUROPE	1910 *Composition No. 2* by **Kandinsky** (1866–1944), Museum of Modern Art, New York; one of earliest abstract expressionist works. 1911 *Large Blue Horses* by **Marc** (1880–1916), Walker Art Gallery, Minneapolis; famous painting by leading artist of the *Blaue Reiter*. 1914 *The Tempest* by **Kokoschka** (b. 1886), Kunstmuseum, Basle; masterpiece of Austrian Expressionist. *c.* 1918 *White Square on a White Ground* by **Malevich** (1878–1935), Museum of Modern Art, New York; ultimate work of Suprematism, purely pictorial art. 1918 *The Little Murderer* by **Grosz** (1893–1959), Collection Mr and Mrs Feigen, New York; painting of sex and violence by member of the Berlin Dada group.	1910 *Steiner House*, Vienna, by **Loos** (1870–1933); reinforced concrete house by important Viennese architectural theorist. 1910–14 *Central Station*, Helsinki, by **Eliel Saarinen** (1873–1950); bold monumental building; designed by the architect in 1904. 1911–14 *Fagus Factory*, Alfeld-an-der-Leine, by **Gropius** (1883–1969) and **Meyer** (1881–1929); novel design, with extended use of glass. 1912–13 *Centennial Hall*, Breslau, by **Berg** (1870–1947); bold construction in reinforced concrete with huge dome. 1919 *Schauspielhaus*, Berlin, by **Poelzig** (1869–1936); imaginative interior design, transforming the old theatre.	1914 *Red Stone Dancer* by **Gaudier-Brzeska** (1891–1915), Tate Gallery, London; waxed red stone figure, example of strong influence of primitive art at this period. 1916 *Forest* by **Hans Arp** (1887–1966), Collection Roland Penrose, London; painted wood relief by founder-member of Dada in Zurich. 1919 *Veiled Beggar Woman* by **Barlach** (1870–1938), Collection Lisa Arnhold, New York; strongly emotive work in wood by Expressionist sculptor.
SOUTH EUROPE	1912 *Dog on a Leash* by **Balla**, Museum of Modern Art, New York; cartoon-like futurist painting. 1916–17 *Disquieting Muses* by **Chirico** (1888–1978), Collection Gianni Mattioli, Milan: famous haunting metaphysical picture.	1914 *Project for the Città Nuova* by by **Sant 'Elia** (1888–1916), exhibited Milan 1914; idealized design by short-lived artist of the *Nuove Tendenze* group.	1913 *Unique Forms of Continuity in Space* by **Boccioni** (1882–1916) Museum of Modern Art, New York; work of artist evolving a form of Futurist sculpture.
NORTH AMERICA	1914 *Portrait of a German Officer* by **Hartley** (1877–1943), Whitney Museum of American Art, New York; brightly coloured composition by painter increasingly concerned with abstract patterns. 1915–23 *The Bride Stripped Bare by Her Bachelors, Even* by **Duchamp** (1887–1968), Philadelphia Museum of Art; notorious glass painting illustrating artist's concept of sex. 1916 *The Rope Dancer Accompanies herself with Her Shadows* by **Man Ray** (1890–1976), Museum of Modern Art, New York; work of artist inspired by the Armory Show.	1910 *Christian Science Church*, Berkeley, California, by **Maybeck** (1862–1957); highly original building by eclectic architect. 1911–13 *Woolworth Tower*, New York, by **C.Gilbert** (1858–1934); Gothic skyscraper conceived in 1909. 1918 *Hallidie Building*, San Francisco by **Polk** (1867–1924); one of first structures with fully-glazed, non-load-bearing outer walls.	1912 *Standing Woman* by **Lachaise** (1882–1935), Whitney Museum of American Art, New York; huge bronze nude portrait of the sculptor's wife. *c.* 1917 *Woman at the Piano* by **Nadelman** (1882–1941), Museum of Modern Art, New York; painted wood sculpture reflecting the influence of Cubism. *c.* 1918 *God* by **Schamberg** (1882–1918), Philadelphia Museum of Art; Miter box and plumbing trap construction, prophetic of assemblage.

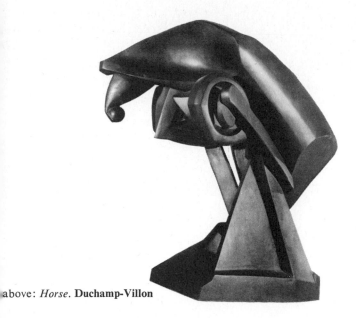

above: *Horse*. **Duchamp-Villon**

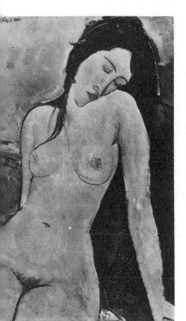

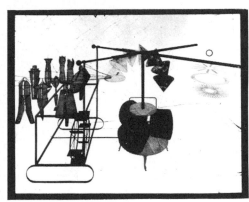

above: *The Bride Stripped Bare by Her Bachelors, Even*. Lower panel. **Duchamp**

left: *Seated Nude*. **Modigliani**

below: *Central Station*, Helsinki. **Eliel Saarinen**

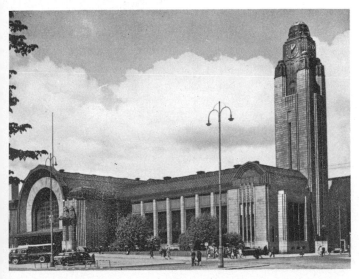

1910 Wilhelm II and Czar Nicholas meet at Potsdam. George V succeeds Edward VII. Revolution in Portugal. Stravinsky's *Firebird* performed by the *Ballet Russe*, and Schéhérazade, with sets by Bakst (1866–1924). *Der Sturm* appears in Berlin. *Die Brücke* move to Berlin. Exhibition of Near Eastern Art in Munich, which Matisse visits. Sculptor Lehmbruck (1881–1919) settles in Paris. 1910–14, Chagall in Paris.

1911 Revolution in Mexico. *Bluebeard's Castle* by Bartok. Treatise on harmony by Schönberg. First *Blaue Reiter* Exhibition, Munich. Camden Town group founded. 1911–12, Rayonism launched in Russia by Larionov (1881–1964) and Goncharova (1881–1962). Schiele (1890–1918) arrested for his immoral drawings. 1911–15, Chirico in Paris. 1911–14, Dutch painter Mondrian in Paris.

1912 First Balkan War. China becomes a Republic. *Daphnis et Chloé* by Ravel. Shaw's *Pygmalion*. *Du Cubisme* published by Gleizes (1881–1953) and Metzinger (1883–1956). Italian Futurists exhibit in Paris. First exhibition of *Section d'Or* artists. 1912–14, Russian sculptor Naum Gabo (b. 1890) in Europe.

1913 Stravinsky's *Rite of Spring*. Lawrence's *Sons and Lovers*. Proust's *A la Recherche du Temps Perdu*. *Alcools* by Apollinaire. *Death in Venice* by Mann. Kandinsky's autobiography *Rückblicke*. The London Group formed by the Camden Town Group and the Vorticists. Group of Seven, Canadian artists, formed. Suprematist Malevich (1878–1935) exhibits in Moscow. The Armory Show in New York.

1914 World War I. Bombardment of Reims Cathedral. *Our Knowledge of the External World* by Russell. Joyce's *Dubliners*. Vorticists, led by Wyndham Lewis (1884–1957), produce the journal *Blast*. *Werkbund* Exhibition in Berlin. Futurist architects exhibit in Milan. Sculptor Nadelman goes to New York. Kandinsky returns to Russia. Macke (1887–1914) and Klee visit Tunis. 1914–21, Delaunay (1885–1941) in Spain.

1915 Rupert Brooke's *1914 and other Poems*. Griffiths' film *The Birth of a Nation*. *The Voyage Out* by Virginia Woolf. Somerset Maugham's *Of Human Bondage*. Kafka's short story *Metamorphosis*. Marcel Duchamp visits New York.

1916 Holst's *The Planets*. The Cabaret Voltaire opens in Zurich: Dada is born. 1916–24, hangars at Orly built by Freyssinet (1879–1962) later destroyed. First exhibition of war pictures by Nevinson.

1917 Russian Revolution, Bolsheviks take control. Ballet *Parade*, music by Satie. *Les Mamelles de Tirésias* by Apollinaire, a Surrealist drama. Galerie Dada opens in Zurich. *Revue Dada* appears. The journal *De Stijl* appears. Feininger (1871–1956) has one-man show in Berlin in the Sturm Gallery. Picabía publishes Dadaist magazine *391*.

1918 Armistice. *Mouvements Perpetuels* by Poulenc. Paul Nash (1889–1946) exhibits in London. Schwitters (1887–1948) visits Zurich.

1919 Treaty of Versailles. League of Nations constituted. Hitler founds the National Socialist German Workers' Party. Mussolini founds the *Fasci di Combattimento*. Falla's ballet *The Three-Cornered Hat*, designed by Picasso. Wiene's film *The Cabinet of Dr Caligari*. Gropius founds the *Staatliche Bauhaus* in Weimar and publishes the *Bauhaus Manifesto*. Dada group founded in Berlin. Spanish painter Miró (b. 1893) visits Paris. 1919–38, Mondrian in Paris. Tatlin (1885–1953) designs the Constructivist *Memorial to the Third International*. 1919–20, Mendelssohn (1887–1953) builds the Einstein Observatory Tower at Neubabelsberg, since destroyed.

1920–1929 Key works: PAINTING Key works: ARCHITECTURE Key works: SCULPTURE

FRANCE

1920 *The Mechanic* by **Léger** (1881–1955), Galerie Louis Carré, Paris; famous post-Cubist work of artist inspired by technology.
1920 *The Mad Woman* by **Soutine** (1894–1943), Collection Rokubin Hayashi, Tokyo; one version of theme by Russian-born Expressionist living in Paris.
1921 *Composition in Red, Yellow and Blue* by **Mondrian** (1872–1944) Gemeente Museum, The Hague; straight line and pure colour abstract by most influential exponent of Neo-Plasticism.
1925 *Three Dancers* by **Picasso** (1881–1973), Tate Gallery, London; improvisatory painting admired by the Surrealists.
1827 *Battle of Fishes* by **Masson** (b. 1896), Museum of Modern Art, New York; one of several scenes of massacres by Surrealist intellectual.
1927 *The Great Forest* by **Ernst** (1891–1976), Kunstmuseum, Basle; one of series, created by Surrealist who developed frottage.

1922–3 *Notre-Dame*, Le Raincy, by **Perret** (1874–1954); unfaced concrete church of simple original form inspired by High Gothic chapels; much imitated in Europe.
1926 *Private Houses*, Rue Mallet-Stevens, Paris, by **Mallet-Stevens** (1886–1945); group of small residences in Cubist style but with variegated façade and interiors.
1927–31 *Villa Savoye,* Poissy, by **Le Corbusier** (1887–1966); spacious house on slender stilts with roof garden; influential early masterpiece by Swiss-born architect.

1921 *The Gift* by **Man Ray** (1890–1976), Collection unknown; domestic iron studded with nails, by American welcomed by Paris Dadaists.
1925 *Bird in Space* by **Brancusi** (1876–1957), Kunsthaus, Zurich; simple expressive form in bronze by one of earliest modern sculptors, resident in Paris.
1926 *Portrait of Marcel Duchamp* by **Pevsner** (1886–1962), Yale University Art Gallery; open plastic construction by brother of Gabo.
1926–30 *Figure* by **Lipchitz** (1891–1973), Collection Joseph H. Hirshhorn, New York; pierced bronze abstract; early example of artist's transparent sculptures.
1928 *Picador* by **Gargallo** (1881–1934), Museum of Modern Art, New York; one of best-known works by Spanish sculptor specializing in metalwork.
1928 *Design for a Monument* by **Picasso** (1881–1973), formerly Collection the artist; bronze; artist's attempt to find an independent sculptural image.

NORTH AND CENTRAL EUROPE

1920 *Rejected Picture* (*Merzbild Collage No. 31*) by **Schwitters** (1887–1948), Private Collection, Berne; collage of scraps by Dadaist, not intended as symbol or composition.
1921 *My Parents* by **Dix** (1891–1969), Kunstmuseum, Basle; one of several objective portraits by *Neuesachlichkeit* painter.
1923 *Battle Scene* from *The Seafarer* by **Klee** (1879–1940), Basle, Private Collection; illustration for comic operatic fantasy, on delicately coloured chequered ground, one of many chessboard compositions.
1927 *The Resurrection* begun by **Spencer** (1891–1959), Oratory of All Souls, Burghclere, England; climax of series of religious mural paintings. Cookham churchyard.
1929 *Sailing Boats* by **Feininger** (1871–1956), Collection Tannahill, Detroit; characteristic work of diagonals and triangles suggesting shafts of light and moving sails, by American painter in Germany.

1920–40 *Grundtvig Church*, Copenhagen, by **Klint** (1853–1930); steeply gabled brick building designed in 1913, anticipating Expressionist developments.
1921 *Eigen Haard*, Amsterdam, by **Klerk** (1884–1923); brick housing estate, begun in 1917, by leading exponent of the romantic Amsterdam School.
1923 *Chile House*, Hamburg, by **Hoeger** (1877–1940); one of the most important Expressionist works in Germany.
1924–7 *Housing Estate,* Hook of Holland, by **Oud** (1890–1963); severely cubic scheme by leading *De Stijl* architect.
1925–6 *Bauhaus*, Dessau, by **Gropius** (1883–1969); famous group of buildings for the School of Art; major example of the International style.
1928–30 *Van Nelle Tobacco Factory*, Rotterdam, by **Brinkman** (1902–49) and **Vlugt** (1894–1936); glass curtain-wall structure of International style.

1920 *Hanging Construction* by **Rodchenko** (1891–1956); hanging wooden spheres; invention by Russian Constructivist.
1922–30 *Light-Space Modulator* by **Moholy-Nagy** (1895–1946); Harvard University, Cambridge, Mass.; metal and plastic; one of earliest mechanized works.
1923 *Column* by **Gabo** (b. 1890), Museum of Modern Art, New York; scientific looking structure in glass, metal and wood by Russian innovator working in Germany.
1927 *War Memorial* by **Barlach** (1870–1938), Antoninerkirche, Cologne; suspended bronze figure by German Expressionist sculptor.
1927 *Volume Relations Projected by the Menton Cone* by **Vantongerloo** (1886–1965), formerly Collection the artist; plaster abstract.
1929 *Reclining Figure* by **Moore** (b. 1898), City Art Gallery, Leeds; first essay on theme in Brown Hornton stone by foremost English sculptor of the time.

SOUTH EUROPE

1923–4 *The Tilled Field* by **Miró** (b. 1893), Clifford Collection, Radnor, Penn.; early mature work painted at Montroig by artist in continual contact with Paris.

1927 *Novecomum*, Como, by **Terragni** (1904–42); controversial block of flats by *Gruppo 7* architect opposed to new International Style.

NORTH AMERICA

1922 *Maine Islands* by **Marin** (1870–1953), Phillips Collection, Washington; Cubist-influenced landscape by master of watercolour.
1926 *Black Iris* by **O'Keeffe** (b. 1887), Metropolitan Museum of Art, New York; delicately-coloured abstract design evolved from organic forms.
1927 *My Egypt* by **Demuth** (1883–1935), Whitney Museum of American Art, Washington; famous precisionist painting of grain-elevators.

1922 *Tribune Tower* by **Hood** (1881–1934), Chicago; Neo-Gothic sky-scraper; winning design in competition between traditionalists and innovators.
1927–9 *Lovell House*, Los Angeles, by **Neutra** (1892–1970); important early work of Austrian-born architect; rambling house framed in steel, with steel-hung balconies.

1924 *Archipentura* by **Archipenko** (1887–1964) destroyed but patented in 1928; box with metal bands activated by electric motor; constructed by Russian *émigré*.
1927–30 *Mother and Child* by **Zorach** (1887–1966), Metropolitan Museum of Art, New York; large pink marble sculpture of generalized smooth forms.

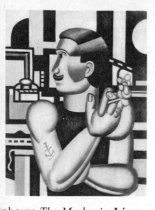

above: *The Mechanic*. **Léger**

right: *Notre-Dame*, Le Raincy. **Perret**

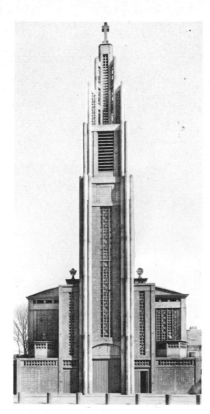

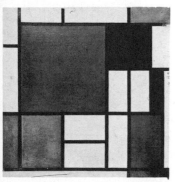

above: *Composition in Red, Yellow, Blue and Black*. **Mondrian**

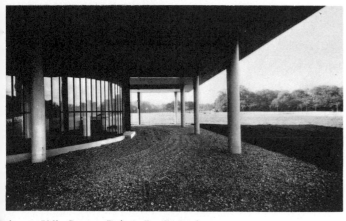

above: *Villa Savoye*, Poissy. **Le Corbusier**

below: *Bauhaus*, Dessau. **Gropius**

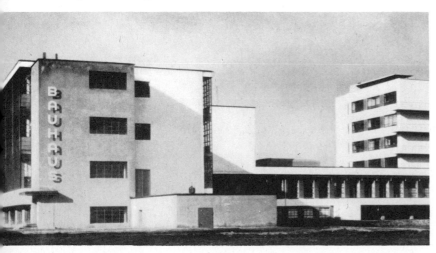

1920 American women receive the vote. *Chéri* by Colette. *The Rise of Cubism* by Kahnweiler. *Realist Manifesto* issued by Gabo (b. 1890) and **Pevsner (1886–1962). *L'Esprit Nouveau* begun by Le Corbusier and Ozenfant (1886–1966). *Ecce Homo* twenty satirical drawings by Grosz (1893–1959) published.**

1921 Reparation Commission. Shaw's *Back to Methuselah*. *Crome Yellow* by Huxley. Film *Anna Bolena* by Lubitsch. Scott Fitzgerald's *The Beautiful and Damned*. **Man Ray (1890–1976) arrives in Paris. Mexican painter Rivera (1886–1957) leaves Europe. 1921–31, Klee teaching at the Bauhaus.** *L'Esprit Nouveau* by Juan Gris (1887–1927), **Spanish Cubist.**

1922 Eliot's *The Waste Land*. Joyce's *Ulysses*. Pirandello's *Enrico IV*. Wittgenstein's *Tractatus*. Sitwell's *Façade*. British Broadcasting Commission (B.B.C.) founded. **Kandinsky (1866–1944) teaching at the Bauhaus. Russian Constructivist El Lissitsky (1890–1941/7) in Berlin at Exhibition of Soviet Art.**

1923 U.S.S.R. established. Hitler's attempted Putsch at Munich. *Mein Kampf*, Part I, published. *De Stijl Manifesto* issued. *Vers une Architecture* by Le Corbusier. *Neusachlichkeit* Exhibition in Mannheim. Pevsner settles in Paris. Eliel Saarinen (1873–1950) and son settle in America.

1924 *Surrealist Manifesto* by Breton. The *Blaue Vier* formed by Klee, Kandinsky, Feininger and Jawlensky (1864–1941). Schwitters creates the Hanover Merzbau, destroyed in 1943. *Café de Unie*, Rotterdam, by Oud, destroyed 1940.

1925 Hindenburg becomes German President. Honegger's opera *King David*. Coward's *Hay Fever*. *A Draft of Cantos* by Pound. **Bauhaus accused of Bolshevism and degeneracy, forced to leave Weimar for Dessau. Paris International Exhibition of Decorative Arts. First Surrealist Exhibition.**

1926 General Strike in Britain. Television invented. *Si le Grain Ne Meurt* by Gide. Philosophy of Existentialism, *Sein und Zeit* by Heidegger. Eisenstein's film *Battleship Potemkin*. Futuristic film *Metropolis*. **Interior decoration of *Café l'Aubette*, Strasbourg, by Doesburg (1883–1931), Arp (1887–1966) and Sophie Taeuber-Arp (1889–1943), now destroyed.**

1927 Socialist riots in Vienna. **Malevich (1878–1935) visits the Bauhaus. Magritte has exhibition in Paris. Fuller (b. 1895) designs the Dymaxion House. Aalto (1898–1976) begins Viipuri Library, now destroyed.**

1928 Discovery of penicillin. Lawrence's *Lady Chatterley's Lover*. Brecht's *Threepenny Opera*. **CIAM, International Congress of Modern Architects, founded.** *The Balance Sheet of Modern Arts* and *The Structure of a New Spirit* by Ozenfant.

1929 Economic and social crisis in America. Severe inflation in Germany. Trotsky expelled from Russia. *The Sound and the Fury* by Faulkner. *Le Chien Andalou*, Surrealist film by Dali (b. 1904). **Gropius (1883–1969) designs his Total Theater. Barcelona Exhibition; influential German Pavilion by Mies van der Rohe (1886–1969).**

	Key works: PAINTING	Key works: ARCHITECTURE	Key works: SCULPTURE
FRANCE	1931 *The Persistence of Memory* by **Dali** (b. 1904), Museum of Modern Art, New York; disturbing painting of soft watches by controversial Surrealist. 1933 *Head of Christ* by **Rouault** (1871–1958), Musée National d'Art Moderne, Paris; famous religious painting showing the artist's knowledge of stained glass. 1934 *Sacré-Coeur, Montmartre and Rue Saint-Rustique* by **Utrillo** (1885–1955), Herron Museum of Art, Indianapolis; famous scene by non-academic French painter who used postcards for inspiration. 1937 *Guernica* by **Picasso**, Museum of Modern Art, New York; mural prompted by bombing of civilians in the Spanish Civil War. 1939 *Le Temps Meublé* by **Tanguy** (1900–55), Collection Soby, New Canaan, Conn.; Surrealist painting, evoking vast space.	1930–2 *Swiss House* for students, Cité Universitaire, Paris by **Le Corbusier** (1887–1966); reflects architect's increasingly bold, organic style. 1930–1 *Studio at Meudon-Val-Fleury* by **Doesburg** (1883–1931); rare work of *De Stijl* painter turned architect. 1932–5 *La Muette*, Drancy, by **Beaudouin** (b. 1898); involved advanced use of pre-fabricated materials.	1932 *Woman with her Throat Cut* by **Giacometti** (1901–66), 1949 version in Museum of Modern Art, New York; famous sculpture by Italian resident in France. 1933 *Maternity* by **Gonzalez** (1876–1942), Collection Mme Gonzalez-Hartung, Paris; linear metalwork figure by Spanish artist who taught metalwork to Picasso. 1935 *Human Concretion* by **Arp** (1887–1966), Museum of Modern Art, New York; plaster original of rich organic form which fascinated the sculptor. 1936–7 *Montserrat* by **Gonzalez**, Stedelijk Museum, Amsterdam; heroic figure in iron. 1936 *Object* by **Oppenheim** (b. 1913) Museum of Modern Art, New York; Surrealistic creation; fur-covered cup and saucer with teaspoon. 1936 *Developable Surface* by **Pevsner** (1886–1962), Muller Collection, Basle; thin sections of oxidized metal soldered into continuous curves; first version of the theme.
NORTH AND CENTRAL EUROPE	1932–5 *Departure* by **Beckmann** (1884–1950), Museum of Modern Art, New York; most intriguing of triptych, by *Neusachlichkeit* painter. 1932–42 *Pillar and Moon* by **Paul Nash** (1889–1946), Tate Gallery, London; famous English painting influenced by Surrealism. 1933 *The Human Condition* by **Magritte** (1898–1967), Collection Claude Spaak, Choisel; painting with optical illusion by Surrealist. 1935 *White Relief* by **Nicholson** (b. 1894), Tate Gallery, London; one of series of austere abstracts by progressive British painter. 1935 *Portrait of Edith Sitwell* completed (begun 1923) by **Wyndham Lewis** (1884–1957), Tate Gallery, London; controversial portrait by Cubist-influenced painter. 1939 *La Belle Jardinière* by **Klee** (1879–1940), Klee Foundation, Berne; famous late painting, mysterious ideograms on ground of softly merging colours.	1930 *Tugendhat House*, Brno, by **Mies van der Rohe** (1886–1969); International Style luxury house; interior designed and furnished by the architect. 1930 *Muller House*, Prague, by **Loos** (1870–1933); finest work by pioneer of modern architecture. 1930–2 *Open-Air School*, Cliostraat, Amsterdam by **Duiker** (1890–1935); school built by *de Stijl* architect in the face of opposition. 1933 *Highpoint Flats*, Highgate, London, by **Tecton** (group, including **Lubetkin** and **Lasdun**); first major building of modern movement in England, admired by Le Corbusier. 1936 *Impington Village College*, Cambridge, by **Gropius** (1883–1969) and **Fry** (b. 1899); major work of foremost Bauhaus architect and leading English International Modernist. 1938–41 *Cemetery Chapel*, Turku, by **Bryggman** (1891–1955); ultimate work in architect's Rationalist phase.	1937–8 *Construction in Space* by **Gabo** (b. 1890), Collection the Artist; clear plastic construction by artist in London; demonstrates the dematerialisation of substance in sculpture. 1938 *The Complaint* by **Kollwitz** (1867–1945), Bayerische Staatsgemäldesammlungen, Munich; bronze relief by sculptor unaffected by modern radical developments. 1939 *Bird Basket* by **Moore** (b. 1898). Collection Mrs Irina Moore; abstract of carved wood with taut string, combination also used by Hepworth (1903–75).
SOUTH EUROPE		1935 *Stands, Zarzuela Racetrack* near Madrid, by **Torroja** (1899–1961); perhaps best-known creation of Spanish pioneer in reinforced and pre-stressed concrete.	1930 *Shulamite* by **Manzù** (b. 1908) Collection Pizzigoni, Bergamo; coloured cement work by Italian sculptor in close contact with Paris.
NORTH AMERICA	1936 *Broadway* by **Tobey** (b. 1890), Metropolitan Museum of Art, New York; early 'white writing' work; abstract by American influenced by Oriental calligraphy. 1939 *New York Movie* by **Hopper** (1882–1967), Museum of Modern Art, New York; Surreal painting of lone figure in artificial light by American scene-painter. 1939 *Hand Ball* by **Shahn** (1898–1969), Museum of Modern Art, New York; realistic scene by artist concerned with social content in his work.	1930–2 *Empire State Building*, New York, by **Shreve**, **Lamb** and **Harman**; comparatively conventional skyscraper. 1932 *Philadelphia Savings Fund Building* by **Lescaze** (1896–1969) and **Howe** (1886–1956); first prominent American building in European International Style. 1936 *Kauffmann House*, Bear Run, Penn., by **Wright** (1869–1959); famous beautifully sited house of great visual impact, with horizontal concrete slabs and cantilevered terraces placed over a waterfall.	1932 *Miss Expanding Universe* by **Noguchi** (b. 1904), Toledo Museum of Art; early work in aluminum by American influenced by Brancusi. 1933 *Calderberry Bush* by **Calder** (1898–1976), Collection Mr and Mrs Sweeney, New York; early mobile in several materials; form invented by the artist. 1939 *Moses* by **Archipenko** (1889–1964); created for artists exiled by Fascist regimes in Europe.

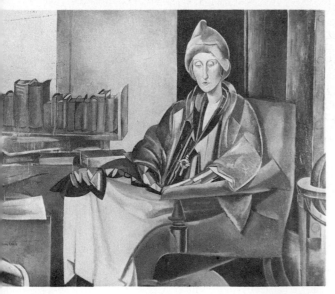

above: *Portrait of Edith Sitwell*. **Wyndham Lewis**

below left: *Montserrat*. **Gonzalez**

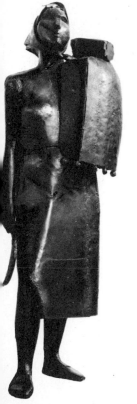

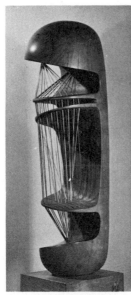

above: *White Relief*. **Nicholson**

left: *Bird Basket*. **Moore**

below: *Stands, Zarzuela Racetrack*. **Torroja**

1930 End of Allied occupation of Germany. Keynes' *Treatise on Money*. Hesse's *Narziss und Goldmund*. **First and only issue of *Art Concert* by Doesburg, Paris. *Ma Vie* by Chagall (b. 1887) published. Mexican painter Rivera (1886–1957) invited to New York for exhibition of his work.**

1931 Spanish Republican Constitution established. De Valeira comes to power in Irish Free State. *Blood of a Poet*, Surrealist film by Bunuel. Walton's *Belshazzar's Feast*. **International Exhibition of Architecture in Berlin. Formation of Abstraction-Creation group in Paris.**

1932 Roosevelt elected President of the U.S. *Brave New World* by Huxley. Runyon's *Guys and Dolls*. ***The International Style: Architecture since 1922* by Hitchcock and Johnson. First exhibition by Calder in Paris: his works named Mobiles by Duchamp. Hepworth (1903–75) visits Paris.**

1933 Hitler becomes German Chancellor: freedom of Speech and Press abolished. *La Condition Humaine* by Malraux. Stein's *Autobiography of Alice B. Toklas*. **Bauhaus closed. Public Works of Art Project organized by the U.S. government. Athens Charter produced by CIAM architects.**

1934 Hitler becomes Führer. Cocteau's play *La Machine Infernale*. Read's *Art and Industry*. **Brauner's (1903–66) one-man show in Paris. Tobey (b. 1890) in the Far East. Gropius in London. Mendelssohn leaves Britain for Israel.**

1935 Stresa Conference. Nuremberg Laws in Germany. Gershwin's *Porgy and Bess*. *Lady Macbeth* by Shostakovich. **The Ten, group of American painters, formed. The Index of American Design begun. French engineer Laffaille erects Exhibition Pavilion at Zagreb, with suspended cable net roofing.**

1936 Spanish Civil War begins. Abdication of Edward VIII, accession of George VI. Italy invades Abyssinia. Chaplin's film *Modern Times*. **Le Corbusier visits Brazil.** Renoir's film *Partie de Campagne*.

1937 Spanish Republicans move capital to Barcelona Bombing of Guernica. **Exhibition of Degenerate Art in Munich.** *Plastic Art and Pure Plastic Art*, **essays by Mondrian (1872–1944). Gropius appointed to Harvard Chair of Architecture. New Bauhaus founded in Chicago by Moholy-Nagy (1895–1946).**

1938 Germany annexes Austria: Munich Pact. Hindemith's opera *Mathis der Maler*. Sartre's novel *La Nausée*. Greene's *Brighton Rock*. **Mies van der Rohe appointed Head of Faculty of Architecture, Chicago.**

1939 Barcelona captured by Nationalists, led by Franco. Outbreak of Second World War. Joyce's *Finnegan's Wake*. *The Grapes of Wrath* by Steinbeck. New York World's Fair. **Spanish architect Torroja settles in Mexico. Candela (b. 1910) emigrates to Mexico.**

1940–1949	Key works: PAINTING	Key works: ARCHITECTURE	Key works: SCULPTURE
FRANCE	1943 *Circle and Square No. 716* by **Kandinsky** (1866–1944), Collection Mme Kandinsky; one of last works by Bauhaus painter settled in France. 1945 *Hostage* by **Fautrier** (1898–1964), Private Collection, Sweden; one of series of innovatory works stressing the quality of the painted surface. 1949 *Studio II* by **Braque** (1882–1963), Kunstsammlung Nordrhein Westfalen, Düsseldorf; second in famous series of harmonious Cubist abstracts.	1947–52 *Unité d'Habitation*, Marseilles, by **Le Corbusier** (1887–1966); one unit in projected group of eight blocks rising on stilts in open parkland. 1949 *Housing Estate* at Meudon by **Prouvé** (b. 1901); prefabricated aluminum elements by outstanding French engineer-architect.	1943 *Gisant* by **Adam** (1904–67); famous carving of figure which scandalized the public at the Salon de la Libération. 1948–9 *City Square* by **Giacometti** (1901–66), Collection Peggy Guggenheim, Venice; stick-like figures on flat base, conveying sense of space and isolation. 1949 *Reclining Woman* by **Laurens** (1885–1954), Hanover Collection, London; bronze by sculptor formerly involved in Cubism.
NORTH AND CENTRAL EUROPE	1941 *Hands* by **Delvaux** (b. 1897), Collection Claude Spaak, Choisel; haunting painting of female nudes, characteristic of Belgian Surrealist. 1944 *Three Studies for a Crucifixion* by **Bacon** (b. 1910), Tate Gallery, London; weird and shocking painting which made the painter notorious. 1948 *The Industrial City* by **Lowry** (1887–1976), British Council Collection; naïve cityscape of industrialized northern England. 1948 *Cry of Liberty* by **Appel** (b. 1921), Stedelijk Museum, Amsterdam; boldly coloured abstract by Dutch member of Cobra. 1949 *Portrait of Somerset Maugham* by **Sutherland** (b. 1903), Tate Gallery, London; strikingly original realistic painting.	1940 *Forest Crematorium* by **Asplund** (1885–1940), Stockholm; major achievement of Swedish architect concerned with integrating architecture into natural environment. 1947 *Grondel Apartments*, Stockholm by **Backstrom** (b. 1903) and **Reinius** (b. 1907); remarkable low-cost housing estate; basic unit repeated in a honeycomb pattern. 1949 *School at Hunstanton*, England, designed by **Alison Smithson** (b. 1928) and **Peter Smithson** (b. 1923); first work of New Brutalism which attracted international attention; completed in 1954.	1943–4 *Wave* by **Hepworth** (1903–75), Collection Havindon, England; characteristic sculpture of painted carved wood and string. 1943–4 *Northampton Madonna* by **Moore** (b. 1898), St Matthew, Northampton; one of his best-known works from this period. 1947–9 *Endless Loop* by **Bill** (b. 1908), Collection Joseph H. Hirshhorn, New York; gilded copper piece by concrete-art sculptor fascinated by relations of art to mathematics. 1949 *Lazarus* by **Epstein** (1880–1959), New College Chapel, Oxford; famous reluctant figure of resurrection by pioneer of modern sculpture in England.
SOUTH EUROPE	1940 *The Poetess* by **Miró** (b. 1893), Collection Mr and Mrs Colin, New York; small gouache, one of series of 'Constellations' exhibited and acclaimed in New York in 1945.	1942 *Olivetti Plant* at Ivrea by **Figini** (b. 1903) and **Pollini** (b. 1903) exemplary industrial unit by *Gruppo 7* architects. 1948–9 *Exhibition Hall*, Turin by **Nervi** (1891–1979); outstanding example of successful large-scale prefabrication and inspired design. 1948–50 *Termini Station*, Rome, by **Montuori** (b. 1907) and Associates; considered finest station of the century, using cantilever and incorporating part of city wall.	1944–6 *Bird* by **Miró** (b. 1893), Gallery Maeght, Paris; bronze cast by Surrealist-influenced painter experimenting with ceramics. 1949 *Porta della Morte*, St Peter's, Rome, by **Manzù** (b. 1908); bronze doors with realistic reliefs, installed in 1964. 1949 *Horse and Rider* by **Marini** (b. 1901), Walker Art Center, Minneapolis; famous bronze of simplified realism; one in series begun in the 1930s.
NORTH AMERICA	1940–2 *Europe after the Rain* by **Ernst** (1891–1976), Wadsworth Atheneum, Hartford; curiously textured, detailed evocation of decay. 1942–3 *Broadway Boogie-Woogie* by **Mondrian** (1872–1944), Museum of Modern Art, New York; title inspired by contemporary jazz; work marks turning point in artist's style from his usual formula. 1944 *The Liver is the Cock's Comb* by **Gorky** (1904–48), Albright-Knox Art Gallery, Buffalo; climactic painting; best-known work of Abstract Expressionist. 1948 *Number One* by **Pollock** (1912–56), Museum of Modern Art, New York; early Action Painting by its foremost exponent. 1949 *At Five in the Afternoon* by **Motherwell** (b. 1915), Collection the Artist; first in series of mainly black and white Abstract Expressionist paintings called Elegy of the Spanish Republic.	1941 *Housing Scheme*, New Kensington by **Gropius** (1883–1969) and **Breuer** (b. 1902); factory estate planned according to the contours of the hillside site. 1946–60 *Solomon R. Guggenheim Museum*, New York by **Wright** (1869–1959); single sculptural unit; internally a spiral ramp. 1946–7 *Kaufmann Desert House*, Palm Springs, Cal., by **Neutra** (b. 1892); lavish domestic building in mature International Style. 1947–50 *United Nations Building*, New York, by **Harrison** (b. 1895) and **Abramowitz** (b. 1908); first in a series of post-war skyscrapers. 1949–56 *General Motors Technical Center*, Michigan, by **Eero Saarinen** (1910–61); imaginative industrial design, using coloured panels. 1949 *Philip Johnson House*, New Canaan, Conn., by **Philip Johnson**; glass box house set in wooded lakeland region; defies distinction between enclosed space and setting.	1942 *Horizontal Spines* by **Calder** (1898–1976), Phillips Academy, Mass.; sheet metal and wire rods; example of developed mobile. 1942 *Medici Slot Machine* by **Cornell** (b. 1903), Collection Mr and Mrs Reis, New York; one of artist's display boxes in which evocative objects are framed. 1944–5 *Kouros* by **Noguchi** (b. 1904), Metropolitan Museum of Art, New York; nude in marble; shown at the Fourteen Americans Exhibition. 1948 *The Royal Bird* by **David Smith** (1906–65), Walker Art Center, Minneapolis; aggressive-looking skeleton in stainless steel.

above: *Kouros*. **Noguchi**

above: *The Poetess*. **Miró**

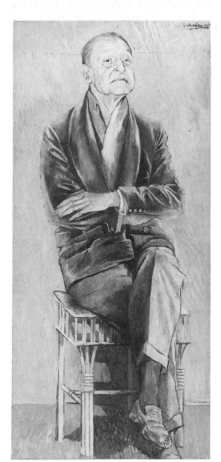

above: *Portrait of Somerset Maugham*.
Sutherland

1940 Fall of France. Battle of Britain. London Blitz. Baedeker Raids begin. Aragon's *Le Crève-coeur*. Sholokhov's *Quiet Flows the Don*. *Portrait of the Artist as a Young Dog* by Dylan Thomas. *For Whom the Bell Tolls* by Hemingway.

1941 Germans invade Russia. Pearl Harbour. Wells' film *Citizen Kane*. **Young Painters in the French Tradition, Exhibition in Paris.** America enters World War II.

1942 Heavy Allied bombing of Germany. Eliot completes his *Four Quartets*. Eluard's *Poésies et Verités*. Anouilh's *Antigone*. **Ernst, Breton and Duchamp produce the Review *VVV* in New York.**

1943 Defeat of German army at Stalingrad. French National Liberation Front founded in Algiers. Mussolini imprisoned. *A Tree Grows in Brooklyn* by Smith. **Pollock's first one-man show at the Art of the Century, New York.**

1944 Allied invasion of Italy. Bombing of Monte Cassino. Eisenstein's film *Ivan the Terrible,* music by Prokofiev. *The Glass Menagerie* by Tennessee Williams. Trevelyan's *English Social History*. **First International Exhibition of Concrete Art in Basle.**

1945 First atomic explosion. Bombs dropped on Hiroshima and Nagasaki. Unconditional surrender of Germany. Allied Conference at Potsdam. *Animal Farm* by Orwell. **Film by Richter and Ernst, *Dreams that Money can Buy*. Architect's Collaborative formed by Gropius and others. *Manifesto del Realismo* by leading Italian artists.**

1946 UNESCO established. Indo-China War begins. Russell's *The History of Western Philosophy*. *Hiroshima* by Hershey. *The Winslow Boy* by Rattigan. **Malraux's *Psychologie de l'Art* begun. The White Manifesto by Lucio Fontana.**

1947 Atom bomb testing at Bikini. India Independence Act. Prokofiev's opera *War and Peace*. Turangalila, symphony by Messiaen. *La Peste* by Camus. **Abstraction-Création group revived in Paris. 1947–8 *Fronte Nuovo delle Arti* formed in Italy.**

1948 State of Israel proclaimed. South Africa adopts Apartheid policy officially. Ghandi assassinated. Mailer's *The Naked and the Dead*. **Group *Dau al Cet* founded in Barcelona. 1948–50, Experimental COBRA group formed in Northern Europe.**

1949 Communist German Democratic Republic established in East Germany. German Federal Republic constituted with new capital at Bonn. Adenauer appointed Chancellor. Chinese People's Republic under Mao Tse-Tung proclaimed. *The Second Sex* by Simone de Beauvoir. Fry's play *The Lady's Not for Burning*. **Moholy-Nagy's *Abstract of an Artist* published.**

left: *Exhibition Hall,* Turin. Interior. **Nervi**

1950–1959	Key works: PAINTING	Key works: ARCHITECTURE	Key works: SCULPTURE
FRANCE	1951–2 *T-50 Painting 8* by **Hartung** (b. 1904), Museum of Modern Art, New York; strong vertical lines on flat ground by painter intrigued by psychic improvisation. 1952 *Painting* by **Soulages** (b. 1919), Museum of Modern Art, New York; forceful composition of black beams of paint on white canvas. 1953 *The Snail* by **Matisse** (1869–1954), Tate Gallery, London; gouache cut-out; one of the artist's most purely arbitrary works. 1954 *Vache la Belle Allègre* by **Dubuffet** (b. 1901), Cochrane Gallery, London; one of best-known works of *Art Brut* exponent seeking to rehabilitate discredited values. 1955 *Le Fort d'Antibes* by **Staël** (1914–55), Collection Dubourg, Paris; one of artist's last works; juxtaposes areas of strong colour.	1950–4 *Pilgrimage Church,* Ronchamp, by **Le Corbusier** (1887–1966); famous building in architect's sculptural style. 1952–8 *UNESCO Building,* Paris, by **Breuer** (b. 1902), **Zehrfuss** (b. 1911) and **Nervi** (1891–1979); ambitious Y-shaped building with many sculptures and murals. 1954 *Basilica of Pope Pius X,* Lourdes, by **Vago** (b. 1910) and **Freysinnet** (1879–1962); underground church; design dependent on use of pre-stressed concrete. 1954–6 *Maisons-Jaoul,* Neuilly, by **Le Corbusier**; marks return to a primitive aesthetic, International Brutalism.	1951 *Baboon and Young* by **Picasso** (1881–1973), Museum of Modern Art, New York; bronze, using toy car for head; humorous work. 1954 *The Bat* by **Richier** (1904–59), formerly collection the artist; sinister mutated creature, early example of sculpture intended to horrify. 1957 *Lux I* by **Schöffer** (b. 1912), Musée National d'Art Moderne, Paris: first of artist's lumino-dynamic ensembles. 1958–9 *Metamachine* by **Tinguely** (b. 1925), Private Collection; painted metal machine which produces abstract drawings. 1959 *The Yellow Buick* by **César** (b. 1921), Museum of Modern Art, New York; compressed car; one of the artist's first *compressions dirigées*.
NORTH AND CENTRAL EUROPE	1953 *Study after Velazquez's Portrait of Pope Innocent X* by **Bacon** (b. 1910), Collection Mr and Mrs Burden, New York; famous distorted and nightmarish reinterpretation of Old Master. 1956 *Just What Is It That Makes Today's Homes So Different, So Appealing?* by **Hamilton** (b. 1922) Collection Mr Edwin James Jr, Cal.; collage satirizing modern domesticity; one of earliest Pop Art works.	1950–2 *Town Hall,* Säynätsalo, Finland, by **Aalto** (1898–1976); his best-known European work; part of a municipal centre. 1953 *Vallingby,* Sweden, by **Markelius** (b. 1889); suburb of widely spaced high-rise blocks for 25,000 people. 1954–62 *Coventry Cathedral* by **Spence** (1907–76); best-known work of British architect, built beside the ruins of the Old Cathedral. 1955 *Jespersen Offices,* Copenhagen, by **Jacobsen** (b. 1902); supreme example of curtain wall building. 1957 *Phoenix-Rheinrohr Building,* Düsseldorf, by **Hentrich** and **Petschnigg**; three slabs with structural core; notable German skyscraper.	1951–3 *The Ruined City* by **Zadkine** (1890–1967), Rotterdam; symbolic and expressive memorial for heavily bombed city. 1956–7 *Falling Warrior* by **Moore** (b. 1898), Collection Joseph H. Hirshhorn, New York; tragic symbol of self-destruction. 1956–7 *Figure with Raised Arms* by **Wotruba** (b. 1907), Collection Joseph H. Hirshhorn, New York; best-known work of Austrian sculptor; multi-jointed figure made of bronze cylinders. 1958 *Japanese War God* by **Paolozzi** (b. 1924), Albright-Knox Art Gallery, Buffalo; bronze by British exponent of Junk sculpture.
SOUTH EUROPE	1951 *Crucifixion* by **Dali** (b. 1904), Glasgow Art Gallery and Museum; crucified figure painted with detailed realism from unusual and evocative viewpoint. 1954 *Sacco 4* by **Burri** (b. 1915), Collection A. Denney, London; example of material art of the 50s; part of series begun in 1952.	1956–9 *Pirelli Tower,* Milan by **Ponti** (b. 1891); architect's finest work; slab of curtain-walling with long sides tapering elegantly. 1957 *Istituto Marchiandi,* Milan, by **Vigano** (b. 1919); prominent example of Italian Brutalism. 1957 *Torre Velasca,* Milan, by **BBPR**; unusual building by partnership of architects; concrete frame dominates the exterior.	1951 *Igor Stravinsky* by **Marini** (b. 1901), Minneapolis Institute of Arts; rare example of successful modern portraiture in the grand style. 1956–7 *The Shadows* by **Minguzzi** (b. 1911), Collection Joseph H. Hirshhorn, New York; characteristically delicate linear work of sculptor who abandoned figurative art around 1950.
NORTH AMERICA	1952 *Woman I* by **Kooning** (b. 1904) Museum of Modern Art, New York; first in well-known series by leading Abstract Expressionist. 1954 *Flag* by **Johns** (b. 1930), collection Philip Johnson, New York; encaustic and collage flag; replica of the subject. 1958 *Two Openings in Black over Wine* by **Rothko** (1903–70), Tate Gallery, London; soft-edged rectangles in abstract composition; intended for the spectator's meditation. 1959 *Homage to the Square: Apparition* by **Albers** (1888–1976) Museum of Modern Art, New York; abstract by artist carefully exploring relations between colours.	1950 *Raleigh Arena,* North Carolina, by **Norwicki** (1910–49) and **Severud**; first construction with hyperbolic paraboloid roof. 1956 *TWA Terminal,* Kennedy Airport, New York by **Eero Saarinen** (1910–61); sensational sculptural creation consciously symbolizing flight. 1957–61 *Richards Medical Research Building,* University of Pennsylvania, by **Louis Kahn** (b. 1901); restless redbrick design, hailed as a new stylistic departure. 1958 *Geodesic Dome* at Baton Rouge, Louisiana, by **Buckminster Fuller** (b. 1895); largest of his domes; built on the space-frame principles.	1953–8 *Rape of Lucrece* by **Nakian** (b. 1897), Egan Gallery, New York; steel-plate construction exhibited and acclaimed in 1958. 1953–6 *Variations within a Sphere No. 10, The Sun* by **Lippold** (b. 1915) Metropolitan Museum of Art, New York; original linear construction in thin gold wire. 1958 *Linear Construction in Space* by **Gabo** (b. 1890), Whitney Museum of American Art, New York; steel springs and transparent plastic structure by Russian settled in America.

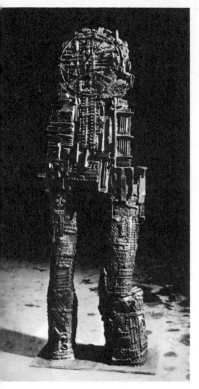

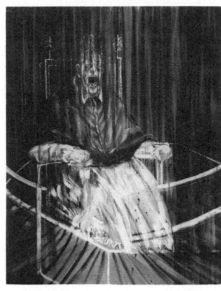

above: *Japanese War God.*
Paolozzi

above: *Study after Velazquez's Portrait of Pope Innocent X.* **Bacon**

left: *Pirelli Tower*, Milan. **Ponti**

below: *The Ruined City.* **Zadkine**

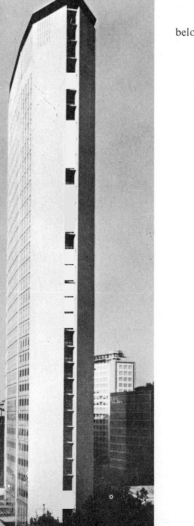

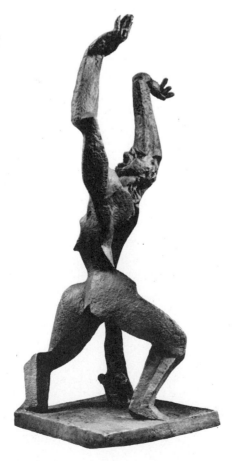

1950 McCarthy Committee of Enquiry into unAmerican Activities begins work. Labour government returned to power in Britain. China invades Tibet, North Korea invades South Korea. Ionesco's play *La Cantatrice Chauve. The Cocktail Party* by Eliot. **1950–60, Niemeyer (b. 1907) produces designs for the new capital, Brasilia, plans by Costa (b. 1902). Le Corbusier commissioned to design new capital of the Punjab, Chandigarh.**

1951 U.S.S.R. tests atom bomb. **Festival of Britain, architectural director Casson (b. 1913). Festival Hall by Matthew (b. 1906). Museum of Modern Art, New York exhibits Abstract Painting and Sculpture in America.** *Anthology of Dada* by Motherwell (b. 1915). **Haring (1882–1958) publishes** *Geometrie und Organik.*

1952 First British atomic test. Eisenhower elected U.S. President. *Art Autre* by Tapiès (b. 1923) **published. Harold Rosenberg coins term Action Painting. Happening staged by John Cage and others at Black Mountain, U.S.A.**

1953 Germany joins NATO. Uprising in East Berlin. Coronation of Queen Elizabeth II. Mount Everest conquered. Britten's *Gloriana. Under Milk Wood* by Dylan Thomas. Beckett's play *Waiting for Godot.*

1954 French Algerian war begins. *Art and Visual Perception: a Psychology of the Creative Eye* **by Arnheim. Exhibition of the Diaghilev Ballet in London. Exhibition of 100 Years of Aluminum, Paris; hall built by Prouvé (b 1901). Competition for the design of the Sydney Opera House; building begun by Utzon (b. 1918) in 1959.**

1955 Geneva Conference. **Movement, large exhibition of Kinetic works at the Galerie Denise René, Paris. Vasarély issues his** *Yellow Manifesto* **on plastic-kineticism. First tent design by Frei Otto (b. 1925), bandstand shelter, Federal Garden Exhibition, Kassel.**

1956 Stalin's policy denounced in Russia. Pakistan proclaimed a Republic. Egypt nationalizes the Suez Canal. Presley records 'Blue Suede Shoes'. *Look Back in Anger* by Osborne. **Clouzot's film** *Le Mystère de Picasso.* **This is Tomorrow Exhibition at the Whitechapel Art Gallery. Mathieu stages Happening in Paris theatre.**

1957 First earth satellites sent into orbit. *A Testament* by Wright (1869–1959) published. **CLASP forms in Britain to build prefabricated schools. Stone (b. 1902) begins building U.S. Embassy, New Delhi.** *Equipo 57,* **group of anonymous artists, most active in Spain.**

1958 European Economic Community established. De Gaulle becomes French President. Kruschev becomes President of the USSR. *La Voix Humaine,* opera by Poulenc. Genet's play *Les Nègres. The Theatre and its Double* by Artaud. **The New American Painting Exhibition, Museum of Modern Art, New York. Pollock (1912–56) Exhibition, Whitechapel Gallery. Brussels Exhibition. Group Zero formed in Düsseldorf.**

1959 Castro takes control in Cuba. Alaska becomes 49th U.S. State. Wilder's film *Some Like it Hot,* with Marilyn Monroe. *Groupe de Recherche d'Art Visuel* **founded in Paris. New Images of Man Exhibition, New York. Group T founded in Milan. Collapse of CIAM. Architects of Team X publish their ideas.**

1960–1969	Key works: PAINTING	Key works: ARCHITECTURE	Key works: SCULPTURE
FRANCE	1960 *ANT 143 'The Handsome Teuton'* by **Klein** (1928–62), London Arts Gallery; work of major Neo-Dadaist personality. 1964 *Made in Japan* by **Raysse** (b. 1936), Dwan Gallery, Los Angeles; garish collage-type paintings, incorporating an Ingres Odalisque. 1967–8 *Arny* by **Vasarély** (b. 1908), Galerie Denise René, Paris; psychedelic composition of coloured geometric forms.	1960 *Monastery of La Tourette*, Evreux, completed, by **Le Corbusier** (1887–1966); powerful and rich design showing constructive attitude to tradition. 1960 *S.-Bernadette*, Nevers, by **Parent**; massive masonry blocks recalling monumentality of primitive architecture. 1960–2 *IBM Research Center*, La Gaude Var, by **Breuer** (b. 1902); sophisticated landscaped complex.	1960 *Monumental Head* by **Giacometti** (1901–66), Collection Joseph H. Hirshhorn, New York; famous work of period, forms becoming bigger and more clearly defined. 1962 *Woven Sphere* by **Morellet** (b. 1925), Galerie Denise René, Paris; hanging sphere of stainless steel wires; Op Art work. 1963 *Signe* by **Brauner** (1903–66), Alexander Iolas Gallery, New York; gilded bronze double image of head by Surrealist-influenced artist. 1965 *Alexander before Ecbatana* by **Ipousteguy** (b. 1920), Galerie Claude Bernard, Paris; deliberate return to grand historical theme.
NORTH AND CENTRAL EUROPE	1962 *Wine Red* by **Pasmore** (b. 1908) City Art Gallery, Bristol; abstract by Bauhaus-influenced painter. 1962–3 *Picture Emphasising Stillness* by **Hockney** (b. 1937), Glazebrook Collection, London; cartoon-like painting; artist's pictures often of striking clarity. 1964 *Crest* by **Riley** (b. 1931), Rowan Gallery, London; best-known work of leading English Op Artist. 1967 *Manganese in Deep Violet* by **Heron** (b. 1920), Collection J. Walter Thompson Co. Ltd, London; abstract pattern of bold sharp-edged colour-forms.	1960 *Skarpnak Church* near Stockholm, by **Lewerentz** (b. 1885); reflects new tendency to seek strong individual expression. 1961 *Memorial Church*, Berlin, by **Eiermann** (b. 1904); stark flat-roofed octagon; uniform steel-grid walls. 1964 *Philharmonic Hall*, Berlin by **Scharoun** (b. 1893) completed; arrangement of stage and seating inspired by Gropius's project for the Total Theater. 1967 *Cathedral of Christ the King*, Liverpool by **Gibberd** (b. 1908) completed; prize-winning centralized Roman Catholic church in symbolic crown form.	1960 *Two Piece Reclining Figure No. II* by **Moore** (b. 1898), Museum of Modern Art, New York; powerful rocky image in two parts; precursor of massive bronze groups of later 60s and 70s. 1960 *The Watchers* by **Chadwick** (b. 1914), GCC Collection, London; delicately balanced work of sculptor who invented his own technique of casting. 1962 *Lock* by **Caro** (b. 1924), Collection Kasmin Ltd, London; coloured steel abstract by progressive British sculptor.
SOUTH EUROPE	1960 *Spatial Concept* by **Lucio Fontana** (1899–1968), Wallraf-Richartz Museum, Cologne; one of numerous versions of the concept in painting and sculpture; five slashes in canvas. 1960 *Painting* by **Tàpies** (b. 1923), Galerie Stadler, Paris; work rejects artificiality, by Spanish artist experimenting with materials.	1961 *Rinascimento Department Store*, Rome, by **Albini** (b. 1905); best-known building of architect. 1961 *Palazzo del Lavoro*, Turin, by **Nervi** (1891–1979); masterpiece of combined modern engineering and design; huge square building supported by sixteen piers with radiating ribs.	1965 *Man with a Door* by **Serrano** (b. 1910); horrifying creature opening itself, by Spanish sculptor in metalwork. 1965 *Space Modulation IV* by **Chillida** (b. 1924), Collection Maeght, Paris; architectural abstract by foremost Spanish sculptor of his generation.
NORTH AMERICA	1962 *Marilyn Monroe* by **Warhol** (b. 1930), Collection Jasper Johns, New York; silkscreen; popular yet mysterious image of filmstar. 1962 *Silver Skies* by **Rosenquist** (b. 1933), Collection Mr and Mrs Scull; New Realist painting; composition of enlarged and fragmented images. 1963 *The Demuth 5* by **Indiana** (b. 1928), Collection Mr and Mrs Scull, New York; precise graphic condemnation of modern materialism. 1963 *Whaam* by **Lichtenstein** (b. 1923), Tate Gallery, London; dramatic silkscreen enlargement of comic strip scene. 1965 *Weatherside* by **Wyeth** (b. 1917), Collection Mr and Mrs Laughlin, New York; sharp-edged realist painting of rural America. 1966 Fourteen *Stations of the Cross* by **Newman** (1905–70), Museum of Modern Art, New York; series of compositions of black stripes on white canvas by veteran Abstract Expressionist.	1963 *Art and Architecture Building* Yale, New Haven, by **Rudolph** (b. 1918); structure of interlocking slabs, creating visual tension. 1965 *City Hall*, Toronto, by **Revell** (1910–64); exciting attempt at formal symbolism by Swedish architect. 1966 *Whitney Museum of American Art*, New York, by **Breuer** (b. 1902); Brutalist building, in dark granite and concrete. 1967 *Ford Foundation*, New York, by **Roche, Dinkeloo** and Associates; imaginative design with balconies enclosing glassed-in space with trees and shrubs. 1967 *World Trade Center*, New York, begun by **Yamasaki** (b. 1912); tall twin towers supported on delicate arcades; one of the architect's favourite motifs. 1967 *National Center for Atmospheric Research*, Boulder, Colorado, by **Pei** (b. 1917); use of local stone in concrete aggregate, part of architect's concern to harmonize building with environment.	1960–65 *An American Tribute to the British People* by **Nevelson** (b. 1900), Tate Gallery, London; elaborate arrangement of gold-painted wooden boxes. 1963 *Hamburger with Pickle and Tomato Attached* by **Oldenburg** (b. 1929), Collection Carroll Janis, New York; huge stuffed canvas work, humorous attempt to force the spectator to reassess reality. 1964 *Untitled* by **Bontecou** (b. 1931) Leo Castelli Gallery, New York; welded steel, with canvas composition of threatening images. 1964 *Cubi XVIII* by **David Smith** (1906–65), Tate Gallery, London; part of series of monumental angular abstracts. 1965 *Untitled* by **Judd** (b. 1928), Leo Castelli Gallery, New York; galvanized iron boxes by exponent of Minimal Art. 1967 *The Restaurant Window* by **Segal** (b. 1924), Sidney Janis Gallery, New York; experiment with literal representation of reality; white plastic figures and real furniture.

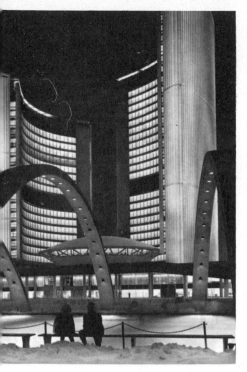

right: *Crest*. **Riley**

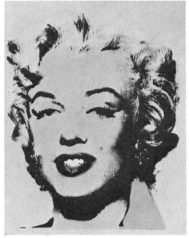

above: *City Hall*, Toronto. **Revell**

above: *Marilyn Monroe*. **Warhol**

left: *Hamburger with Pickle and Tomato Attached*. **Oldenburg**

below: *IBM Research Center*, La Gaude Var. **Breuer**

1960 French atomic tests in the Sahara. New capital of Brazil inaugurated. Authorized version of Mao's Thoughts in Western translation. Pinter's play *The Caretaker*. Hitchcock's film *Psycho*. *History of Kinetic Art* by Ramsbott. Oud (1890–1963) publishes *Mijn Weg* in *De Stijl*. Oldenburg's exhibition The Street. *Self-Destructing Homage to New York* by Tinguely. Ocean City project, Unabara, by Kitutake.

1961 Organization of Economic Cooperation and Development established. U.S. attempt to overthrow Castro fails. Bernstein's *West Side Story*. *Elegy for Young Lovers*, opera by Henze, libretto by Auden. *Katz und Maus* by Grass. The Art of Assemblage exhibition, New York. Light Ballet by Piene (b. 1928) tours European museums. Hockney visits America. Young Contemporaries Exhibition in London.

1962 U Thant elected Secretary-General of the United Nations. Dylan records *Blowing in the Wind*. David Smith invited to Italy to create works for the Spoleto Exhibition. Major Picasso (1881–1973) Exhibition in New York.

1963 President Kennedy assassinated. Nuclear test ban treaty between Russia, U.S. and Britain. *Interaction of Colour* by Albers (1888–1976). Exhibition at Darmstadt, Zeugnisse der Angst in der Modernen Kunst.

1964 Johnson signs Civil Rights Bill. Vietnamese War begins. Kosygin replaces Krushchev as Russian Premier. Olympic Games at Tokyo; dramatic Gymnasia designed by Tange (b. 1913). Swiss National Exhibition at Lausanne. Post Painterly Abstraction exhibition, organized by Greenberg. New Tendency Exhibition in Paris.

1965 Rhodesian Independence declared. *Marat/Sade*, play by Weiss. New Generation show at the Whitechapel Gallery. First retrospective of Warhol's work, Philadelphia. The Responsive Eye Exhibition, New York.

1966 Warhol's film *Chelsea Girls*. Severe flooding in Italy; devastation in Florence. Happenings by Kirby. Exhibition of Systematic Painting in New York. Kunst Licht Kunst Exhibition in Eindhoven.

1967 June War; Israel invades the Sinai peninsula. Colour television in Britain. Beatles record 'Sergeant Pepper's Lonely Hearts Club Band'. Expo 67 Montreal; habitat housing displayed by Safdie. Lumière et Mouvement show in Paris.

1968 Apollo 8 orbits the moon. Soviet troops invade Czechoslovakia. Student riots in Paris. Economic depression in Britain. Luther King assassinated. Ronan Point tower block disaster, London, shakes confidence in systems building. Vadim's film *Barbarella*. Bergman's film *Shame*. Solzhenitsyn's *The First Circle*.

1969 Brandt elected Chancellor of West Germany. Pompidou elected President of France. Golda Meir becomes Premier of Israel. Serious disturbances in Northern Ireland. *Sexual Politics* by Kate Millett. Fellini's film *Satyricon*. The Pompidou Centre, Paris, envisaged; designed by Rogers and Piano and opened in 1976. *Wrapped coast*, Little Bay, Australia, by Christo (b. 1935).

INDEX